FOLK MASTERS

FOLK MASTERS

A Portrait of America

Photographs by TOM PICH

Text by BARRY BERGEY

INDIANA UNIVERSITY PRESS

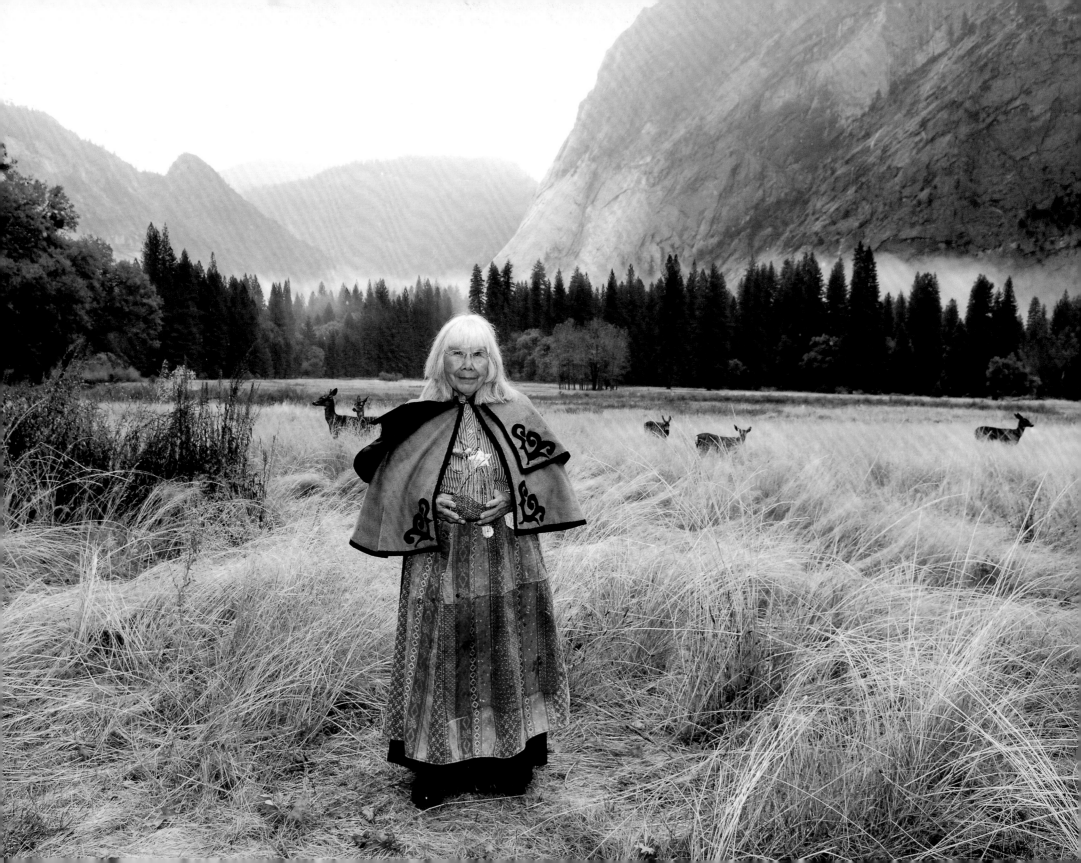

This book is a publication of

Indiana University Press
Office of Scholarly Publishing
Herman B Wells Library 350
1320 East 10th Street
Bloomington, Indiana 47405 USA

iupress.indiana.edu

This book is printed on acid-free paper.

Manufactured in China

Cataloging information is available from the Library of Congress.

ISBN 978-0-253-03232-4 (cloth)
ISBN 978-0-253-03233-1 (ebook)

1 2 3 4 5 23 22 21 20 19 18

Frontispiece: 2007 Heritage Fellow Julia Parker in
Yosemite Valley meadow, Yosemite National Park.

For Tara and Jean, our families,
and in recognition of the role
family plays in sustaining our
nation's living cultural heritage

2014 Heritage Fellow Henry Arquette's baskets on
St. Regis River, Akwesasne Reservation, New York.

CONTENTS

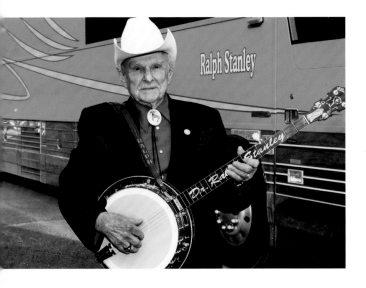 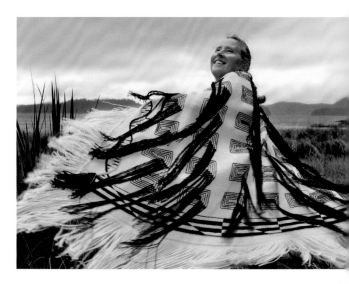

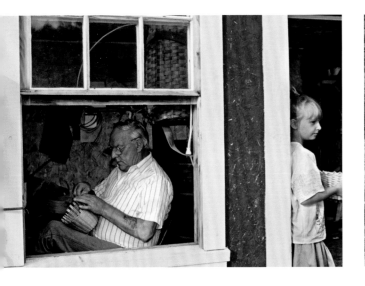 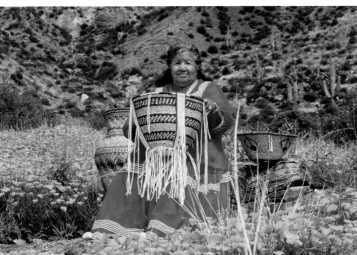 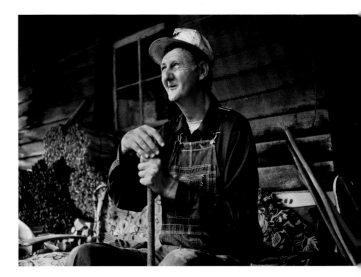

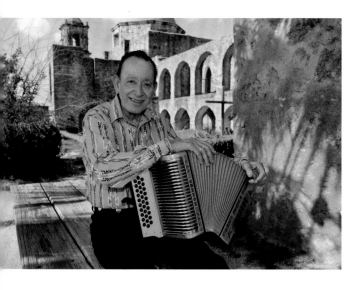 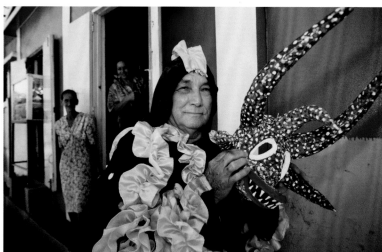 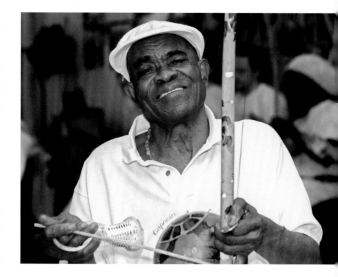

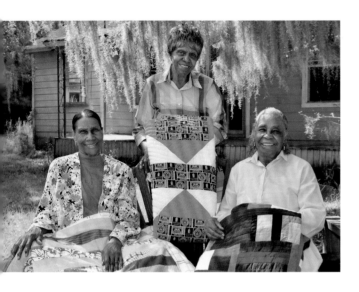
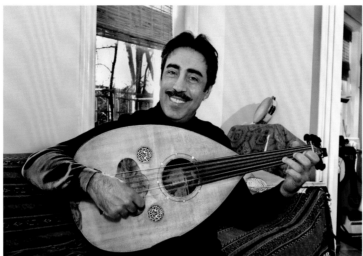
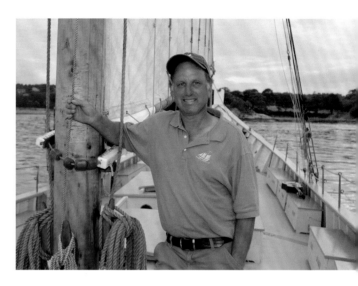

FOLK MASTERS

INTRODUCTION

IN 2009, PROFESSIONAL PHOTOGRAPHER Tom Pich was lining up an unlikely combination of individuals to have a group portrait taken. He was working in the cavernous reception area of the recently opened Visitor Center of the United States Capitol, named Emancipation Hall to honor the many unnamed enslaved laborers who helped build the domed structure. The assembled group included, among others, a cowboy poet from Texas, a basketmaker from South Dakota, a contra dance caller from New Hampshire, a Tlingit weaver from Alaska, and a gospel quartet from Alabama. All had come to Washington, DC, to be honored with a National Heritage Fellowship, the highest form of federal recognition of folk and traditional artists, given by the National Endowment for the Arts (NEA). With tourists and con-

gressional staffers wandering through this open area, and friends and relatives crowding around, Pich was having difficulty getting the artist honorees to pay attention and line up. His efforts were made more difficult by the sound of pneumatic drilling echoing off the polished stone walls and emanating from the top of a scaffold set up nearby. Pich went over to see if he could convince the workman to suspend efforts long enough for him to take the photograph. Looking up, he spied 2007 National Heritage Fellow Nick Benson.

Benson, a designer of script and a limner of names, titles, and quotes on many of the monuments and buildings in Washington, had been working largely unnoticed in the midst of ceremonial and routine activity below. He was inscribing the words "In God

2009 NEA National Heritage Fellows with Barry Bergey, Folk and Traditional Arts Director, posing for group portrait in Emancipation Hall of the Capitol Visitor Center, Washington, DC. *Photo by Tom Pich.*

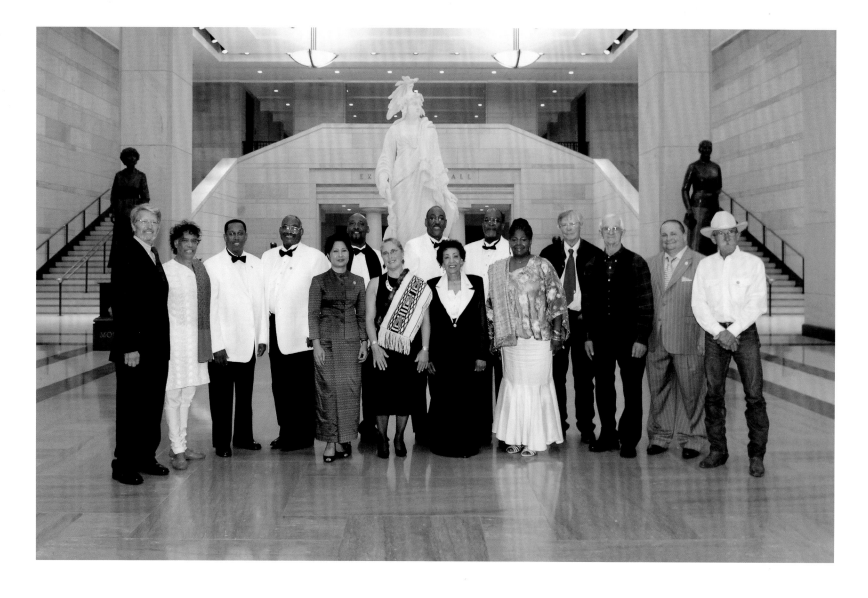

We Trust" on the interior facade of this hall, words meant to endure and, like the best of art, intended to convey truth and embody beauty. Beneath him, this diverse group of artists, none of them celebrities outside their communities, was posing for a portrait prior to an event honoring their contributions to our nation's artistic and cultural heritage. The National Heritage Fellowships recognize the "better angels of our nature" as Abraham Lincoln phrased it at his first inauguration, standing in front of that same Capitol building almost 150 years before. At the time Lincoln spoke, master craftsmen working in metal, wood, and stone, not

2

unlike Nick Benson, were still in the process of finishing that structure, a building meant to house a government that was laboring to fulfill an idealized sense of itself—struggling with an uncertain vision of who we were and what we wanted to become. This collection of photographs is intended as one statement about ourselves, a century and a half later, as expressed through a portrayal of the excellence and diversity of our citizen artists. It is a portrait of America, still a work in progress.

HONORING NATIONAL LIVING TREASURES

Bess Lomax Hawes, the first director of folk arts at the NEA, recalled that in one of her early conversations with Nancy Hanks, chair of the agency, Hanks asked if the United States might develop a form of recognition of folk artists similar to the Japanese National Living Treasures program. Although Hawes was intrigued by the idea, she also had some reservations. Japan, unlike the United States, had a population that was relatively monocultural and benefited from a cultural heritage of much greater time depth. However, she initiated a series of discussions with folk arts specialists and panels. In 1982, following a period of five years of deliberation and worry—What should be the proper size of the award ($5,000 then and now $25,000)? Would the award create jealousy among artists? How should the artists be chosen? Is it appropriate to honor individuals in a community-based art form?—the National Heritage Fellowship Program was born.

Thirty-five years later, the National Heritage Fellowships have become one of the most lauded programs of the National Endowment for the Arts, an expression of our nation's aesthetic democracy and a keystone in our federal cultural policy. Anyone can nominate an artist for this recognition. Art forms eligible for consideration include crafts, dance, music, oral traditions, and visual arts, and are typically learned as part of the cultural life of

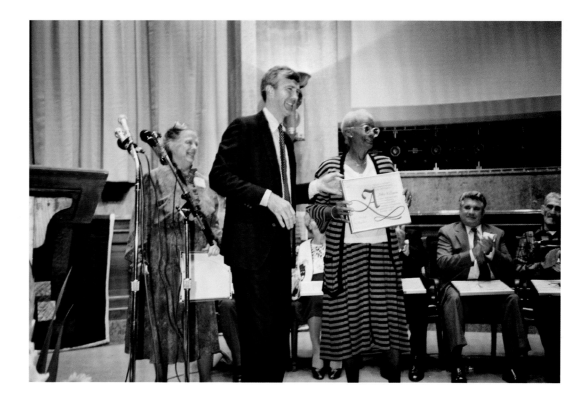

NEA Chairman John Frohnmayer presents certificate to quilter Arbie Williams at 1991 National Heritage Fellowship ceremony. Standing behind the chairman is Bess Lomax Hawes. *Photo by Tom Pich.*

a community whose members share a common ethnic heritage, cultural practice, language, religion, occupation, or geographic region. These traditions are generally considered to be shaped by the aesthetics and values of a shared culture and are passed from generation to generation, most often within family and community through observation, conversation, and practice. The guidelines for nomination are intentionally broad, allowing for the inclusion of new and evolving concepts of community, heritage, and excellence. Honorees are selected by a group that includes cultural specialists and one layperson, convened each year to consider the nominations.

To date, more than 400 artists have received this honor. Heritage Fellows come from all fifty states and five special jurisdic-

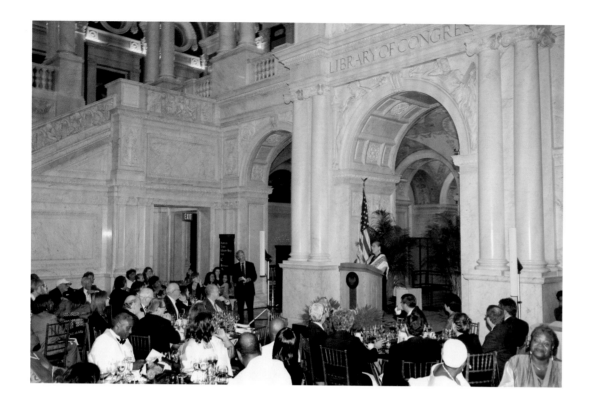

Heritage Fellow Teri
Rofkar speaks at the
National Heritage
Fellows banquet in the
Great Hall of the Library
of Congress, 2009.
Photo by Tom Pich.

hosted in the Great Hall of the Library of Congress, an appropriate venue given that the Heritage archives are housed there at the American Folklife Center. The banquet allows family and friends social time together and gives them a chance to share stories and, oftentimes, oratory and song. At the close of the week, a concert produced by the National Council for the Traditional Arts presents the artists to a large public audience that more recently has expanded through streaming on the web.

In 2000, following the death of Bess Lomax Hawes, a special award was added in her name to honor individuals who have made major contributions to the excellence, vitality, and public appreciation of folk and traditional arts through teaching, advocacy, support of artistic performance, or documentation. The vision of Bess Lomax Hawes has been realized, and her aspirational statement on the goals of the Heritage Fellowships remains true to this day:

> Of all the activities assisted by the Folk Arts Program, these fellowships are among the most appreciated and applauded, perhaps because they present to Americans a vision of themselves and of their country, a vision somewhat idealized but profoundly longed for and so, in significant ways, profoundly true. It is a vision of a confident and open-hearted nation, where differences can be seen as exciting instead of fear-laden, where men of good will, across all manner of racial, linguistic, and historical barriers, can find common ground in understanding solid craftsmanship, virtuoso techniques, and deeply felt expressions.[1]

tions, and recipients have practiced artistic traditions rooted in at least ninety-one distinctive ethnic, tribal, or cultural communities. Artists working in fifty-three different genres have been honored, from an aerialist in a circus to a zydeco musician, and honorees' works represent at least forty types of craft, twenty dance forms, twenty-two styles of vocal music, and performance on at least forty-seven different musical instruments.

Yearly events surrounding the Fellowships encompass three dimensions of life in our nation's capital—the personal, the political, and the public. Artists come to Washington, DC, in the fall of each year for an award ceremony, often with members of Congress, held on Capitol Hill or at the White House. A banquet is

After the first year of the program, President Ronald Reagan released a statement noting that the fellowships "offer us a unique opportunity to honor the cultural contributions of the best of today's traditional artists and through them, countless others who have preceded them."[2] True to Hawes's vision, the fellowships

have spun off many activities that in turn help raise public visibility and understanding of folk and traditional arts. Major festivals, such as the Smithsonian Folklife Festival, held annually on the National Mall, and the National Folk Festival based on a three-year cycle in different cities around the country, have highlighted the fellowship program. Two exhibitions touring the United States have featured the Heritage fellowships, and a third exhibition opened at the UNESCO headquarters in Paris and toured to a number of cities in Belgium. A *Great Performances* special entitled "Songs for Six Families," focusing on six Fellows, was broadcast on public television stations. A number of publications and magazine articles, as well as at least three books, focus on the National Heritage Fellowships. A website, *Masters of Traditional Arts*, presents biographical, audio, and visual materials on each of the Fellows and provides educational resources for teaches. For individual Fellows, the recognition has led to bookings at local and regional festivals, access to new markets for craft artists, and opportunities to participate in master-apprentice programs. In addition, many individual states now administer parallel honorific awards for resident master artists.

This cultural strategy, pioneered by the Japanese government, of honoring masters and masterpieces of intangible cultural heritage, as it is more commonly known internationally, has also now become inscribed in international law. In 2003 UNESCO ratified a Convention on Intangible Cultural Heritage that recognizes and supports the practice and practitioners of folk and traditional arts. An element of this convention, in effect a treaty, is a program aimed at identifying and honoring significant elements of cultural heritage in individual countries. This policy instrument also encourages member nations to inventory elements of cultural heritage that are at risk and calls for the sharing of information about successful initiatives that address the perpetuation of artistic traditions.

A PHOTOGRAPHIC JOURNEY

In 1991 a copy of *National Geographic* featuring an article about fourteen NEA National Heritage Fellows arrived in the mailbox of professional photographer Tom Pich. Intrigued by what the authors, Marjorie Hunt and Boris Weintraub, described as "the astonishing diversity of American life" reflected in this program and inspired by the beautiful photographs of David Alan Harvey, Pich immediately set out to learn more about these awards and the work of the NEA, an agency unknown to him at the time.[3] A native New Yorker and graduate of the School of Visual Arts in photography, he had spent the 1980s learning his craft and earning a living shooting corporate, sports, and magazine projects.

Pich tracked down the phone number for the National Endowment for the Arts, and upon calling the general number, he was transferred to the Folk Arts Program. It was his good fortune to reach Rose Morgan, a specialist in the office, whose friendly and supportive responses to his queries ended with Rose suggesting that he come to Washington, DC, to visit with staff. That evening when his wife, Tara, returned from work, she found him packing bags and asked where he was going. Tom said he was taking the train to Washington to visit the National Endowment for the Arts. She asked, "Why?" He answered, "I'm not sure."

Tom Pich's unannounced visit to the offices at NEA resulted in a conversation with Folk Arts Director Daniel Sheehy, who encouraged him to pursue documentation of National Heritage Fellows with the caveat that the agency had no money to support such an effort. As Tom puts it—"That was the beginning of forever." It led to a career-long mission to photograph the ever-growing

Sandman Sims
performing streetside
with an admiring
audience, 1991.
Photo by Tom Pich.

young boxer. This skill morphed into a dance that incorporated a wooden board sprinkled with sand, allowing him to enhance his tap rhythms with the swishing sounds of his feet scraping across the surface. Even in his later years, he would take out his board and participate in "challenge dances" on street corners. Not long into their visit, Sims suggested to Pich that they go outside to the streets, where he'd demonstrate a few moves. Soon he attracted a group of neighborhood children, and Tom photographed their interaction.

Tom Pich came away from that experience with several new ideas. He had envisioned this documentation project as one using black-and-white film with a square-format Hasselblad camera. After his visit with Sims, he was convinced that he needed to use color film and a 35mm camera that allowed more versatility in format and mobility in handling. Pich also understood that each photo session would present its own unique combination of circumstances governed by the personality of the artist, the nature of the location, and the accidental and spontaneous responses to the act of documentation.

In August of 1991 Pich set off on the first of two lengthy adventures that marked the beginning of his lifelong commitment to traveling across America's landscape to document National Heritage Fellows. Two lifelong friends, Michael Singer and Michael Nash, accompanied him on a number of these journeys, and in subsequent years he often tied his professional assignments with side trips to visit Heritage Fellows in their home communities.

The first trip, a 2,000-mile journey taken with Nash, originated from Pich's Connecticut home and stretched from low country South Carolina to the mountains of Appalachia, with stops in the Carolina and Virginia Piedmont on the way home. Pich first visited decoy carver Harry Shourds in New Jersey, followed by an excursion to the Charleston, SC, area to photograph blacksmith Philip Simmons and basketmaker Mary Jane Manigault. A drive

list of honorees. In the twenty-five years since, he has visited and taken portraits of more than 214 National Heritage Fellows located in forty-five states and territories.

Pich's first photograph was taken close to home. Just a few months after his trip to Washington, DC, he visited 1984 National Heritage Fellow "Sandman" Sims at his apartment in Harlem. Sims, a tap dancer who performed for years at the Apollo Theater, had later enjoyed a long career in theater productions and film. He had become one of the central figures in the revival of interest in tap during the 1970s. His specialty was the "sand dance," thus his nickname, which he developed standing in the rosin box as a

across the Carolinas took him to Beech Mountain in the Blue Ridge Mountains to visit storyteller Ray Hicks. The return trip across the Piedmont took him to the homes of singers and guitarists Etta Baker and John Jackson, in North Carolina and Virginia. All six of these portraits appear in this collection.

One experience on this trip brought home the urgency of his mission of shooting portraits of the Heritage Fellows. Pich went to John's Island, South Carolina, to photograph Sea Island singer Janie Hunter. Hunter, who was seventy-three at the time, met him at the door and said that she had been traveling and was very tired, asking if he could return the next day. When he returned the following day, there was an ambulance in front of the house, so he and Nash left, not wanting to impose on the situation. Although Hunter's condition at the time was not life threatening, when Pich tried to contact her again, she had passed away. Both the National Heritage Fellowship Program and the photography project are responses to the passage of time and are subject to it.

In February of 1993, on assignment to photograph during Mardi Gras in New Orleans, Pich asked Singer and Nash to join him in Louisiana, where, operating from a base in New Orleans, they visited Cajun country. Their first venture took them to Eunice and the Savoy Music Center, where they met accordion maker and player Marc Savoy.

The following day Pich and friends traveled to Welsh to visit Canray Fontenot, whose front lawn was dotted with crawfish mounds. Fontenot proceeded to give them a firsthand lesson about how to catch the crustaceans that, after a photo shoot, were consumed in a meal prepared by his wife, Artile. Fontenot's long-time friend and musical partner, Bois Sec Ardoin, was photographed the next day at his farmhouse, built by his father, in the rural settlement called l'Anse de 'Prien Noir (Cove of Black Cyprien), named after an early resident.

Finally, Irván Pérez, Isleno (Canary Islander) singer and decoy carver from Poydras, took Pich and Singer on a journey through the bayou landscape of St. Bernard Parish, where Pich photographed him several times during stops. Not atypically for Louisiana or for Pich's subsequent visits with artists, a large family dinner closed out the afternoon.

In the following years, this photographic odyssey has taken Pich to all corners of the United States, from Maine to Hawaii and from Florida to Alaska, with many stops in between. He continues to photograph individual artists and travel to Washington, DC, to document the ceremonial activities surrounding the award for the National Endowment for the Arts. Pich also generously shares his photographic work with other institutions—his photographs have been used for programs at the World Music Institute, National Folk Festival, National Museum of the American Indian, Smithsonian Folklife Festival, and Smithsonian Folkways Recordings. In 2007 the National Endowment celebrated the twenty-fifth anniversary of the National Heritage Fellowships and as part of that program thirty-four of his portraits were displayed in the Russell Senate Office Building rotunda under the sponsorship of Senator Edward Kennedy. The exhibition opening included a reception and reunion of past Heritage Fellows hosted by Senator Kennedy, the last public event he was able to attend. Later that same year, Pich's photographs were exhibited at the Kennedy Center for the Performing Arts. In 2009, the New York Public Library for the Performing Arts at Lincoln Center mounted an exhibition of Pich's portraits titled *Living Legacy: Portraits of NEA National Heritage Fellows 1982–2008*. The journey continues—in January of 2017 Pich traveled to the State of Veracruz, Mexico, to photograph former Director of Folk and Traditional Arts and National Heritage Fellow Daniel Sheehy while he was visiting and documenting musicians and instrument makers of that region.

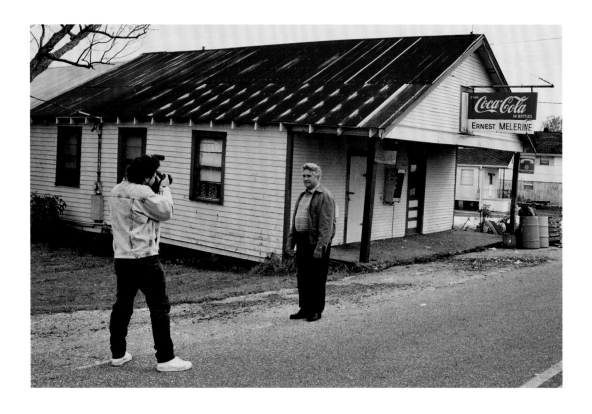

Tom Pich photographing
Irván Pérez in St. Bernard
Parish, Louisiana, 1993.
Photo by Michael Singer.

FRAMING A VIEW

One of the most difficult elements of shaping this publication has been framing a view: selecting for inclusion just 100 portraits out of the 215 Pich has taken. It is no stretch to say that each of these individuals deserves book-length treatment. Writing in the 1994 Smithsonian Folklife Festival program booklet, Daniel Sheehy described the fellowships as having three key components: (1) frames—singling out individual artists for attention; (2) fames —enhancing the artist's role in his or her own community; and (3) aims—demonstrating for our nation our diverse cultural heritage.[4] In the same sense, the selected photographic portraits provide a frame for viewing the contributions of these individual art-

ists, and the accompanying text is intended to fill in the cultural importance of the artists and their work and the backstory about the making of the image.

By visiting artists in their homes and often spending extended times with them, Pich turned the image making into a collaborative process: a hybrid of portraiture and candid photography. The choice of setting and "pose" became a cooperative venture—an opportunity for self-presentation, but allowing for the possibility of happy accidents that sometimes provide the magic in the final image. It would have been impossible to plan to have a herd of deer rise up out of the grass in Yosemite Park behind basketmaker Julia Parker, or for two steers to go head-to-head behind rancher and cowboy poet Joel Nelson, or for a rooster to wander into the background of the portrait of Creole accordionist Bois Sec Ardoin. Revelatory moments such as these extend both the visual interest and narrative depth of the portraiture.

Radical changes in imaging technology have occurred over the past twenty-six years. The early portraits were made on film, and Pich often ended his visit with individual artists without knowing whether he had captured a satisfactory photograph. Sometimes he would add a Polaroid back to his camera to share images with the subjects and their families immediately. With a switch to digital cameras in 2003, the portrait-taking process became more collaborative. Pich notes that Joel Nelson wanted to be sure that his horse's ears were erect and alert in the photograph. Chitresh Das kept checking the images to be sure that his hands and feet were in exactly the correct position in his dance pose. As Pich spent increasingly more time with artists he began recording video interviews with many of the Heritage Fellows and following up after visits by sending Fellows and their family members prints of the photographs.

Each image benefits from a degree of engagement and trust between photographer and subject. "Subject" is an imperfect term because, as mentioned earlier, the photographic process was frequently a collaborative effort, with the artist suggesting the setting for the portrait. This manifests itself in the capacity of the subjects, and in turn the images, to make a statement and establish a visual and emotional connection with us, the viewers. Documenting less than a hundredth of a second of a person's life, photographs can convey a much larger and richer narrative. The images succeed when they speak to a sense of the person, a sense of place, and a sense of purpose.

A SENSE OF THE PERSON

Just as Nick Benson drew little attention from the passersby as he did his work in the Capitol Visitor Center, many people who look at the products of his efforts will not necessarily connect them with a particular creator, let alone with the creative process. For folk and traditional arts, "anonymous" is a common attribution. Two other stories about Heritage Fellows build on that point. Years ago, television host Merv Griffin was traveling in Ireland and noticed a photograph displayed prominently behind a bar. He thought the person looked familiar, and he asked who that was. The bartender replied: "Why that's Joe Heaney, the greatest singer to come from here. He lives in New York." Griffin thought, *Yes, and he also operates my elevator and works as my doorman.* When he returned to the United States Griffin invited Heaney to be on his television program, and in 1982 Joe Heaney received a National Heritage Fellowship.

In 2008, Moges Seyoum received a National Heritage Fellowship for his work as a religious song leader in the Ethiopian Orthodox Christian Church in Washington, DC. As he was preparing to

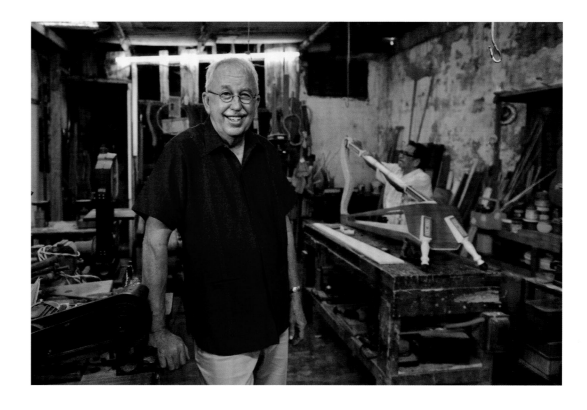

Former Folk and Traditional Arts Director and recipient of the 2015 Bess Lomax Hawes National Heritage Fellowship Daniel Sheehy, doing fieldwork in the State of Veracruz, Mexico, 2017. *Photo by Tom Pich.*

perform at the Heritage Concert, the stage manager at the auditorium felt he had seen him before somewhere. Finally, he realized that Moges Seyoum was the person who managed the parking lot across the street from the concert hall, the place where he parked his car every day.

Portraits, by their nature, bring us face-to-face with the subject matter. In some cases, with an extremely tight shot such as that of Piedmont blues singer John Jackson, we practically come cheek-to-cheek. Other photographs create intimacy by inviting us into the living room or workshop of the artist. The accumulated decor or the well-used tools revealed within serve as a visual diary of the artist's life and work. Betty Pisio Christenson described

her Ukrainian egg painting as "writing a story on an egg," and the interior of the home she and her husband built in Suring, Wisconsin, is filled with items, including eggs, as intricately patterned and nearly as aesthetically interesting as her pysanky.

Tom Pich commented about his visit to boat maker Charles Hankins that he talked as much about the tools in his workshop as he did the boats he made. He explained that it was important that hand tools live up to their name, that they comfortably fit the hands of the user and achieve their intended purpose. Blacksmith Philip Simmons stands near the door of his shop, while in the shadows behind him are the chisels, punches, pokers, and tongs made by his hand, for his hand.

In other cases, the work the artist may be holding tells us all we need to know about their creative efforts. Decoy carver Harry Shourds says that he tries to put a "little dream," a bit of his personal vision, in the decoys, such as the one resting in his hands. Pueblo potter Helen Cordero says of her storyteller dolls, "They're my little people. They come from my heart and they're singing."

Rancher and poet Wally McRae, at home on the stage as well as the range, did not want to have his portrait taken on a horse. After all, this Heritage Fellow is as comfortable writing a quatrain as reining a quarter horse. A graduate of Montana State University with a major in zoology, McRae manages his 30,000-acre ranch. He also has been active in local theater, is an advocate for environmental stewardship, and served a term as a member of the National Council on the Arts. His multidimensional personality is better revealed in his portrait, which shows him sitting on stage at the National Cowboy Poetry Gathering with one of his four published books in his lap.

Steve Siporin, in his book *American Folk Masters: The National Heritage Fellows*, says of these artists: "Through their skill and enthusiasm, we see a future with a human face, art with human di-

mensions. We see the curve of the maker's hand in things lovingly shaped. The voice of the singer is nearby and need not strain. We beg the storyteller not to stop, even if we fall asleep."[5] Whether through a well-crafted object, a personalized space, or an expressive face, the portraits document and reveal some of the character of individual master artists.

Photographs selected for this volume were taken in locations ranging from northeastern Maine, not far from where the sun first rises on the continental United States, to the Big Island of Hawaii, near where the sun last sets. This geographic span features a variety of landscapes and environments, and many artists express a special connection to their place on the map. Ukulele player and singer Clyde Sproat described his experience as a youth on his family's remote Hawaiian home place:

> We sat on mats that were woven from the leaves of the pandanus tree and watched the reflection of the sun rising up the east wall of the valley, then dancing on the trees at the very top of the ridge before slowly fading out of sight. I sang my heart out. At that time I felt like we were singing the sun to sleep, so in the morning as he crept over the west ridge with his long shadowy legs, he would be warm and friendly and let us have another good day of swimming and fishing in the stream and doing all the things that little boys do in a day.[6]

It would be hard to separate his music from that place, a two-hour mule ride from the nearest road. Fellow Hawaiian and National Heritage Fellow, slack key guitar player Ledward Kaapana, who also grew up in a rural community, mused: "People say that in Kalapama, the music got better as you went further down the road."[7]

In a similar vein, New Mexico santero (saint carver) Ramón José López, says that his art work "is a reflection of our environ-

ment, the sacred space we live in. The beautiful sunsets that inspire us every day, the fresh air, the Sangre de Cristo Mountains. You wake up and say, 'Oh yeah, I'm happy to be alive.'"[8] For him, that inspiration is expressed through the wood and metal items that he creates for local chapels and museums.

Alabama potter Jerry Brown had particular ties to the land—he dug the material used for making pots in clay pits not far from his home. It is no accident that good clay and accomplished potters are most often found in close proximity. In the North Carolina Piedmont region, within a 25-square-mile area of where Jugtown potter Vernon Owens works, there once were over 200 potters working. There also was excellent potting clay. Owens seems to think it is pretty straightforward: "When you come right down to it, pottery's a fairly simple thing. Clay can be found everywhere and will do the same job of being shaped and hardened in the fire. Of course, there are some materials you may want that are not so easy to get because they were only deposited here and there and some that are really rare, like cobalt. But people have been making pots in every corner of the world since folks settled down on the land."[9] Land and landscape shape pots, both literally and figuratively, and those corners of the world where master potters can be found are today very special places, indeed.

In the case of basketmakers, the availability of materials is inextricably connected with their natural environment. Sweetgrass basketmaker Mary Jackson, responding to the loss of habitat through coastal development and other environmental factors, helped organize the Mt. Pleasant Basketmakers' Association to assure continued access to the sweetgrass and palmetto essential to the basketmaking process. Basketmaker Henry Arquette became concerned about the threats to the ash trees on the Akwesasne Reservation due to overharvesting, pollution, and insect infestation and began advocating for protection of the forests, earning him the Ross Silversides Forestry Award in 2001 from the National Aboriginal Forestry Association.

When asked about how the New Mexico landscape influenced his weaving, Irvin Trujillo said: "I see the colors—the browns and greens in the ground and trees, the blues in the sky, the reds, purples, oranges in the sky at sunset, the yellows in the plants. I weave with these and other colors. I'm influenced so much by the landscape and anything I see."[10] There is another truth behind this beauty, though, because this arid landscape both inspires and challenges. The earliest record of the Trujillo family in Chimayo, New Mexico, is a 1775 document granting water rights on their property. Water was essential for raising corn and beans, as well as the sheep that are the source of wool for weaving. Access to water, snowmelt from the mountains, has been a matter of contention ever since. Trujillo points out that for them water is life and livelihood. When possible, he still rinses his dyed wool in the irrigation stream behind his shop—making a connection with the land and his ancestors and putting a little bit of his personal environment into his weaving.

A sense of place, however, is not limited to the expansive natural landscape. Among these photographs, we see New Orleans clarinetist Michael White sitting streetside at a French Quarter café; Puerto Rican mask maker Juan Alindato embarking on a parade through the neighborhood streets of his hometown of Ponce; Pinetop Perkins sitting backstage at a music hall in Connecticut; and Billy McComiskey standing in front of an Irish pub in midcity Baltimore. It would be hard to imagine that the ensemble traditions of New Orleans jazz could have survived without the confluence of musicians that occupied the clubs and streets in this urban setting; that the electrified blues would have evolved other than in the crowded dance halls of Chicago or Detroit, brought there by migrants from the rural South; or that Irish music in

America could thrive without the musical sessions in the pubs and parlours of New York, Boston, Chicago, and Baltimore.

A SENSE OF PURPOSE

When she attended the National Heritage Fellowship banquet in Washington, DC, Passamaquoddy basketmaker and National Heritage Fellow Mary Mitchell Gabriel told the story of someone commenting to her, "You must be very happy with your hobby." Gabriel replied, "This is not my hobby, this is my life." Heritage Fellows are deeply engaged in their artistic practice and have spent a lifetime acting on that commitment. The faces of Philip Simmons, Eppie Archuleta, Vanessa Paukeigope [Morgan] Jennings, and Charles Hankins, among others, reveal a mien imbued with seriousness. Pueblo potter Helen Cordero's movement carrying one of her storyteller dolls from her outdoor kiln into her home is captured by Pich's photograph and reveals an expression of determination that would be hard to ignore or impede.

For some, this sense of purpose takes the form of teaching and passing on inherited knowledge and skills. As Kiowa regalia maker Vanessa Jennings describes it: "My work is not an end in itself. Nor is it something meant to bring me fame or riches. It is simply a perpetuation of the Kiowa people for the generations after me."[11] When Tom Pich went to visit tea master Sensei Sosei Matsumoto, she was surrounded by students and followers. Estimates are that she has taught thousands of students over her career and continues to practice the way of tea at the age of ninety-six.

Basketmaker Molly Neptune Parker, one of a dwindling number of fluent speakers of Passamaquoddy, combines basketmaking apprenticeship teaching with passing along her endangered Native language. In Maine, thanks to the efforts of Heritage Fellows Parker, Mary Gabriel, Clara Neptune Keezer, Theresa Secord, and others, there has been a renaissance of Maine Indian basketry. A group of basketmakers, including these women, came together in 1993, concerned about diminishing interest in the craft and dwindling access to basketmaking materials. At the time, the average age of the handful of basketmakers was sixty-three. With assistance from the Maine Arts Council and funding from the National Endowment for the Arts, they formed the Maine Indian Basketmakers Alliance and initiated a master-apprentice program. Today, there are more than 200 active basketmakers with an average age of forty. Recently, a basket made by one of those apprentices won Best of Show at the Santa Fe Indian Market and sold for $25,000.

Many of the art forms represented here occupy the uncertain space between risk and resilience. Jennie Thlunaut, Tlingit/Chilkat (Alaska Native) weaver was ninety-five when it was announced that she was to receive a National Heritage Fellowship. Unfortunately, she passed away before the ceremonies were held that fall. She was thought to be the last of the master weavers of the intricate Chilkat robes. At a potlach in Hoonah she was given the honorary name *L'eex'eendu.oo* (Keeping the Broken Pieces) in recognition of her important cultural knowledge. In the year prior to her death she gathered fifteen younger apprentices and said: "I don't want to be stingy with this. I am giving it to you, and you will carry it on."[12] Among those who studied with Thlunaut was Clarissa Rizal, but she was so grieved over her mentor's death that she stopped weaving for a time. Only when granddaughters of Thlunaut asked her to teach them did she begin to weave again. Rizal continued creating and teaching, and in 2016 received a National Heritage Fellowship for her efforts at cultural preservation and artistic innovation. Sadly, less than two months after receiving the award, Rizal passed away at the young age of sixty, leaving the tradition to her students, including Thlunaut's grandchildren and her own children and grandchildren, to carry on.

The portrait of capoeira master João Grande depicts students behind him performing at the Capoeira Angola Center of Mestre João Grande in New York City. A poem that he has written and posted on his website illustrates his mission:

I am a ripe fruit
Falling slowly from the tree
The impact spreads my seeds
Looking for fertile earth
To be fruit once again.[13]

Commitment to purpose among some of the Heritage Fellows also reflects a commitment to faith. Santeros (saint carvers) like Ramón José López and Byzantine woodcarver of icon screens Konstantinos Pilarinos make their beliefs manifest in objects meant to be displayed in homes or churches. Tibetan Buddhist mandala maker Losang Samten creates sand paintings that through a ritual process are then destroyed and scattered in flowing water, reflecting the impermanence of all things as well as assuring the necessity of reenacting the process of creation and destruction. Ethiopian Orthodox singer Moges Seyoum, gospel group the Blind Boys of Alabama, and Afro-Cuban Santeria initiate Felipe García Villamil enact their belief through movement, music, and song in repeated practice and performance.

Former coal miner, religious singer, and preacher Frank Newsome has been using his voice in the service of the church for over fifty years. On Sundays, that voice can be heard, rising against the gravitational pull of black lung disease, as he leads worship and lines out hymns for the ninety-one members of Little David Church in rural southwest Virginia. Newsome turns down money for preaching at funerals and special services, even though he has been asked to travel to states throughout the region to officiate at the request of family members and friends. He says, "I am not doing this for no big name or no pat on the back. No, I don't want that. I'm just an old country feller. I ain't got nothing and I ain't looking for nothing, but I believe I've got a home in Heaven when I leave."[14] When he received the honorarium from his Fellowship, he used the money to fix the roof on his church.

Ironworker Francis Whitaker often used a story to demonstrate to his students the ways commitment to purpose might be tested in the practice of their craft. He said, "Say you're doing a forge weld and you take it out and put it on the anvil. You hit a couple of licks and a piece of molten steel gets between your thumb and your hammer handle. Do you drop the hammer or do you finish the forge weld?"[15] Two years after he received his National Heritage Fellowship he was in the hospital and asked friends to bring him his hammer so that he could fulfill his lifelong wish to die with his hammer in his hand.

PICTURING AMERICA

This book is subtitled *A Portrait of America*, but it does not purport to be "the" portrait of America. The subject matter is drawn from the constellation of honorees selected for this recognition over a span of thirty-five years. Like all portraits, the individual images convey a blend of the real and the ideal, or as Bess Lomax Hawes put it, a vision both profoundly longed for and profoundly true. The common threads defining these 100 individuals, and the 115 not featured here, are artistic excellence and a lifetime of contribution to our cultural heritage. As a whole, the collection reflects diversity, but the diversity is a natural by-product of excellence, not the other way around. Forty-three states and territories are represented by the Fellows. Many pictured on these pages would not even presume to call themselves artists. The list of one-time occupations reads like a Walt Whitman poem: logger, gravedigger, iron rigger, civil engineer, parking lot tender, airline execu-

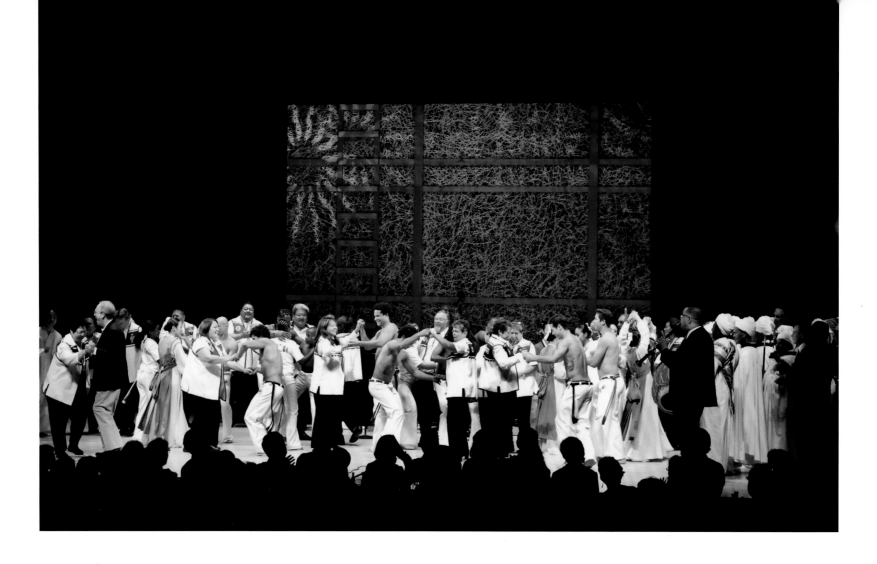

tive, keeper of books, restaurant cook, coal miner, truck driver, factory worker, sheepherder, janitor, dockhand, stockman, auto dealer, and spiritual healer. In the views of their peers and their government they are all master artists as well.

This collection should be treated as a visual narrative—the text is meant to give a brief introduction to the artist and a comment on the story behind the photograph. The images bring us face-to-face with folk masters on their terms, and it is hoped that this counters any temptation to exoticize, romanticize, or histori-

cize them or their work. Individual portraits, like all photographs, have borders, are defined by perspective, and reveal, to a greater or lesser degree, depth of field and breadth of context. As a group, they hint at the creative life, often unseen and underappreciated, within our nation's culturally diverse and geographically dispersed communities.

It is this sense of the whole that emerges in the end. In 2008 a cultural critic and magazine writer attended the celebratory concert featuring Heritage Fellows and opened his account of the

event saying, "On Friday, September 19, I witnessed one of the most miraculous things I've ever seen on a stage. I use that adjective with a purpose; the only way to describe what happened is with the language of religion." During the finale, capoeira artists, Oneida hymn singers, bluegrass musicians, and a Korean dancer moved onto the stage while the New Orleans jazz band played "When the Saints Go Marching In"; a spontaneous dance broke out—"the mélange of cultures had melted into one joyful snake of human happiness . . . barriers had been melted by the unifying power of art."[16]

In my thirty years of involvement with the National Heritage Fellows Program at the National Endowment for the Arts, I was amazed each year to witness the powerful connections formed as artists celebrated one another, shared stories, and presented themselves to the broader public. In 2001, Heritage events were scheduled just a week after September 11. Frenzied discussions about whether to cancel the program ensued, but finally we decided to go ahead. All but one of the artists came, including Apache basketmaker Evalena Henry, who had never flown on a plane, and an eighty-nine-year-old rag rug weaver from Iowa who told me that she was not about to be deterred. The concert was the first public event in Washington, DC, other than memorial services. At the opening, after a moment of silence, *taiko* drum master Seiichi Tanaka performed a cleansing ritual, chanting and playing a flute and striking a bell. Capoeira master João Grande and his group entered the hall through the aisles, dressed in white, singing and playing the one-string *berimbau*. As they reached the stage, the curtains opened to reveal large *taiko* drums, and thunderous drumming filled the air. As the drums finished, the rest of the recipients filed onto the stage, and the audience erupted into a prolonged ovation. It suddenly seemed that we could feel good about feeling good again.

Every artist whose image is featured in this volume, and indeed every National Heritage Fellow, has given us and our nation's living cultural legacy inestimable gifts. Skokomish elder and 2004 National Heritage Fellow Gerald Subiyay Miller, speaking to fellow recipients at the celebratory banquet in the Library of Congress, summed up his feelings about this honor with these words, later entered into the *Congressional Record*:

> I want to extend my gratitude on receiving this award to all of our ancestors who left us the gifts that we exhibit today; the gift of the song, the gift of the dance, the gift of the story, and the gift of creativity. As long as we keep these traditional arts alive, we speak for our people. . . . We all live our own story. We all come from different walks of life. But right here . . . tonight and right here in these next few days we all share the same story. From this moment in time we are brothers and sisters.[17]

Our hope is that these portraits and the accompanying text provide an opportunity to appreciate the contributions of master artists, to visually share a brief moment in their individual lives, and to imagine that we can all be part of the story.

NOTES

1. *The National Heritage Fellowships, 1985* (Washington, DC: National Endowment for the Arts Folk Arts Program, 1985), n.p.

2. *The National Endowment for the Arts National Heritage Fellowships 1982–2011, 30th Anniversary* (Washington, DC: National Endowment for the Arts, 2011), 5.

3. Marjorie Hunt and Boris Weintraub, "Masters of Traditional Arts," *National Geographic*, January 1991, 74.

4. Daniel Sheehy, "The National Heritage Fellowships: Frames, Fames & Aims," in *1994 Festival of American Folklife* (Washington, DC: Smithsonian Institution, 1994), 86–90.

5. Steve Siporin, *American Folk Masters: The National Heritage Fellows* (New York: Harry N. Abrams, 1992), 211.

6. National Endowment for the Arts, National Heritage Fellows Files, quoted in Siporin, *American Folk Masters*, 77.

7. *2011 National Endowment for the Arts National Heritage Fellowships* (Washington, DC: National Endowment for the Arts, 2011), 5.

8. Michael Pettit, *Artists of New Mexico Traditions: The National Heritage Fellows* (Santa Fe: Museum of New Mexico Press, 2012), 81.

9. Mark Hewitt and Nancy Sweezy: *The Potter's Eye: Art and Tradition in North Carolina Pottery* (Chapel Hill: University of North Carolina Press, 2005), 233.

10. Meg Pier, "Irvin Trujillo/New Mexico," *View from the Pier* (blog), August 31, 2010, http://www.viewfromthepier.com/2010/08/31/irvin-trujillo/.

11. Vanessa Morgan [Jennings], National Endowment for the Arts National Heritage Files, quoted in Siporin, *American Folk Masters*, 161.

12. *The National Heritage Fellowships 1986* (Washington, DC: National Endowment for the Arts, 1986), 14.

13. *Capoeira Angola Center of Mestre João Grande*, http://www.joaogrande.org/.

14. Josephine Reed, "Interview of Frank Newsome," September 21, 2011, https://www.arts.gov/honors/heritage/fellows/frank-newsome.

15. *National Heritage Fellowships 1982–2011*, 40.

16. Mark Gauvreau Judge, "Concert of the Year: A Holy Joy," *Books & Culture*, October 2008, http://www.booksandculture.com/articles/web exclusives/2008/october/oct13.html.

17. *National Heritage Fellowships 1982–2011*, 54.

PORTRAITS

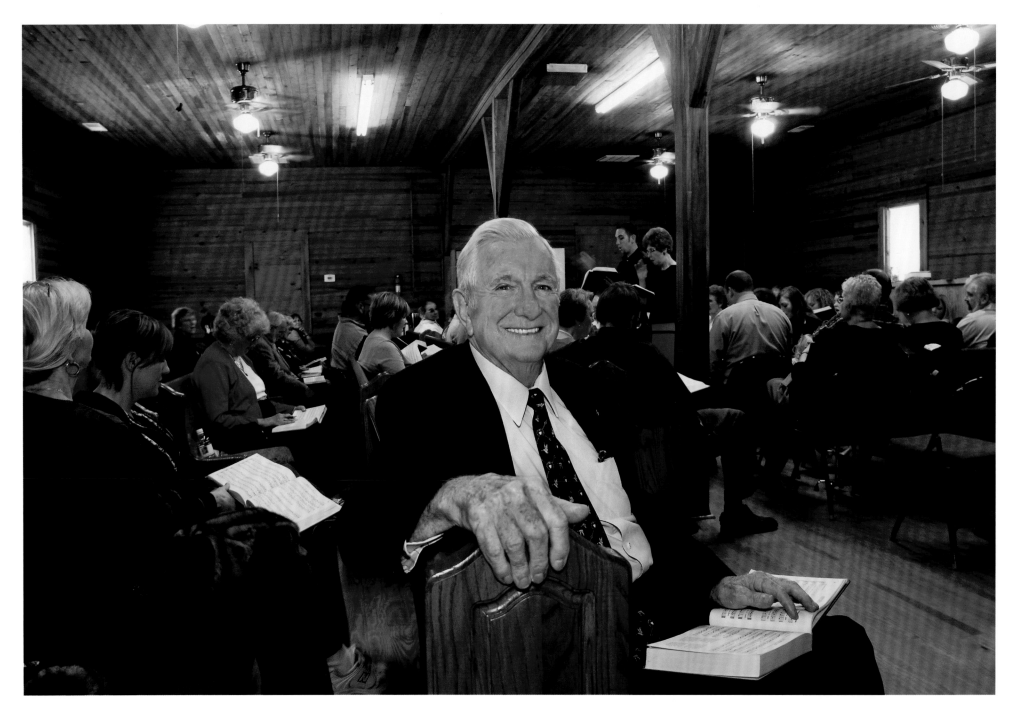

HUGH McGRAW

Bremen, Georgia | 1982

All I can say about Sacred Harp music could be summed up in a few words. Uncle Tom Denson once said, "If you don't like it, you had better stay away from it, because it will get hold of you and you can't get away."

Shape note singing spread throughout New England in the eighteenth century as a simplified way for church members to grasp the melodies of religious hymns. Teachers traveled from community to community to instruct singing school attendees in a method of singing that associates shapes on the staff of a hymnbook with notes on the musical scale. The melody is often sung in unison using the "fasola" syllables before adding the words of the hymn. *The Sacred Harp*, published in 1844, became one of the most popular shape note hymnals. This form of a cappella group singing took root in the South, where it continues today, usually not as part of a church service but at afternoon singings and larger-scale regional conventions. Hugh McGraw was born into a family of Sacred Harp singers, but did not take it up until he was twenty-five years old. When he did, McGraw became an ardent singing school teacher, composer of hymns, and public ambassador for this tradition of religious singing. For forty-three years he served as secretary of the Sacred Harp Publishing Company, and in 1991 he spearheaded a revision of the hymnbook, adding a number of new compositions. McGraw's willingness to travel far from home to conduct singing schools sparked a revival of shape note singing that now reaches throughout the country and across the seas.

Tom Pich attended a shape note sing at Hugh McGraw's home church, Holly Springs Primitive Baptist Church, in Bremen, Georgia. As is common, singers arranged themselves in a hollow square, facing one another, as the singing commenced. McGraw introduced his special guest and invited Pich to join him in the center of the group, where the song leader stands. The singers opened with "Amazing Grace." When one of the members offered him a hymnal, Pich politely demurred, saying he had forgotten his glasses, but he later acknowledged that his hesitance was more an issue of vocal ability than of visual acuity. Eventually, Pich found a pew at the edge of the singing space for the portrait, where McGraw sits resting his open songbook on his knee, while in the background, two song leaders can be seen keeping tempo with the motion of their hands, as the group sings another hymn. Following the afternoon of song, everyone gathered outside for the customary dinner on the church grounds.

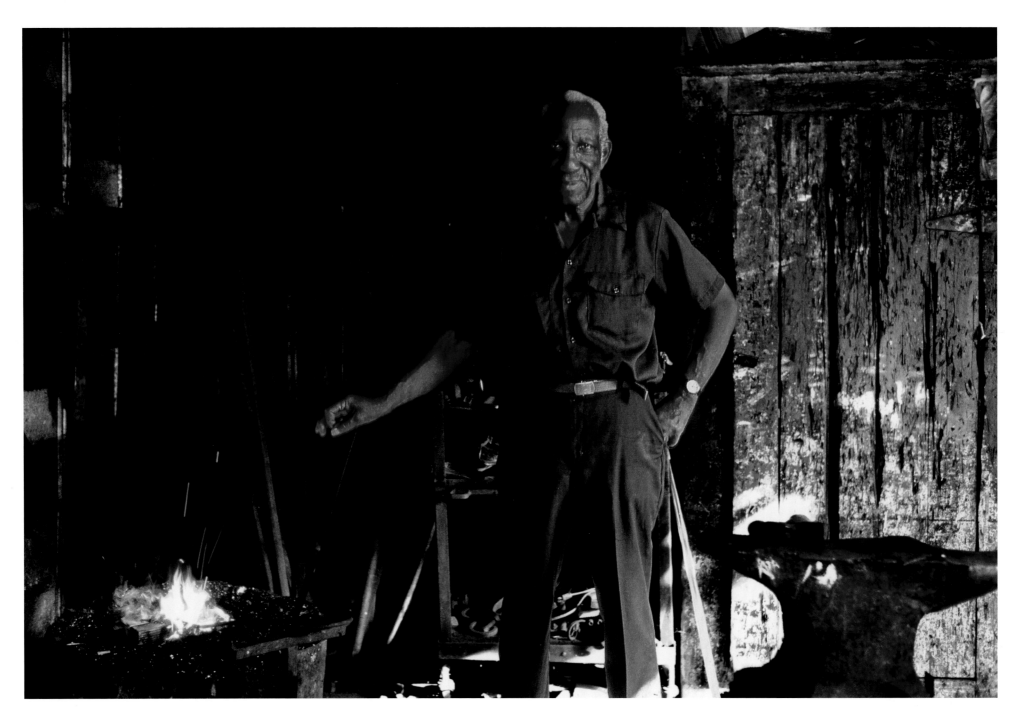

PHILIP SIMMONS

Charleston, South Carolina | 1982

It was action what brought me to the shop. I liked to see sparks and the fire, and hear the hammer ring.

Philip Simmons's art combines masterful ironwork with imaginative design, as expressive as it is functional. At thirteen, Simmons apprenticed with Peter Simmons (no relation), a former slave, who had a blacksmith shop in Charleston. Like craftworkers of the antebellum South who preceded him, Philip Simmons first concentrated on the basic skills of the blacksmith—making tools, fashioning horseshoes, and repairing equipment. In time his attention turned to more sculptural endeavors, and, consistent with the architectural history of Charleston, he began contracting to produce decorative pieces of ornamental ironwork: gates, window grills, balcony rails, and fences. His work combines a strong graphic sense, sometimes distinctively accented with a figurative element appropriate to the region, such as an egret, a snake, a bass, or a palmetto tree. Over his seventy-eight years of work, Simmons created more than 500 pieces that can be found across the city of Charleston, as well as in museums of the Smithsonian Institution and the Museum of International Folk Art.

Tom Pich's first extended trip to photograph National Heritage Fellows took him to South Carolina, after a stop in New Jersey to photograph decoy carver Harry Shourds. Reaching the Palmetto State, Pich and his friend Michael Nash drove through Charleston neighborhoods looking for Simmons. Most likely because their van had out-of-state plates and they were driving slowly, scanning each house, it was not long before they were pulled over by the local police. After explaining their mission, the two were sent in the general direction of Simmons's home and workshop. Simmons, who was in his eighties, had been taking an afternoon nap, but he got up, dressed in his work clothes, and fired up his handmade forge. As Pich describes it, with the use of slide film, every shot had to count. Blacksmith shops are notoriously dark, as it is necessary for the smith to detect the subtle changes in color and thus gauge the temperature of the coals and the pliability of the metal. Simmons turned to face the camera, and the sunlight coming through the shop door, warmed by the glow of the embers in the forge, provided the dramatic lighting for this photograph.

RAY HICKS

Banner Elk, North Carolina | 1983

One's got it in him to tell stories. . . . Maybe I was one fixed by the Creator to keep it. Once you learn a tale, you never forget it.

Ray Hicks was raised in a cabin on Beech Mountain in western North Carolina. Both of his parents sang ballads and told stories, and his father was one of the first dulcimer makers in the region. It was from his grandfather that Hicks first heard the traditional tales, most with early English and European roots in oral tradition. Many of these stories had a hero named Jack, familiar to most today through such widely told stories as "Jack and the Beanstalk," and referred to as "Jack tales." In 1973 Ray Hicks shared some of these tales at the first National Storytelling Festival in Jonesborough, Tennessee. In a setting that consisted of a circus tent, some hay bales, and wagon beds, with an audience that numbered less than a hundred, the event launched a revival of storytelling that continues to this day. Many consider that festival to represent the big bang of the storytelling movement and Hicks to be its godfather.

As New Yorkers on their first journey into the upland South, Tom Pich and his friend Michael Nash, a postal worker by profession, came to appreciate the role oral communication plays in traversing this particular cultural and geographic landscape. With no specific address and no marked street names, it took a visit to the local post office and then frequent stops at individual homes, many with roadside mailboxes tagged with the name Hicks, before they were able to track down the cabin of Ray and Rosa Hicks. Described by some as an "all-day talker," Hicks settled his frame, as long and tall as his tales, into a seat on his porch and launched into stories as Pich photographed him from below. Typical of his expressive style of storytelling, his smile conveyed the immediate pleasure he always took in these more than twice-told fabulous tales, even with an audience of two.

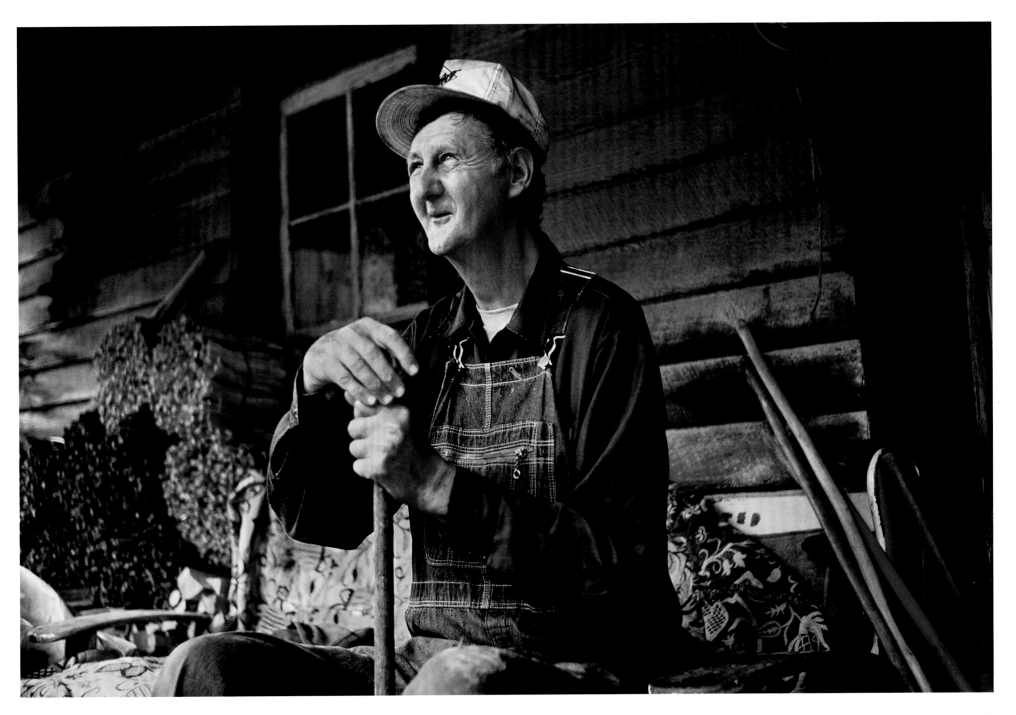

MARY JANE MANIGAULT

Mt. Pleasant, South Carolina | 1984

When you sew baskets, you have to have long patience. You can't be a nervous somebody and make baskets. You have to sit in one place and really get into what you are doing. You can't have your mind running on all kind of different things. You have to have a settled mind.

The practice of making coiled sweetgrass baskets in the South Carolina Low Country dates to the earliest plantation-based culture in that region and in turn can be traced to the agricultural practices of West Africa. Rice fanners and produce baskets were crafted from locally available natural materials gathered along the coasts of South Carolina and Georgia. This craft eventually evolved from what were called "work" baskets to "show" baskets. Mary Jane Manigault, born in 1913, learned basketmaking from her parents, Sam and Sally Coakley. Residents of a post-Reconstruction community near Mt. Pleasant, South Carolina, the Coakleys marketed their largely functional baskets to tourists and customers in the North. Using rush, sweetgrass, pine needles, and palmetto and drawing on her parents' skills, Manigault created baskets with innovative woven patterns, sculptural forms, and solid construction. For years she sold her wares at the open-air Charleston Market, always happy to demonstrate techniques and share her cultural knowledge with those who stopped by.

Tom Pich photographed Mary Jane Manigault sitting on her front porch, holding one of her baskets. In a tight shot, the angle of the light brings out the texture and beauty of her face, qualities echoed by the surface of her basket. Manigault's observation that in order to make good baskets, you need a "settled mind" is reflected in the sense of calm her contemplative expression conveys.

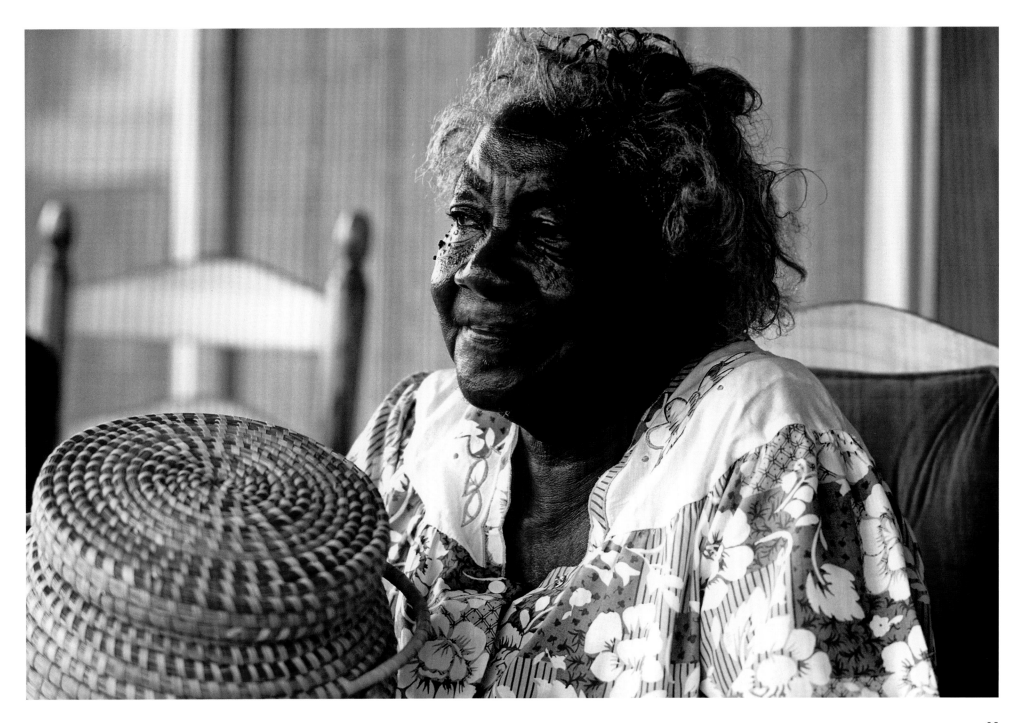

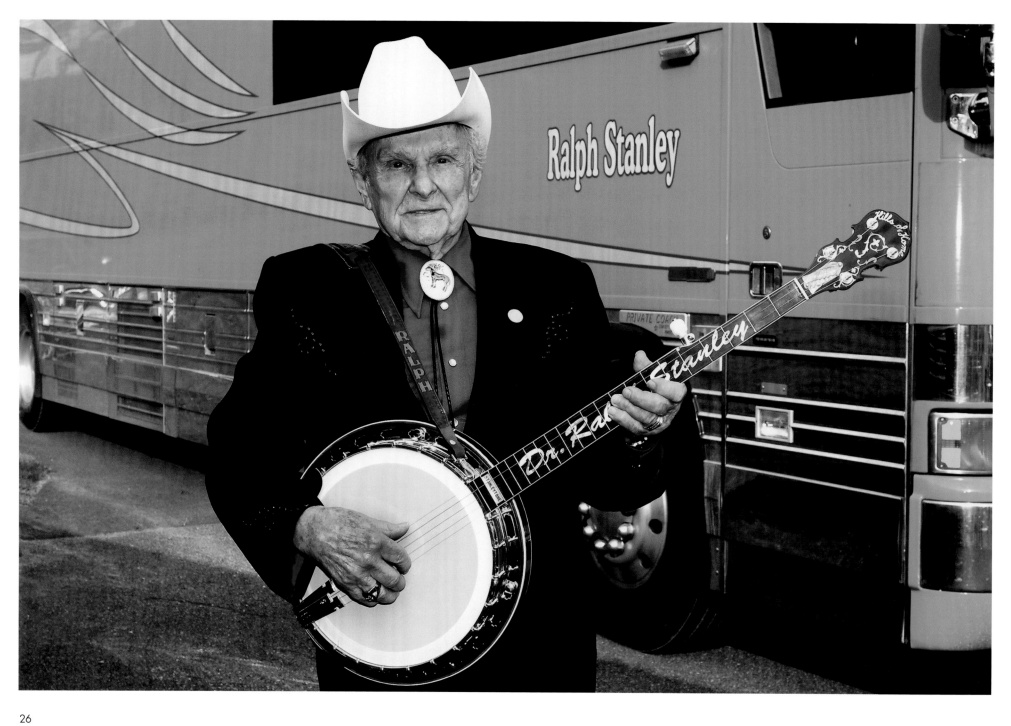

RALPH STANLEY

Coeburn, Virginia | 1984

What do I listen for in a song? Well, mostly the feeling. 'Course the words are important too. It's hard to say. Me, I like it just as lonesome as you can get it.

From the Clinch Mountain area of Southwest Virginia, Ralph Stanley and his brother Carter were seminal musicians in the development of bluegrass music. Steeped in the older sounds, Ralph heard his mother sing and play banjo in a style known as clawhammer, striking the strings with the back of the fingers in a downward motion and using the extended thumb to pick individual notes. His father also sang, and through attendance at the local Primitive Baptist Church Ralph heard a repertoire of a cappella lined-out hymn singing that would later become critical to his set list. In 1946, after Carter got out of the army, he and Ralph formed a band that performed on local radio stations and at community venues. They began recording, and many historians believe that their record of a Bill Monroe song, "Molly and Tenbrooks," was the first indication that bluegrass music was spreading as a distinct musical genre. Following Carter's untimely death in 1966, Ralph continued to perform with his own band and gained a wide reputation for his distinct renditions of older ballads and religious songs. His arrangements of traditional songs and a cappella hymns, often sung in modal keys with a textured and exuberant blend of vocal harmonizing, brought a certain emotional authenticity to his music that has had a profound influence on bluegrass music. On the road as a performer for better than fifty years, in 2000 Stanley received further acclaim when his haunting version of "Oh Death" was featured in the movie *Oh Brother, Where Art Thou?*

The bluegrass repertoire features many songs that reference the highway, from "Traveling the Highway Home" to "Highway of Regret." Although folklorist Alan Lomax described bluegrass as "folk music in overdrive," the vehicle most often used by these musicians is the ponderous tour bus. This photograph, taken at the Blue Ridge Music Center near Galax, Virginia, just a few mountain ridges away from Stanley's home, shows Ralph standing in front of his tour bus. The pin-striping on its side seems to emerge from Stanley's shoulder as a second strap for his banjo, linking musician, music, and mode of transportation.

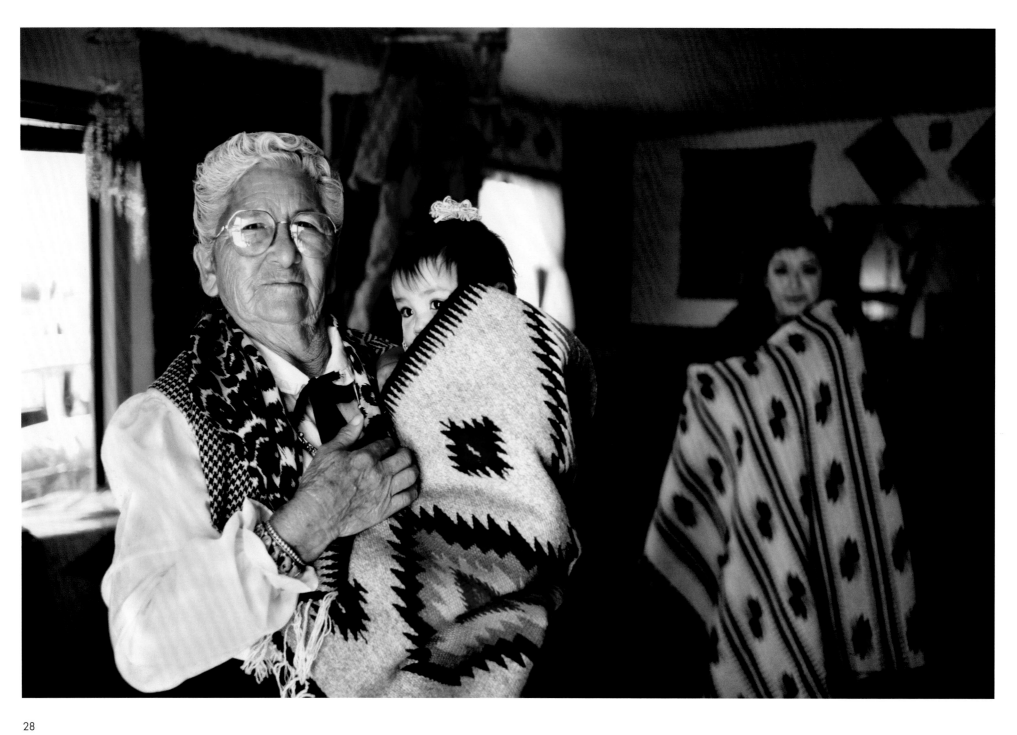

EPPIE ARCHULETA

San Luis Valley, Colorado | 1985

Ever since I could reach the loom, I was weaving. I was born a weaver. It was impossible not to be. My mother was always at the loom, and my dad used to run the farm. When we were very, very small and we couldn't weave, we'd gather the wool.

Eppie Archuleta grew up in the Rio Grande Valley of northern New Mexico, an area known for its finely woven textiles, mainly wool blankets that combine Hispanic and Native American visual elements. The tradition of weaving goes back at least five generations in her family, as does the practice of carding, dyeing, and spinning the wool. In the 1940s she moved with her husband and family to the San Luis Valley in southern Colorado, and when not raising sheep and working in the potato and lettuce fields she continued to weave. By the 1950s she had begun teaching at the Los Artes del Valle craft cooperative, and later she opened the San Luis Valley Wool Mill to supply woolen yarn to other weavers in the region. In 2001 she received the master's award for lifetime achievement from the Spanish Market in Santa Fe.

Tom Pich visited the shop in southern Colorado that Archuleta set up to supply wool and supplies to local weavers. The portrait illustrates the generational continuity of the weaving tradition, as Archuleta is holding her granddaughter while her daughter, also a weaver, stands in the background. Starting young runs in the family, as Archuleta recalls sleeping under the loom as a child and starting to weave as soon as she could reach the shuttle and treadles. Striking blankets encircle the shoulders of her grandchild and give visual affirmation to the importance of textiles in the everyday lives of the Archuleta family. The expression on Archuleta's face suggests pride in her family and determination that the weaving tradition will continue for generations to come.

JULIO NEGRÓN RIVERA

Morovis, Puerto Rico | 1985

The day that I have an instrument, I'm in good shape. The day that I don't feel so good, I pick up an instrument, and I play it, and with that I feel fine.

The jibaro (mountain Hispanic) music of Puerto Rico is rooted in the highland interior of the island where coffee trees are cultivated and grown. The cuatro, a ten-stringed guitar, is central to the music of this region and has become known to many as the national instrument of the commonwealth. Julio Negrón Rivera's grandparents and parents were musicians, and his father was also an instrument maker. Family members performed secular music, such as valses (waltzes) and décimas (sung poetry, often improvised), as well as religious songs such as those in honor of the Virgen del Carmen (patron saint of Morovis) and others, performed at saints' days, novenas, and wakes. Although he performs music with his family to this day, the instruments he makes have gained him a reputation well beyond Puerto Rico.

In 2007 the National Endowment for the Arts celebrated the twenty-fifth anniversary of the Heritage Fellowships, and in conjunction with the event, a gold pin and commemorative booklet were produced. On his trip to Puerto Rico, Tom Pich carried with him the pin and booklet to present to Negrón Rivera. Pich was taken to the family home by craft advocate Walter Murray Chiesa, later to receive a Heritage Fellowship himself. Upon arriving, they were greeted by more than forty family members and friends anxious to witness a "ceremony" honoring the artist. The pin and booklet were presented to Negrón Rivera, after which the family serenaded the honoree and his special guests, and then proceeded to partake of a large meal cooked outside over an open fire. Later, as more family members arrived, Pich was asked to reenact the presentation so they could videotape the event. In the midst of the celebratory activity, Pich was able to photograph Negrón Rivera in his workshop near his house with his wife and daughter looking on. The space is filled with works in progress, such as the cuatro he is holding, and behind him a family of instruments commonly used in jibaro music can be seen—tiple (smallest instrument), tres (nine-stringed instrument), cuatro, and bordonúa (bass).

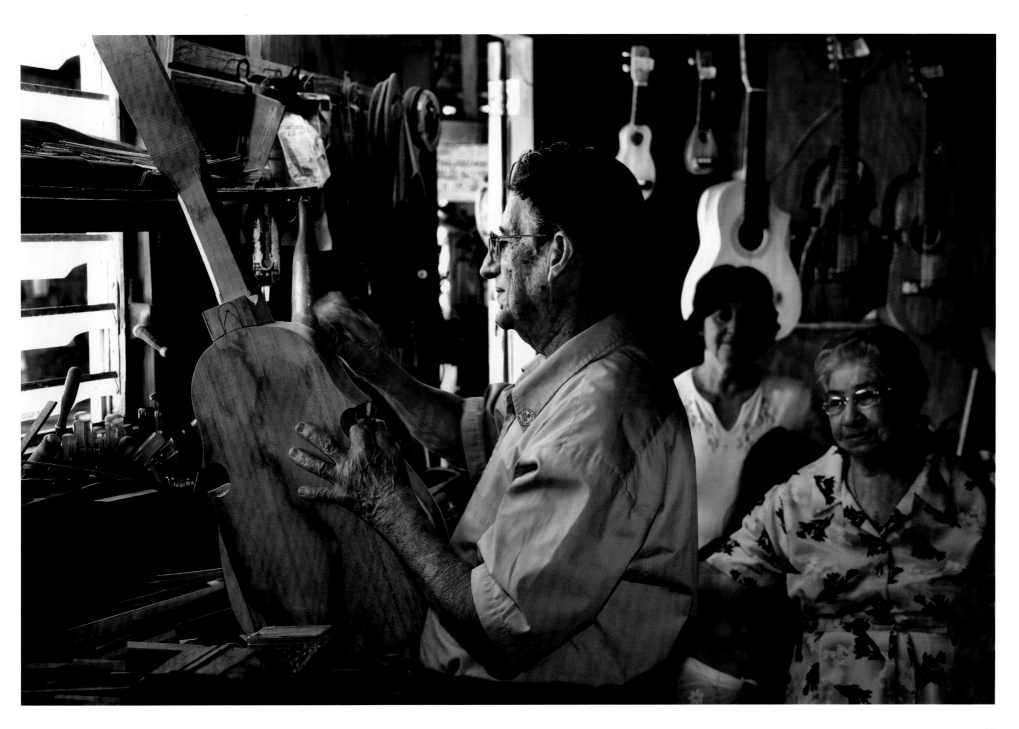

PERIKLIS HALKIAS

Astoria, Queens, New York | 1985

My job is to make them [dancers] look good. If you have a musician who's not looking on, it's chaos on the floor, and no one is getting the full richness of the experience that otherwise you can get.

Periklis Halkias was born in the mountainous Epirot region of northern Greece, not far from Albania. His skills playing the clarinet led him on a journey to Athens to play in the folk music clubs, where he continued to perform until 1964, when he came to the United States. In New York he became a featured entertainer in the Greek nightclubs along Eighth Avenue. While, at the time, Greek music was more widely heard and appreciated in film scores and through modern Panhellenic arrangements on electrified bouzouki in bars, Halkias performed for community celebrations incorporating the older "Oriental" style, characterized by improvised ancient tunes rendered with highly decorated melodic phrasing.

For Tom Pich, the short commute to Astoria Queens took him back to his childhood. Periklis Halkias lived in a typical three-story building hugging the street, housing six apartments, all occupied by either family members or, by necessity, close friends. The smell of cooking wafted through the halls. Given the close quarters, it was difficult to get a good shot, so Tom suggested that they try the front stoop. Finally, the afternoon sun hitting the hallway provided the dramatic lighting of Halkias's face and the distinct patterns, including the cross formed by the panes of glass in the front door, that characterize this portrait. Pich commented: "The strong hands, a working man's hands, and our proximity to the street, echo experiences I had with the older Italian men that I knew as a child in the Bronx."

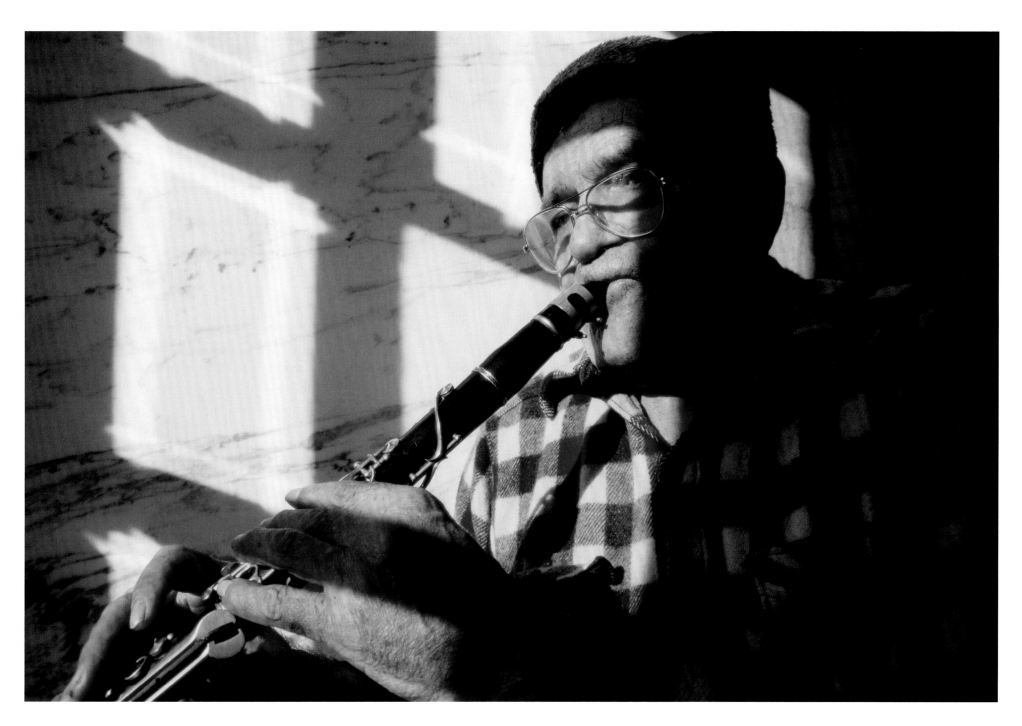

ALPHONSE "BOIS SEC" ARDOIN

Eunice, Louisiana | 1986

You know, you have to have music in you to play. To be a musician, you have to be committed to music and have it in your family.

Alphonse "Bois Sec" Ardoin lived in a settlement near Bayou Duralde, first occupied by his great-great-grandfather. He got his nickname, translated as "dry wood," as a child because it was said that he was always the first to run into the barn for shelter when a rainstorm hit the fields. In the 1930s, Bois Sec Ardoin's cousin Amédé Ardoin was the first musician from the region to make 78 rpm recordings in a Creole style that later evolved into a more blues-inflected sound called zydeco, a blend of Cajun, African American, and French musical traditions. In 1966 Amédé Ardoin and his musical partner Canray Fontenot took their music to the Newport Folk Festival, thus becoming significant figures in introducing Louisiana Creole music to a broader public. Amédé Ardoin said that he was so intimidated by the large crowds that he followed his "guide" closely around the festival grounds, practically wearing the leather off the back of the gentleman's shoes.

The circumstances of Bois Sec Ardoin's portrait gives added significance to his nickname. Tom Pich began photographing on Ardoin's screened porch, but a storm blew up and both the photographer and subject were getting wet, so they moved indoors. With the loss of good light inside, Pich decided to pack up and try again the following day. However, in the process of loading the car, Pich noticed that there was a spot on the carport that was both sheltered and well lit. With chickens still scrambling for cover, he photographed Bois Sec just as a rooster entered the scene. Those familiar with Mardi Gras practices in rural Louisiana will appreciate that capturing a rooster in the barnyard is integral to the festivities, although unfortunately for the object of the revelers' attention, the bird also frequently makes a critical contribution to the gumbo eaten afterward.

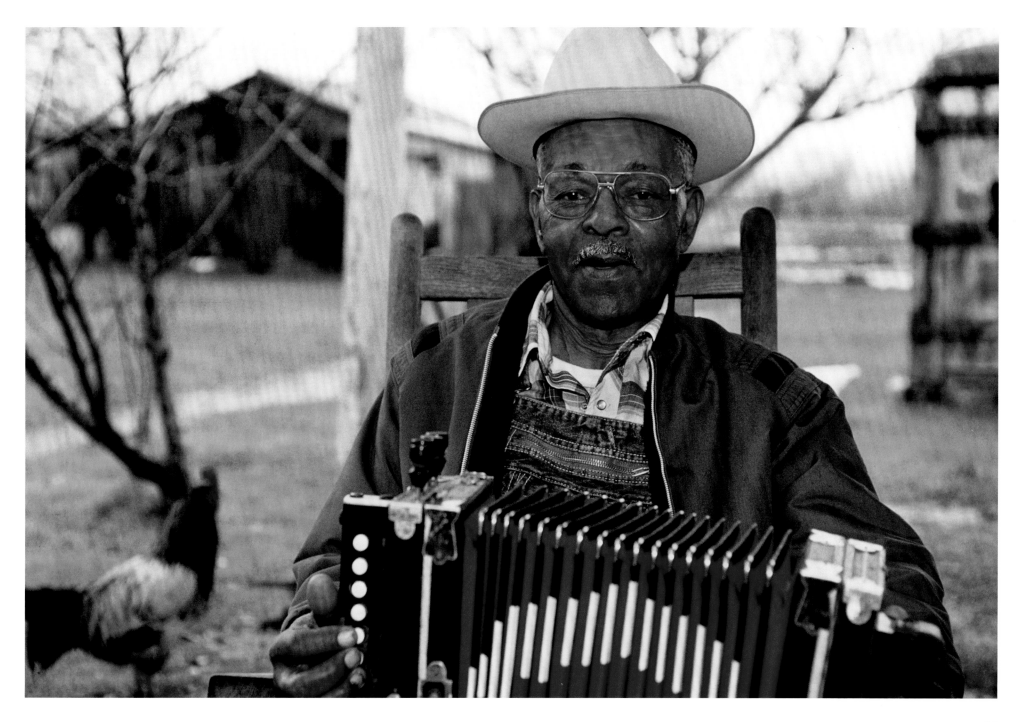

HELEN CORDERO

Cochiti, New Mexico | 1986

To make good potteries, you have to do it the right way, the old way, and you have to have a special feeling inside. All my potteries come out of my heart, I talk to them. They're my little people, not just pretty things that I make for money.

Although the practice of making pottery extends over several millennia in the southwestern United States, Helen Cordero is known as one who brought new life to these ancient traditions. Using traditional hand-shaping and open-firing techniques, in 1964 she decided to start making figures based on her grandfather telling stories to children, and that choice led to both a new aesthetic and a unique subject matter for Pueblo potters. Using a variety of configurations, her pots both feature a storyteller figure and tell their own story. Today her work is found in museums around the world. Cordero gave new life to pueblo pottery, a role that was confirmed in 1981 when an exhibition of storyteller figures featured more than two hundred such figurines by sixty-three potters.

Tom Pich's visit to Cochiti Pueblo to photograph Cordero occurred on a day when she was firing pieces. This open-firing technique, using cedar gathered from the surrounding desert, requires careful attention to both the fragile clay and the temperamental fire, not an endeavor well served by interruptions. After a casual visit, Pich returned the next morning and photographed her in the early sunlight as she carried the unpainted figures from the open pit, where they were fired, into the living space, where she paints them at her kitchen table. Later in the day, a gallery owner arrived and bought some of her work to sell in his Santa Fe shop. Upon his return to Santa Fe, Pich encountered those same pieces selling at more than ten times the amount that Cordero received.

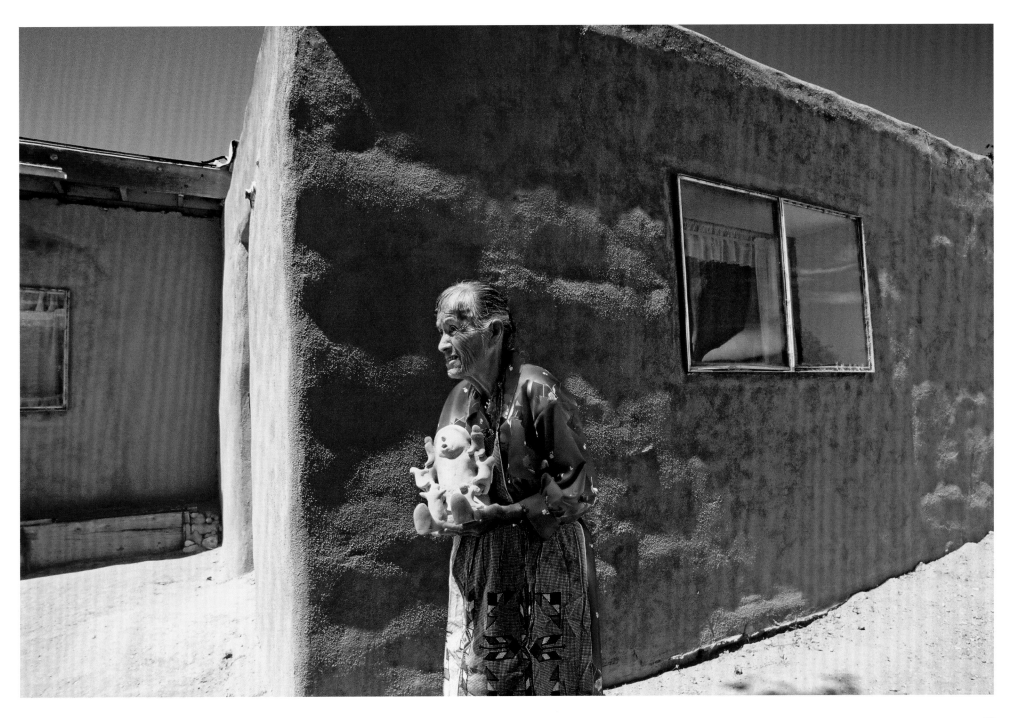

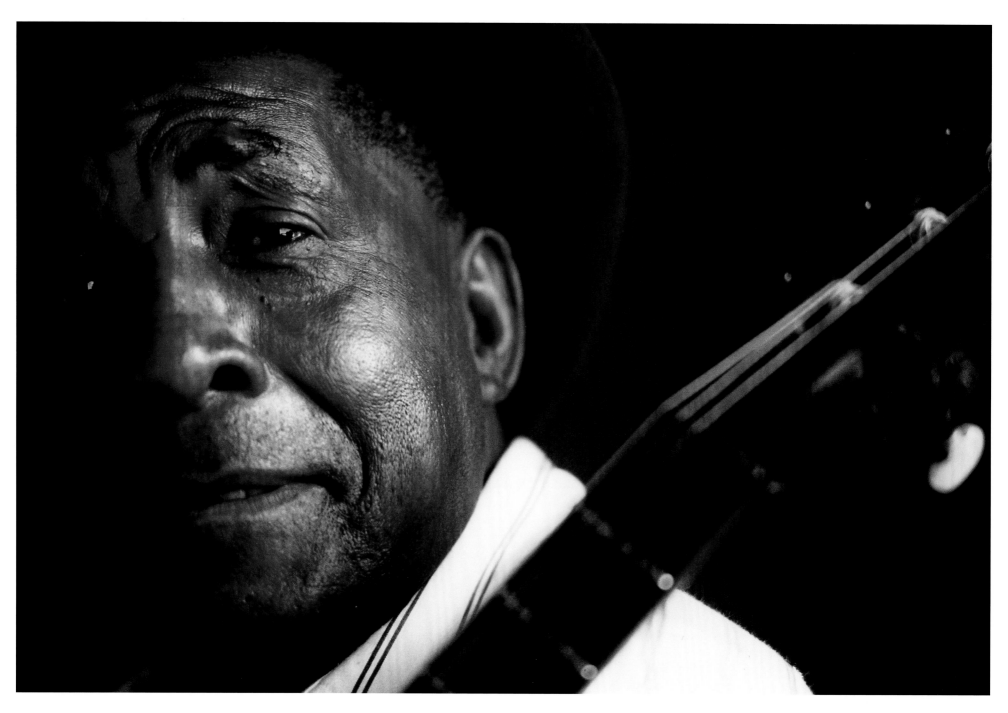

JOHN JACKSON

Fairfax Station, Virginia | 1986

Sometimes I'd walk like 30 miles on the weekend with a guitar, maybe play for a party or a dance and get back in time to go to work on Monday morning. We didn't have no automobiles. It wasn't hardly any money then, and which if we had money I don't know what you'd've done with it. Wasn't no place to spend it.

John Jackson spent a lifetime digging graves and taking care of local properties, but in his spare time he often traveled to Virginia's battlefields with a metal detector, unearthing Civil War artifacts. His rich musical talents were not "unearthed" for a broader public until folklorist Charles Purdue overheard him picking his guitar at a service station in 1962. Jackson was brought up in a musical family and started out playing on his father's $4.98 flat top guitar at the age of four. Purveyor of an eclectic repertoire of blues, gospel, ragtime, and country material in a laid-back but rhythmically complex style often referred to as Piedmont blues, he in later years made numerous recordings and performed internationally as a member of groups representing our nation's cultural heritage for the United States Information Agency.

Tom Pich explains that he visited with John and Cora Jackson for several hours before pulling out his camera, most of that time spent listening to Jackson's stories and looking over the Civil War memorabilia that Jackson had collected near his home. As Pich began to photograph Jackson inside his living room, nothing was working visually—the space was crowded with relics and the light was dim. Pich decided to pack up and return the following day. Saying goodbye to Jackson at the front door, he noticed that the late-afternoon lighting applied a special glow to Jackson's already warm and friendly face. He retrieved his camera from the car and photographed Jackson with a tight close-up, necessitated by the narrow porch. Six frames later, Pich felt he had the image he wanted.

SONIA DOMSCH

Atwood, Kansas | 1986

My Great-Aunt Anna had to have had patience because I don't ever remember her scolding me for making a mistake. The one thing I do remember her saying is "Keep your threads pulled tight or you'll have sloppy looking lace."

Sonia Domsch was born near Atwood, Kansas, in the house that her great-grandmother built after coming to America from the Bohemian region of what is now Czechoslovakia. When Sonia was young she watched her great-aunt make lace using the bobbins brought from the "old country." Although she began making lace herself at the age of four, she did not pursue the craft seriously until her aunt was in her late seventies and Sonia realized no one else in the family was taking an interest. An uncle who traveled to Belgium brought back some lace samples that inspired Sonia to further pursue more complex lace patterns. This led to her own travel to Belgium to research bobbin lace making and the speculation that her great-grandmother most likely learned the skill from Belgian nuns who had come to Bohemia. Domsch has taught her daughter, as well as several apprentices in Kansas, how to make lace. Occasionally, for inspiration, she pulls out the well-worn bobbins that her great-grandmother, a widow with three children, used to support her family on the Kansas plains over 122 years ago.

Tom Pich drove to Atwood, Kansas, a small town of just a little over a thousand in northwestern Kansas, over roads as straight and flat as a lace runner carefully placed on the surface of a Midwestern dining room table. Sonia Domsch was photographed in the living room of her house, surrounded by works in progress, as well as finished pieces. Her late husband, Don, who was a woodworker, made these bobbins and the pillow stands on which they rest. To make lace, the bobbins attached to the linen thread are flipped back and forth two at a time in rapid sequence to produce intricate doilies, collars, bookmarks, and pillowcases. Domsch says that it was the rhythmic clicking sound of the bobbins that first attracted her to the craft.

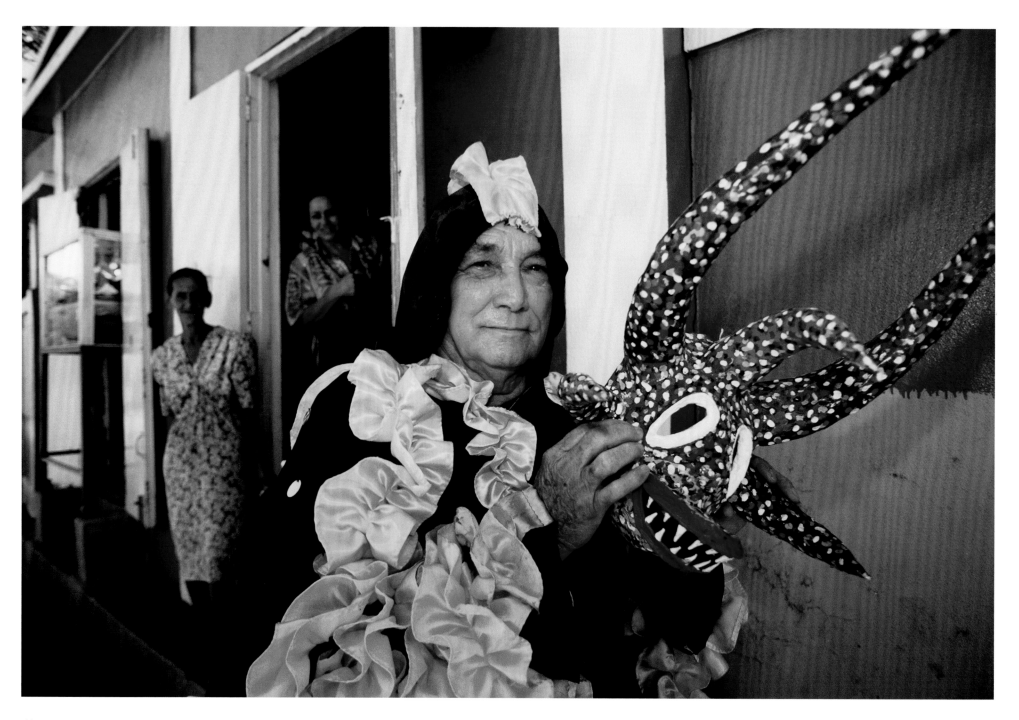

JUAN ALINDATO

Ponce, Puerto Rico | 1987

When I first started, I made masks with only two horns and sold them for twenty-five cents.

Juan Alindato, a dockworker by trade, also was well-known for making elaborate masks meant to terrify and delight carnival celebrants in Ponce, Puerto Rico, and other cities on the southern side of the island. In a practice dating to the mid-eighteenth century, during carnival season figures wearing caretas (masks) would roam the streets carrying inflated cow bladders on small sticks and chasing people they encountered. These individuals, called vejigantes, took their name from the words vejiga (bladder) and gigante (giant). Originally their intimidating costumes and behavior were intended to represent the devil, and to scare people into going back to church. Masks with multiple horns, jutting snouts, and sharp teeth were made with papier-mâché and then painted and decorated with brightly colored stippling. Alindato has taught his wife, five children, and a number of grandchildren how to craft these imaginative and sometimes startling wearable sculptures. His works are still used in the streets during carnival, but also can be found in many galleries and museums.

When Pich visited him in Ponce, Alindato insisted that it would be best if he showed off both the mask and the costume used in carnival. He took to the streets, where he attracted quite an audience, including the two women in the background who have just emerged from a café to witness the one-man parade. The ruffles and cape-like sleeves on his costume reference bat wings, another fear-inducing element of the outfit.

GENOVEVA CASTELLANOZ

Nyssa, Oregon | 1987

If I am not feeling pretty, I can't work. . . . Things will not turn out how I want to see them. And my roses are angry because that's how I am.

While an artist's impact can be measured in many ways, its breadth can sometimes be measured in miles. Genoveva Castellanoz has for decades served the widely dispersed Mexican American agricultural communities that stretch from eastern Oregon through southern Idaho and beyond. She makes coronas (crowns) and flowers that are essential to quinceañera (coming of age) and wedding ceremonies. Made with wire, paper, melted wax, and dye, the arrangements serve both as beautiful elements of rites of passage and as personalized artefacts, meant to be saved and displayed as reminders of the significance of these events. Castellanoz uses the preparation for ceremonies as an opportunity to counsel young people and brides-to-be. In addition, she is a curandera (healer) and herbalist who tends to both the physical and spiritual health of her community, relying on what she calls "God's pharmacy." But she is quick to point out that she also takes people to see the doctor when she feels it is necessary.

When Tom Pich arrived at Castellanoz's home, she was busy counseling a couple who had driven from the Midwest to seek her advice about a problem with their marriage. Once the couple departed, Pich photographed Castellanoz sitting in her living room surrounded by evidence of her work. On her lap is a paper and wax floral arrangement that might be used in a wedding, while on the lower shelf to the right is a quinceañera corona. Generally, the coronas for coming of age ceremonies depict all-white flowers in the budding stage, indicating youth and purity.

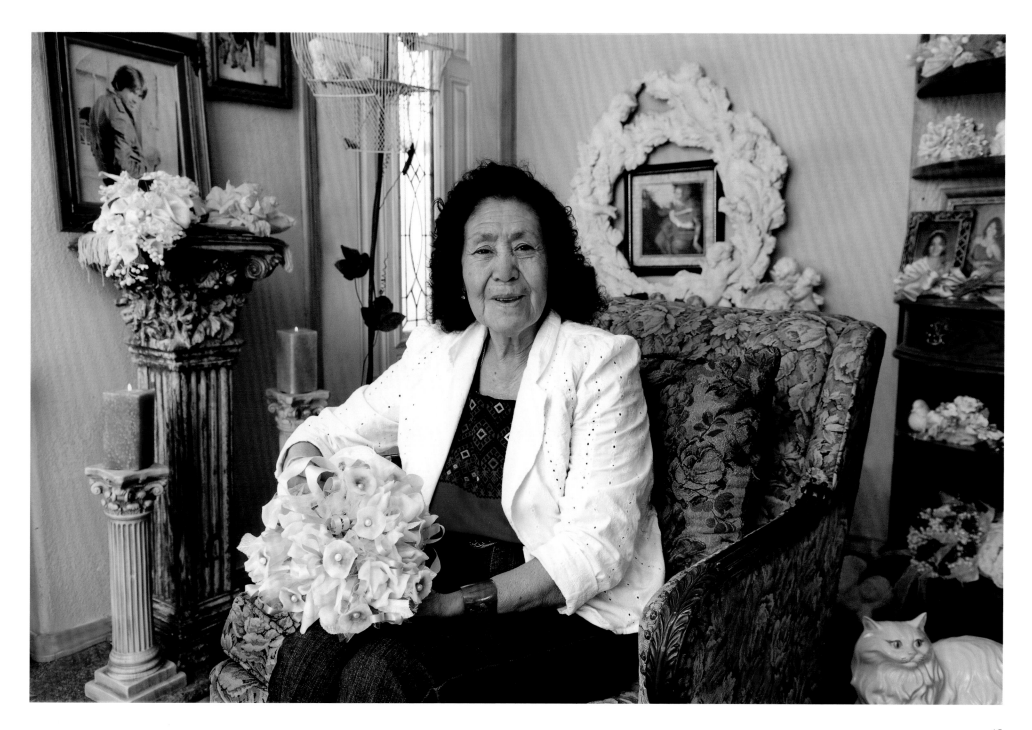

KANSUMA FUJIMA

Los Angeles, California | 1987

*I love teaching my art. The dances are
my life and my life is my art.*

Kansuma Fujima, born Sumako Hamaguchi, started her training in kabuki dance at the age of nine, rather a late start to master this tradition. Typically, a child begins to learn this complex form on the sixth day of the sixth month of one's sixth year. Upon graduation from high school in Los Angeles, she went to Japan, where she studied acting, dancing, and proper dress, as well as the tea ceremony, flower arranging, and performance on the required instruments. By 1938 she was given her stage name, Kansuma, and made her professional debut. After returning to the United States, Kansuma opened a dance studio, but with the outbreak of World War II, she and her parents were taken to a relocation camp in Arkansas. With only a fan, a kimono, and recorded music, she entertained the detainees. After the war, she returned to Los Angeles and began performing and teaching. A revival of pride in Japanese heritage initiated an annual Nisei Week Parade through Little Tokyo. Kansuma tells of performing at a post-parade party honoring the grand marshal that year—Charlie Chaplin. A variety of artists were entertaining Chaplin with mainly comic pieces, given the honoree. She performed one of her serious dances and afterward worried that it was not appropriate. Her spirits were buoyed when he came over and said, "Don't give up." That is what she has done, continuing to perform and training an estimated 1,000 dancers over her career. Now, at the age of ninety-eight, she continues to teach from a sitting position with the aid of her daughter, Miyako, and she participates in the Nisei Parade when her schedule allows.

This portrait was taken in front of the house that Kansuma Fujima's father built after the war, featuring plantings and landscaping that one might see in Japan. When Pich took the photo, Fujima was ninety and maintained a very busy teaching schedule. As soon as he was finished, a friend of about the same age and wearing similar dress pulled up to the house, and the two headed off to meet with students.

NEWTON WASHBURN

Bethlehem, NH | 1987

Mother started me out with a flat bottom. Then we went to round baskets. Each one you had to do "till it was right." The first one you did was right because if it wasn't you took it apart and started over again.

The Sweetser family was known for producing baskets in New England as long ago as the 1850s. Newton Washburn's mother, a Sweetser, said that her family came originally from Switzerland to settle in Vermont, and an early relative married a woman from the Abenaki tribe. As a result, the family's basketry skills and techniques combine European and Native American traditions using locally available black ash wood. Although at one time there were said to be seventeen different branches of the family making baskets, the early twentieth century witnessed a decline of the market for and interest in handmade baskets. Washburn took up basketry in a serious way following a career doing auto bodywork. He made a laundry basket for his wife to replace the plastic one that had broken. She hadn't even known that he could make baskets, but, encouraged by the interest others took in his baskets, he began producing more. In the following decades he continued to teach others his inherited knowledge and skills.

When Newton Washburn came to Washington, DC, to receive his Heritage Fellowship, he commented, "It gives you a lovely feeling to take a log, with no machinery, and turn out a basket. You have to love it to do it." His shop, in a shed next to his house, reflects that love, as it is filled with the raw materials he has prepared in order to begin the weaving process. Washburn's granddaughter stands in the doorway holding one of his baskets, while, viewed through the window, he is working on a small carrying basket. Above his head is one of the larger baskets that might be used for the gathering or transport of produce, similar to those the Sweetser family would have made.

WADE MAINER

Flint, Michigan | 1987

Nobody ever showed me anything on the banjo. I just stuck to what I got and I hung on to it.

Wade Mainer is recognized as a transitional figure in the evolution of Appalachian string band music to what became known as bluegrass. He and his brother J. E. grew up in western North Carolina, moving as young men to the Piedmont region to work in a cotton mill. The siblings formed a string band and were hired by a patent medicine company, Crazy Water Crystals, to do a radio broadcast from Charlotte. With Wade on banjo and J. E. on fiddle, the band known as J. E. Mainer and the Mountaineers toured the region and made popular recordings. In 1936 Wade formed his own band and continued to perform with his distinctive two-finger style of picking the banjo. In the 1950s Wade left the music business and joined many other out-migrants in a move to Flint, Michigan, where he worked for General Motors. With a renewal of interest in bluegrass and early country music, Mainer began performing again with his wife, Julia, and they were able to generate a whole new audience for their music.

Tom Pich and I arrived at the Mainers' residence on the occasion of his one hundredth birthday celebration. The house was crammed with relatives and well-wishers, so we repaired to the yard to photograph Wade, where he was joined by Julia, his singing and life partner for seventy years. Following the photo session, we traveled to the Fenton Community Center, where the Mainers performed for a standing-room audience. Pich situated himself on the side of the stage to continue the documentation of the event, but Wade insisted that he come out on stage. After another number, some members of the audience began yelling, "Sit Down," and Pich sheepishly crept off stage, not knowing that they were using shorthand to call for one of the Mainer's most popular duets—"I Can't Sit Down."

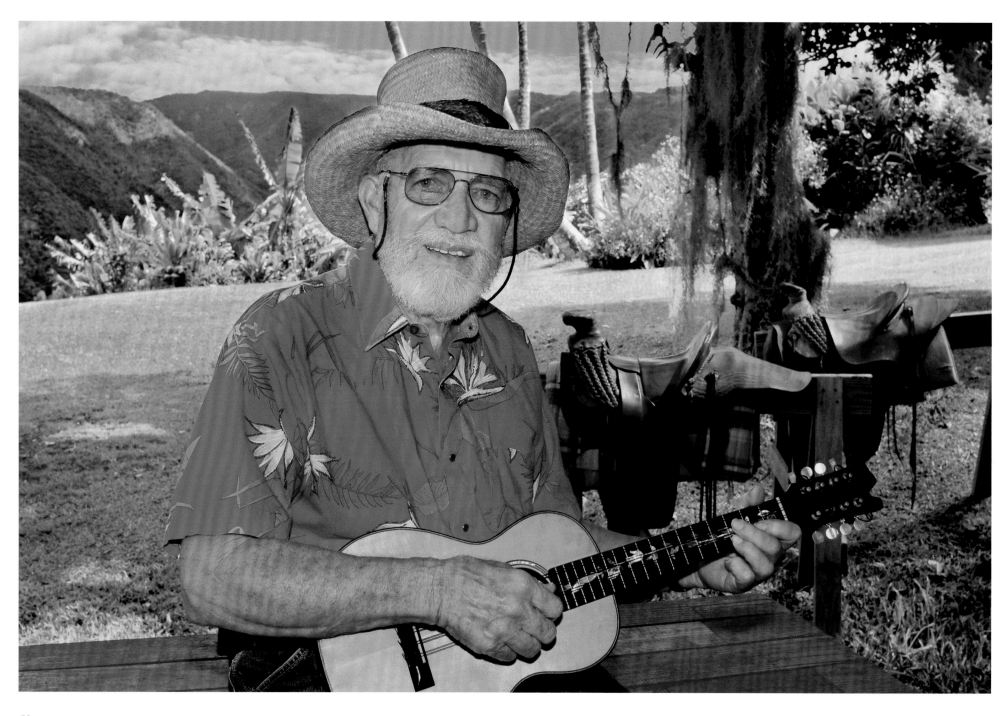

CLYDE "KINDY" SPROAT

Kohala Coast, Hawaii | 1988

I hope and pray that someday I will find someone interested enough to learn these songs and stories . . . someone in whom I could impart this feeling that I have inside my heart and every fiber of my body of the love for Hawai'i, its songs and tales.

When one thinks of Hawaiian music, cowboy songs wouldn't be the first thing that comes to mind. Actually, some of the largest individually owned ranches in the United States can be found on the Big Island of Hawaii, and consequently cowboy music, stories, craft, and ranching skills reflect a long tradition there. First imported to Hawaii from California in the late nineteenth century, cattle roamed free in feral herds until around 1830, when Mexican vaqueros came to the island to domesticate the environmentally destructive livestock. Clyde Sproat was a cultural beneficiary of this blend of deep Hawaiian tradition with cowboy skills and knowledge. He grew up in a remote valley, a two-hour mule ride from the main road. His Hawaiian mother played the banjo and sang, so he grew up in a musically rich setting that also included hearing the ukulele and the slack key guitar, played by neighbors as well as the paniolos (Hawaiian word for cowboys, derived from Español) who worked on nearby ranches. Eventually Sproat mastered the ukulele and built on a family repertoire of over 400 songs. In later life Sproat carried his beautiful falsetto singing and unique repertoire to Carnegie Hall and the Cowboy Poetry Gathering in Elko, Nevada.

While trying to get to Clyde Sproat's home, Tom Pich stopped in town to ask directions and was told to go down a certain road until you can't go anymore. This remote area serves as the backdrop for Sproat's photograph. In the background are mountain ranges where he and his father would ride horses to pack in supplies for a leper colony, as they were known then. To the photographer's left is a cliff bordering the ocean, with a beach so isolated that during the Second World War US soldiers bivouacked there in hiding. Sproat said that in his youth he would often pick papayas off the trees on their property and take them down to the soldiers, where he would trade the fruit for cans of Spam.

CHESLEY GOSEYUN WILSON

Tucson, Arizona | 1989

I believe that the way to remain a strong, healthy, and happy person is to remember your roots, your heritage, and your traditions. It is vital to never lose sight of Apache values, beliefs, culture, language, religion, and worldview. In other words, remain Apache!

Chesley Goseyun Wilson was born into a family of violin makers on the San Carlos Reservation in the White Mountain area of Arizona. The Apache name for the one-stringed violin, an instrument made of the dried flower stalk of the agave plant, is Tsii'edo'a'tl, or "wood singing." Used to perform ceremonial music, love songs, and dance tunes, the instrument is decorated with geometric designs depicting traditional symbols that represent the four directions, the landscape, and a variety of spirits. Known as a medicine man, Wilson has instructed many younger students in Apache artistic practices and spiritual values. His commitment to Apache culture is reflected in his frequent comment: "My fiddle only plays Apache songs."

As the desert is the source of the material from which the Apache violin is fashioned, Wilson suggested that the portrait be taken in that environment, so he and Tom Pich traveled to nearby Saguaro National Park. Following Wilson down the trail into the park, Pich realized that his corduroy pants and sneakers were not the appropriate dress for this environment. Soon he began to accumulate cactus needles. He relates that given the heat and the discomfort, the photograph was made as quickly as possible, with only a slight breeze—evident in the portrait—to take his mind off the thought of the impending retreat over the same path. Upon their return to the car, because Wilson is also known among tribal members as a healer, Pich asked how to deal with the cactus needles poking into his skin. With little hesitation, he was given this sage advice: "Take off your pants."

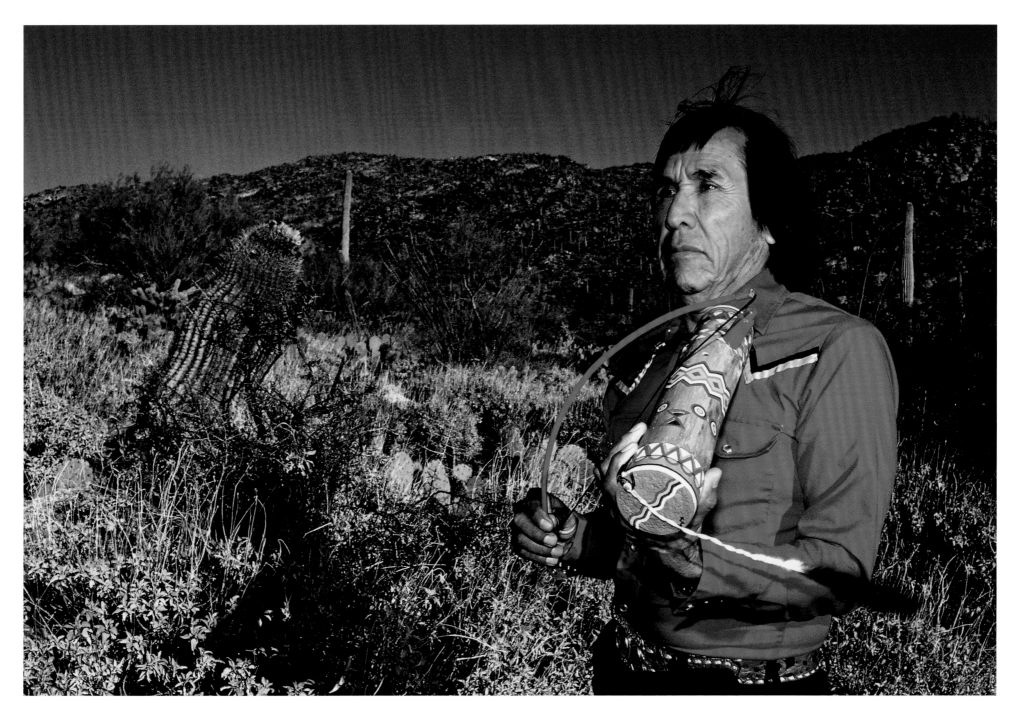

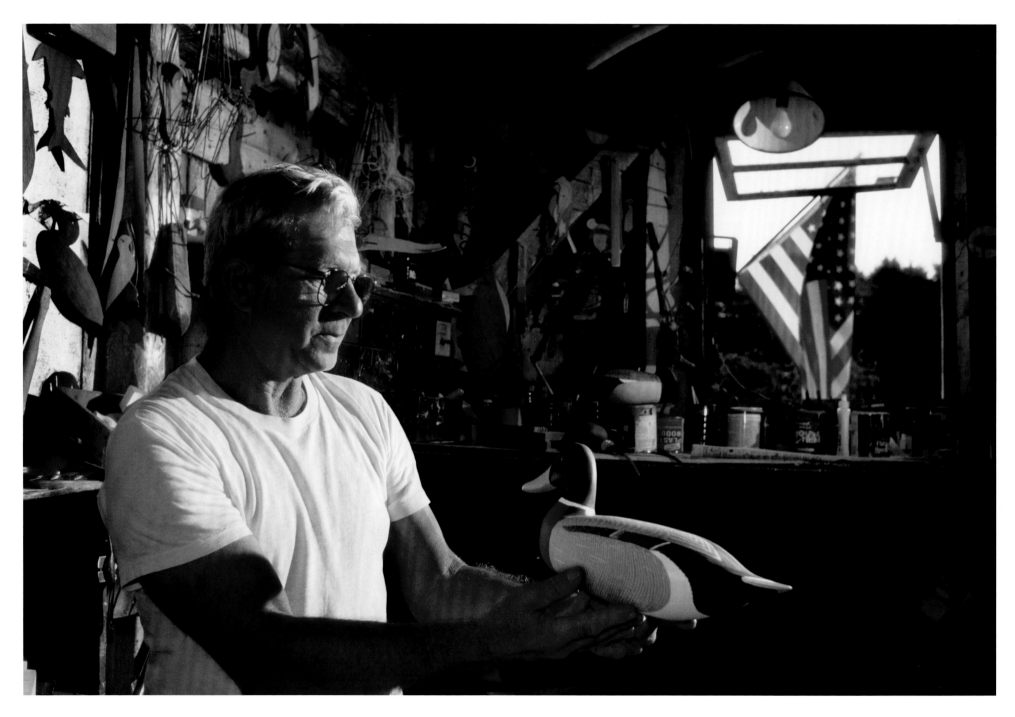

HARRY V. SHOURDS

Seaville, New Jersey | 1989

Today, the carvers are getting real ducks. They're getting mounted or frozen ducks and they copy them feather for feather. It's really model making instead of carving. It's nice sculpture when it's finished. But I like to put a little dream into it.

Harry Shourds is a third-generation woodcarver whose grandfather was described as the greatest professional carver of working decoys in Barnegut Bay, a hotbed of carving and wildfowl hunting. Shourds has mused that his grandfather could sit down in a barber's chair for a shave and whittle a duck's head beneath the cape, emerging from the chair with a pocketknife in one hand and a completed head in the other. He points out that even though his forbears, and his son and grandson today, carve decoys, each has a unique and distinctive style. Still, the important thing about a decoy, in his opinion, is that it is a product of the creative memory and imagination of the carver. A good decoy needs to ride naturally on the water and look realistic enough to attract the attention of wildfowl from the air. Today, many of Shourds's decoys have retired from work, and a good number of them enjoy a well-earned rest sitting peacefully in the display cases of museums throughout the region.

This photograph was the second portrait that Tom Pich took of a Heritage Fellow and marked the start of the road trip that took him and Michael Nash through New Jersey, Virginia, the South Carolina coast, and rural Appalachian North Carolina. Shooting with film, he had no opportunity to check his work. In this case, Pich feared for the visual impact of a window in the rear of Shourds's workshop. As he described it: "The window drew your eye through the photo and out the back." Nash was kind enough to hold the American flag, flying outside the building, to provide shade and fill the open space of the window, perhaps inadvertently recording a visual statement about an artist who has been recognized by his government as a national treasure.

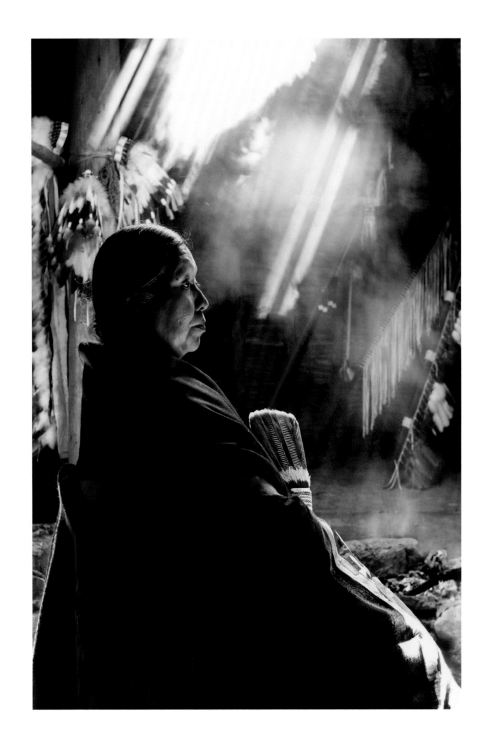

VANESSA PAUKEIGOPE [MORGAN] JENNINGS

Fort Cobb, Oklahoma | 1989

I am a Kiowa woman. My work is traditional Kiowa work. . . . It frightens me that our Kiowa heritage that was so powerful and beautiful has almost disappeared. It is more important that I continue my traditional work than to take artistic liberties at this time.

Spending most of her childhood with her grandparents, Vanessa Jennings began learning Kiowa traditional ways and artistic skills at an early age. She became a master beadworker and skin sewer, paying particular attention to the clan and tribal traditions of her family. Out of respect, elders were always buried in their best regalia, and this placed a particular responsibility on the maker of the tribal clothing and ceremonial objects. It also conveyed an expectation for the maker to teach design and fabrication to future generations. It is a responsibility that she has fulfilled throughout her career—instructing young people in the necessary techniques to make regalia and demonstrating her artistry for broader audiences at museums and cultural centers.

Capturing the deep spiritual side of Vanessa Jennings and her continuing respect for Kiowa tradition, the image was taken in a dugout earthen lodge that she and her husband maintain for ceremonial purposes, as well as for refuge during hot summer nights. The timber-sided underground structure has an opening in its roof over the fire pit where sage is burned, and that provides the dramatic light in midday. Vanessa is holding a blanket and fan given to her by her godmother at the age of thirteen, during a coming-of-age ceremony. Headdresses of her great-grandfather and other ceremonial regalia can be seen in the background through the smoke.

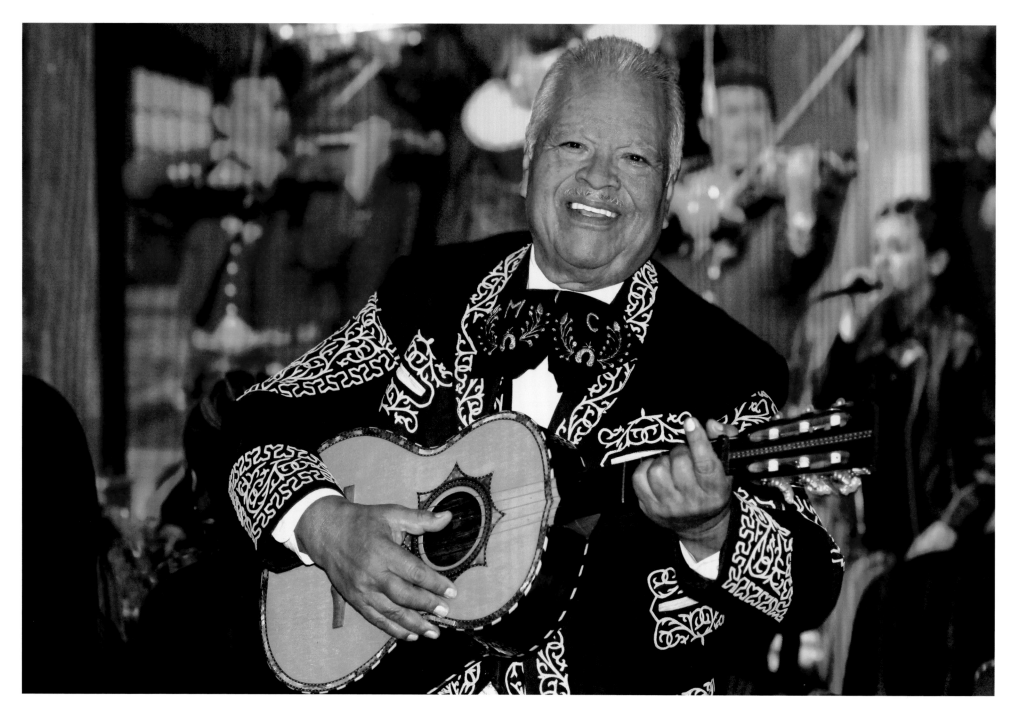

NATIVIDAD "NATI" CANO

Fillmore, California | 1990

You should not change things that are classic. . . . The taco, apart from the mariachi and tequila, is the worldwide image of Mexico, right? On the taco, put salsa de tomate, salsa verde, salsa de chipotle, put whatever salsa you like. But just don't put ketchup.

Nati Cano spent his youth near Guadalajara in the state of Jalisco, considered to be the cradle of mariachi music. Following study at the Academia de Música in Guadalajara and an apprenticeship playing with his father and grandfather in local cantinas, he traveled to Mexicali and joined Mariachi Chapala, where he soon became the group's musical arranger. In 1960 he emigrated, arriving in Los Angeles, and eventually became director of Los Camperos (The Countrymen). Motivated by the fact that he had once been refused service in a restaurant because he was Mexican, he opened a restaurant, La Fonda de Los Camperos, in Los Angeles that became a musical venue for the band and served as a cultural center for Mexican music. Cano and Los Camperos backed Linda Ronstadt on her groundbreaking album *Canciones de mi Padre*, which exposed mariachi music to new audiences. In

later years, he developed folk arts in education programs and was instrumental in convening mariachi conventions, a strategy of presentation and preservation that was later adopted by the mariachi musicians who continue to perform in Guadalajara today.

La Fonda proved to be the ideal setting for this photo, given the history of Nati Cano's original impetus for opening the restaurant. A social center, as well as a rehearsal and performance space for his band members and musicians who may drop by to sit in, La Fonda serves the community in multiple ways. As both the maestro and maître d', Cano would often roam from table to table, greeting guests as he directed the band. In the background of the image, an aspiring teenaged musician brought in by her parents joins the group for a song.

WALLACE "WALLY" McRAE

Forsyth, Montana | 1990

People didn't realize it, but cowboys were one of the few surviving occupational groups that still dealt in poetry. Sailors and loggers and farmers and military personnel all have left a history of writing poetry, but for some reason they quit. We didn't.

Wally McRae ranches near Montana's Rosebud Creek on land that has been in his family since 1885. Although his first public recitation was a Christmas "piece" delivered at a local one-room schoolhouse when he was four, in adulthood he has become widely known as a writer and reciter of cowboy poetry. This form of verse and verbal performance dates to a time when working cowboys entertained in bunkhouses and around campfires. McRae has published four books of poetry, and his poem "Reincarnation" has become a classic and a part of ongoing oral tradition, recited at cowboy poetry gatherings around the West.

Tom Pich traveled to the annual Cowboy Poetry Gathering in Elko, Nevada, to photograph McRae and several other Heritage Fellows who were attending. McRae enjoyed a reputation as an independent personality; he had published a book of poems titled *Cowboy Curmudgeon* and he was quite clear that he didn't want to pose on a horse or be asked to look at the camera. On an earlier occasion, a videographer had come to his ranch and disrupted his work routine. While McRae was out feeding his cattle, the offending documentarian asked him to reenact throwing a bale of hay off the back of his truck. McRae's response: "Come back tomorrow at exactly the same time and I'll be doing it again." In this case, the photograph does the subject justice—it portrays a multidimensional person sitting with a book of poetry in his lap—a rancher, a thinker, and a poet.

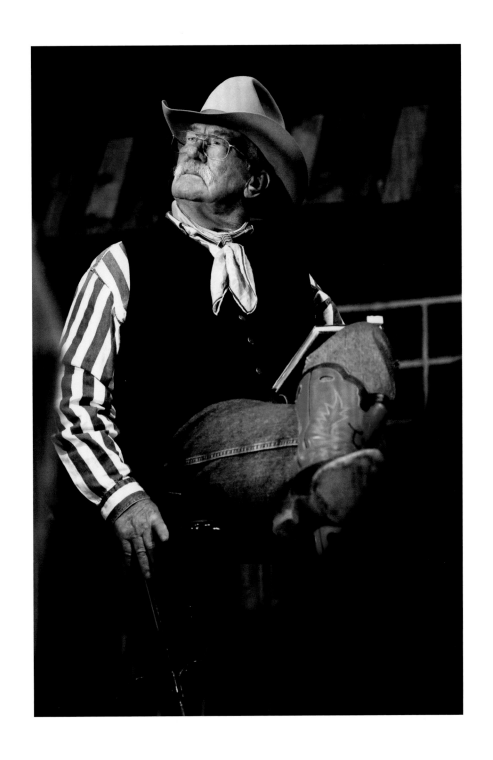

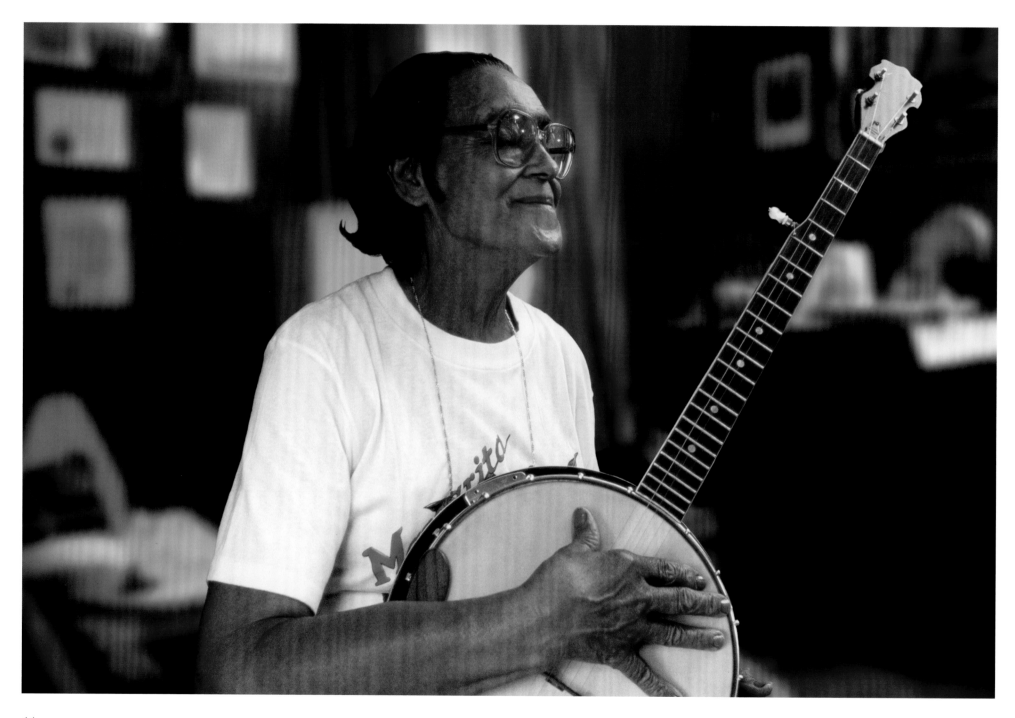

ETTA BAKER

Morganton, NC | 1991

I want my music to be clear and not hit a string that's not necessary because that blurs the tune. You want to keep it clear.

Etta Baker grew up in a household filled with music. Her grandfather played banjo; her father was accomplished on banjo, fiddle, and guitar; and her mother often joined in on harmonica and Jew's harp. The music they played included dance tunes, rags, love songs, and blues typical of the rural Piedmont region and reflective of the cultural mix of its African American, Anglo, and Native American settlers. She and her husband, a piano player, moved to Morganton, where Etta worked in a textile mill, but she continued to play her music for family and friends. In 1965 she encountered folklorist and musician Paul Clayton while he was on a recording trip in the region, and her performances on guitar documented on the album *Instrumental Music of the Southern Appalachians* had a profound impact on younger musicians during the folk revival. In her later years she appeared at events such as the Knoxville World's Fair and the National Folk Festival.

Tom Pich initially attempted to photograph Baker in her backyard as she played her guitar. Later they went into her house and she picked up her banjo. With her hands on the banjo, an instrument that her grandfather played, she began to reminisce about family and early life experiences. With her eyes closed and a wistful look on her face, this portrait captures that moment. Historically, the banjo has deep connections to African American musical tradition. The earliest visual portrayal of an antecedent of the banjo appears in a late-eighteenth-century watercolor entitled *The Old Plantation* depicting a Congolese-based practice of broom jumping in a marriage ritual.

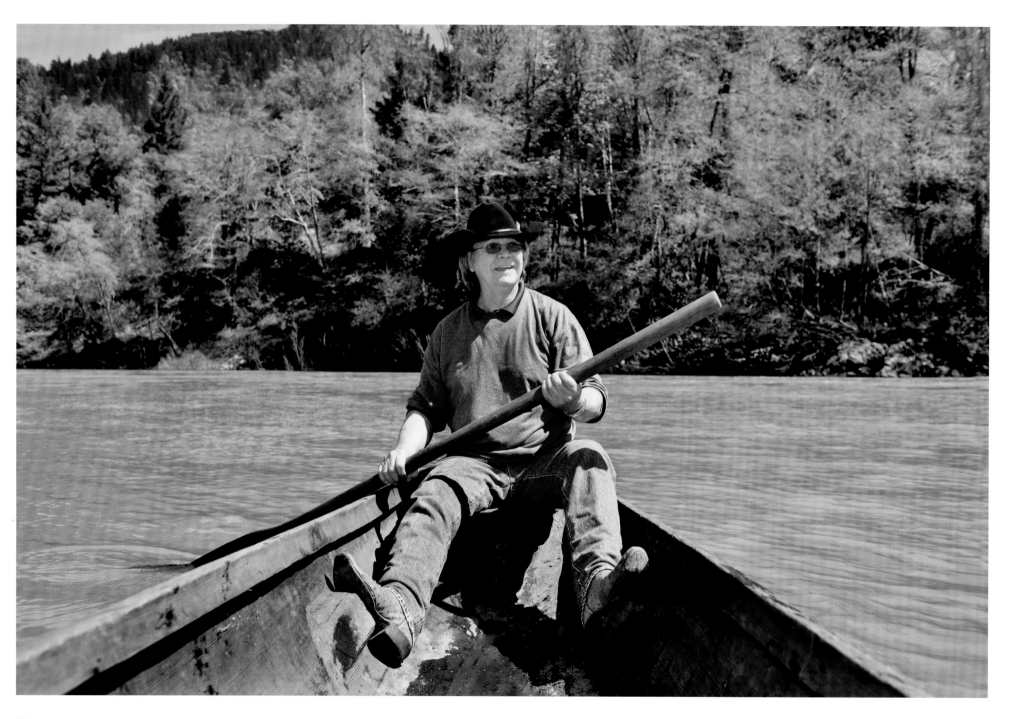

GEORGE BLAKE

Hoopa Valley, California | 1991

I wanted to do what the old people did.

George Blake has made it his life pursuit to learn about the Hupa and Yurok traditions of his ancestors. As has been the case with the knowledge and skills of many Native American tribal groups, his recovery of historically accurate practices involves research combined with conversation with elders. He has mastered the art of making regalia such as elk-antler purses, deerskin headdresses, sinew-strung bows, and otter-skin quivers used in ceremonial dances. After studying with the last two elders who knew how to make Yurok dugout canoes, Blake was able to recreate the vessels that the tribe used to ply the Klamath and Trinity Rivers. One of his canoes is on permanent display at the Humboldt State University library, where he received an honorary doctorate in 2016.

Tom Pich spent several days documenting Blake's myriad artistic creations. During this time, one of Blake's sons called, saying that he was taking one of the canoes out to the Trinity River. Pich and Blake quickly packed up and drove to the shoreline. Before Pich could get his camera equipment out of the trunk, Blake was already out on the water, paddling upriver and floating back down. On one of his passes, he picked up Pich and this portrait was taken. The canoe is considered to have a spirit and is in effect a being. In this image, the photographer is sitting at the head; there are lungs carved on the bottom, and Blake's feet rest on what would be the kidneys.

IRVÁN PÉREZ

Poydras, Louisiana | 1991

To understand Islenos you need to understand decimas. . . . When something unusual happened in St. Bernard or if someone needed to be taken down a few notches, they'd make a decima about it.

St. Bernard Parish in Louisiana is home to a unique community of settlers who arrived in the late 1700s from the Canary Islands. Spanish-speaking "Islenos," as they refer to themselves, took root in this swampy terrain and supported themselves through hunting, trapping, fishing, and farming. Irván Pérez maintained a rich cultural heritage by continuing to perform the songs, tales, riddles, and proverbs of his ancestors. His repertoire includes the decimas, the ten-line narrative songs, often improvised and about current events, in a form rooted in sixteenth-century Spain. In addition, he was known as a woodcarver who crafted both functional and decorative decoys. In later years, he served as a community scholar, providing valuable historical information for the development of the Isleno Museum at the Jean Lafitte National Historic Park. In 2001 he was given the honor of performing decimas for King Juan Carlos and Queen Sofia of Spain when they attended an exhibition of Spanish art in the United States.

Irván Pérez faces the camera as several alligator hunters head away from the dock in St. Bernard Parish. This visual landscape, including structures such as the stilt house in the background, was completely destroyed by Hurricane Katrina in 2005. A five-foot wave flooded and damaged Irván's home, as well as recordings of his father's singing and the treasured implements in his workshop. The family was relocated to FEMA trailers in a state park six hours away from Poydras, but before his death in 2008 Irván was able to move back to a home in the area that he had rebuilt with his daughter. Pérez's funeral was the first ceremony held in their rebuilt church after the hurricane. This photograph documents a cultural landscape that, thanks to the efforts of cultural preservationists like Irván Pérez, and even in the face of disasters such as Katrina, had the tools and will to survive.

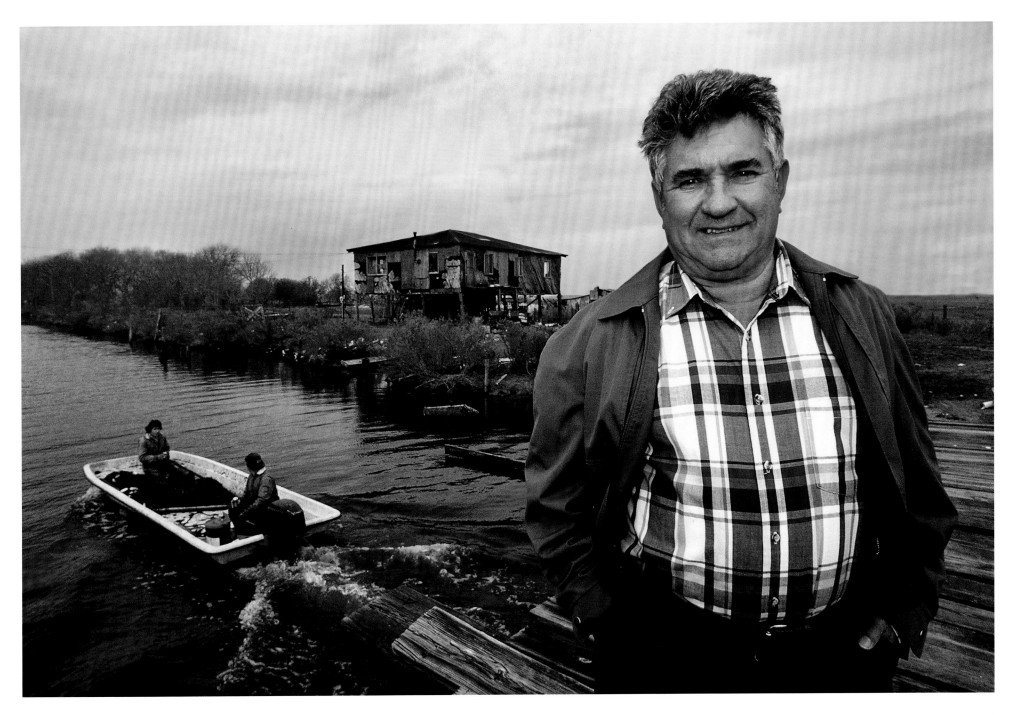

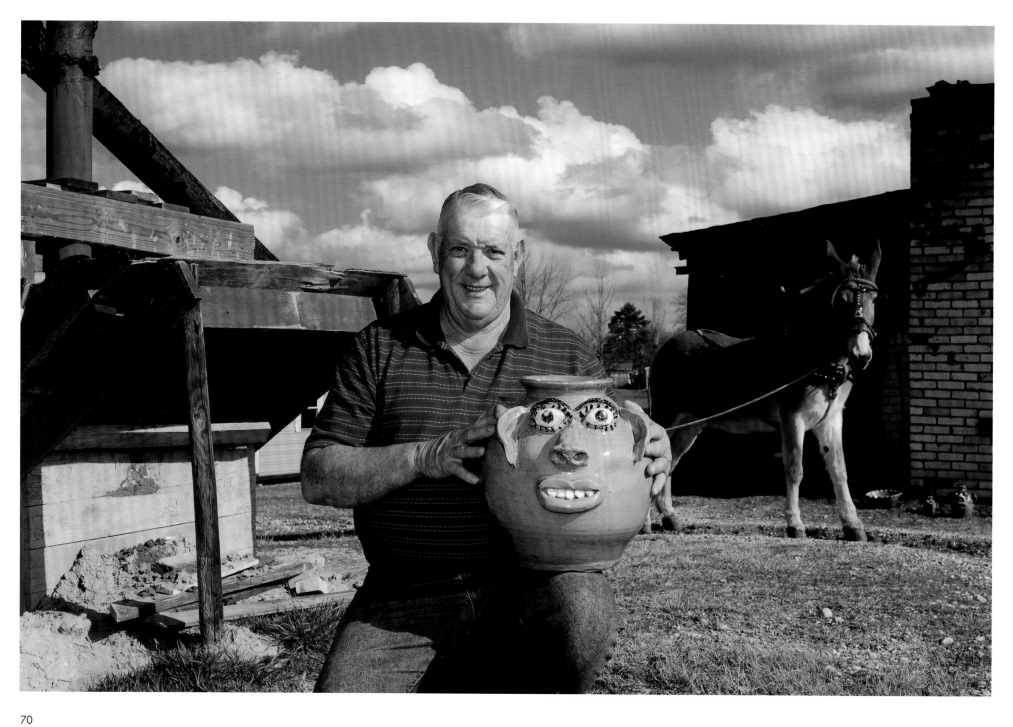

JERRY BROWN

Hamilton, Alabama | 1992

Everything about the pottery business has art to it. . . . The pottery business is one of the oldest trades in the world. . . . People come to my shop and say, "I believe I could do that." And I tell them "There's another wheel over there . . . and they get in there and play with it and (then) they say, "It's not as simple as it looks."

The area of northwestern Alabama where Jerry Brown lived was known for a type of clay prized for pottery making, so independent farmers, such as Jerry's father, could supplement their income by making clayware. Jerry and his brother made clay pieces even before they started attending school. After a career in logging, Brown returned to pottery. Though he originally had in mind selling to the local market, as potters of the region had done for decades, his reputation spread, and museum gift shops and tourists beat a path to his door to purchase decorative churns and face jugs that feature stylized and often grotesque faces. He has said that the face jugs fashioned by early pottery makers warned people of poisonous materials within. In the late twentieth century face jugs became popular as whimsical pieces, with no connection to their original intent.

Brown was thought to be the last person in Alabama, if not the United States, who still milled his raw clay with mule power. He observed that successful pottery making required a whole series of steps—finding the right clay, mixing it to remove impurities, stacking the pots correctly in the kiln without breaking them, and firing the pots at the right temperature. He chose to be photographed next to his pug mill, with his prized mule, Blue, looking over his shoulder. The depth of the tracks around the pug mill attest to Blue's contribution to the pottery-making process over the years. At one time, Brown had a dog that would ride, round and round, on the back of his mule, jumping off and barking to get the mule started again if it stopped.

CHARLES HANKINS

Lavallette, New Jersey | 1993

There's no machine that I've ever seen or known that can put a bevel on a plank other than by hand, and it comes only by experience of how much bevel it takes for each plank and how each plank fits together. Without that you have a leaky boat.

Building techniques and design features of boats acquire characteristics unique to their use and maritime environment. This certainly is the case with the Sea Bright skiff, a boat used along the coast of New Jersey. The shoreline often required that fishing and lifesaving boats be launched directly into the surf. As a result, the Sea Bright skiff was designed with a flat bottom and rounded sides and constructed to be light and sturdy. Charles Hankins has a direct connection, through his boatbuilder father, to this distinctive handmade wooden boat that has a 185-year history. He became known for the quality of his boats, and when fishing transitioned to larger mechanized craft, his skiffs were prized by lifeguards and customers who appreciated handmade vessels. Over the course of Hankins's more than sixty-year career he built over 1,000 boats.

For the purpose of his portrait, Charles Hankins lowered one of his finished skiffs from its storage place in the rafters of his shop. When Hankins came to Washington, DC, to receive his award, he brought along this boat. At the concert, when the craft was rolled onto the stage, the audience broke into spontaneous applause in response to its beauty. The array of hand tools seen in the photograph are for the most part made by his father and grandfather. Hankins pointed out that they were designed to fit the large hands of their users. The "competition" bronze oarlock in the foreground was custom-designed by Charles Hankins to be safer and more efficient in lifeguard races.

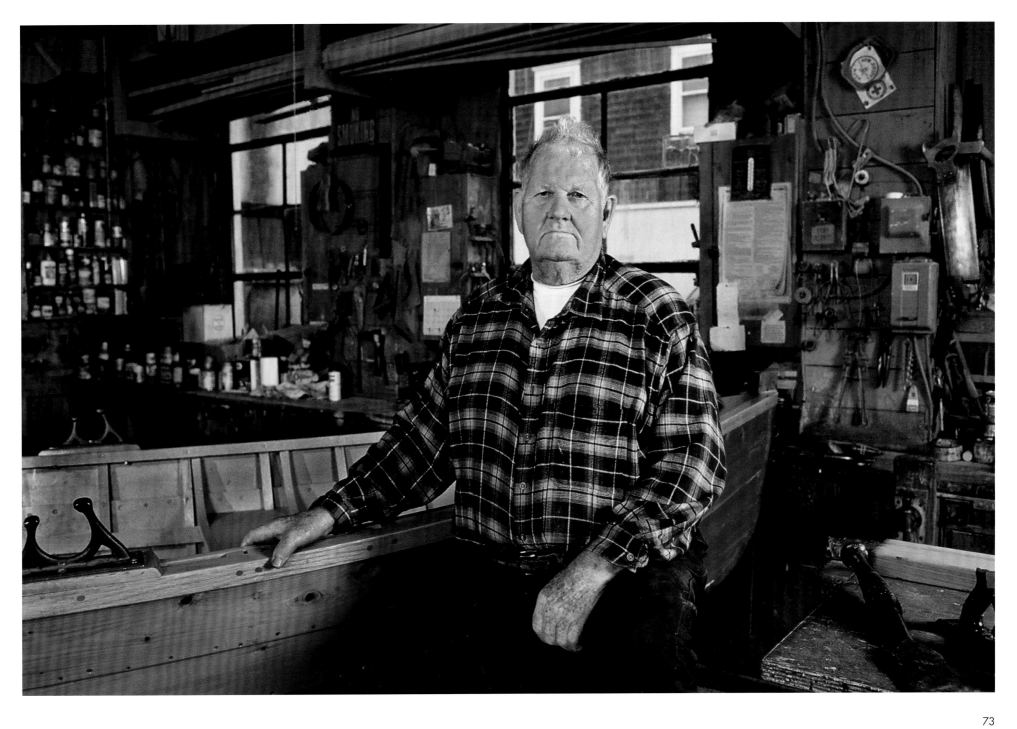

D. L. MENARD

Erath, Louisiana | 1994

I first learned to sing by listening to an old battery-powered wooden radio that we had. Every night, I turned it on to listen to Del Rio, Texas, and I learned those songs that I heard on the radio. The battery would die every year about a month or two before we sold the cotton.

Often referred to as "the Cajun Hank Williams," D. L. Menard grew up listening to border radio stations that broadcast country music sung in English. When he was sixteen he heard a local Cajun band singing in French, and soon thereafter he ordered a guitar from the Montgomery Ward catalog for $11 and began to play with bands in the region. Eventually he started to sing and compose songs of his own. One of those, "La Porte d'en arrière" (The Back Door), became a regional hit. He continued to work at a service station and later made chairs to earn a living, but in 1973 Menard was heard by Dick Spottswood, who was doing fieldwork in Louisiana, and was invited to perform in Washington, DC, at the National Folk Festival. From that time forward, he and his band, The Louisiana Aces, appeared at music festivals around the country and toured internationally representing Cajun musical culture.

D. L. Menard wanted to have his portrait taken in the café and bar next to the Acadian Museum in his hometown, Erath, where he often performed. Above the door, over his right shoulder, can be seen an advertising sign for Hadacol, a patent medicine that literally, and in this case visually, links Menard, Erath, and Hank Williams. This elixir, meant to be a vitamin supplement, had the added attraction of containing 12 percent alcohol. It was first marketed by Dudley J. LeBlanc, a state senator from Erath, who is said to have named it after a previous enterprise—Happy (HA) Day (DA) Headache Powder Company (CO), LeBlanc (L). On the other hand, LeBlanc often would quip "I hadda call it something." The sponsor for Williams's first radio show, Health and Happiness Hour on WSM radio, home of the Grand Ole Opry, was Hadacol.

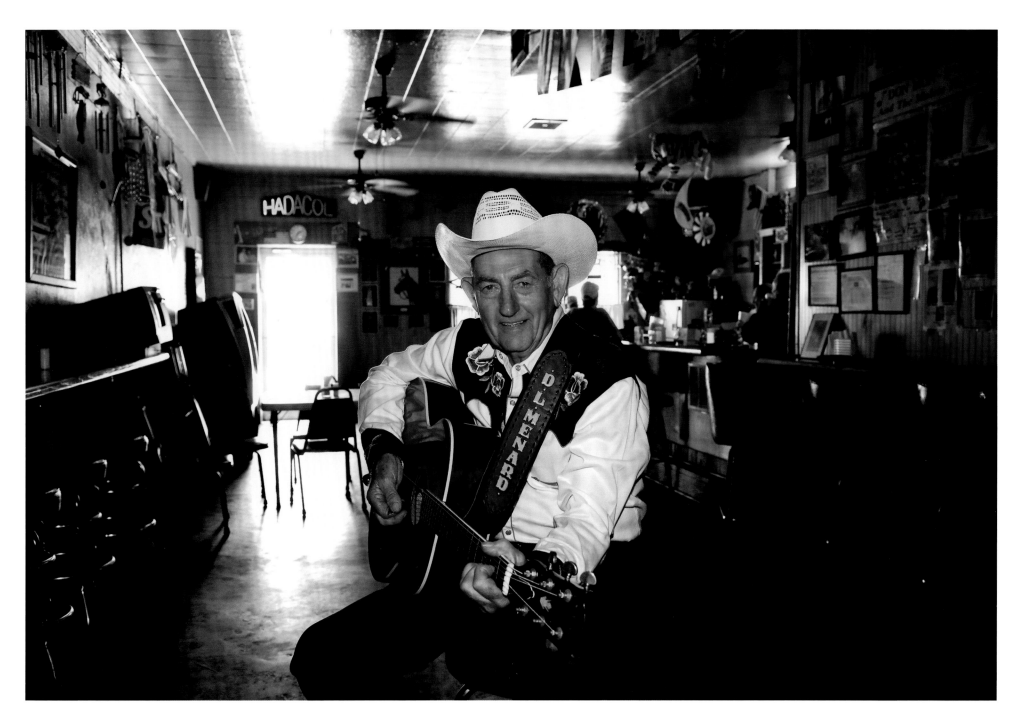

SIMON SHAHEEN

Brooklyn, New York | 1994

I was surrounded by art and music at home, in the village, and everywhere I accompanied my father. I lived the musical experience by listening to him, observing him, and living with him.

Simon Shaheen has been deeply immersed in Arabic music since he took up the oud at the age of four. His father was a renowned teacher and composer, and it was at home that he first learned the complex system of tuning and improvisation that dates to at least the seventh century. Shaheen was born to an Orthodox Catholic family in an Arab village in Galilee and collected folk music from that region, in addition to pursuing formal studies at such institutions as the Academy of Music in Jerusalem. After moving to New York to complete graduate degrees at Manhattan School of Music and Columbia University, Shaheen formed the Near Eastern Musical Ensemble to continue performing, teaching, and composing music. Worldwide he is recognized as a virtuoso on the oud and violin, and more

recently he has formed an ensemble named Qantara ("arch" in Arabic) to fuse Arabic music with jazz, classical, and Latin American musical styles. His performance during a memorial service at Riverside Church in Manhattan just days after the September 11th attacks has been lauded for its sensitivity and healing, a trait that his musical and educational efforts further to this day.

There is little doubt that Shaheen lives in an apartment devoted to musical performance and composition. Musical instruments provide the primary décor: three lutes and a tambourine. In the study behind we can see a music stand and collection of books, a reflection of Simon Shaheen's role as composer, performer, and scholar.

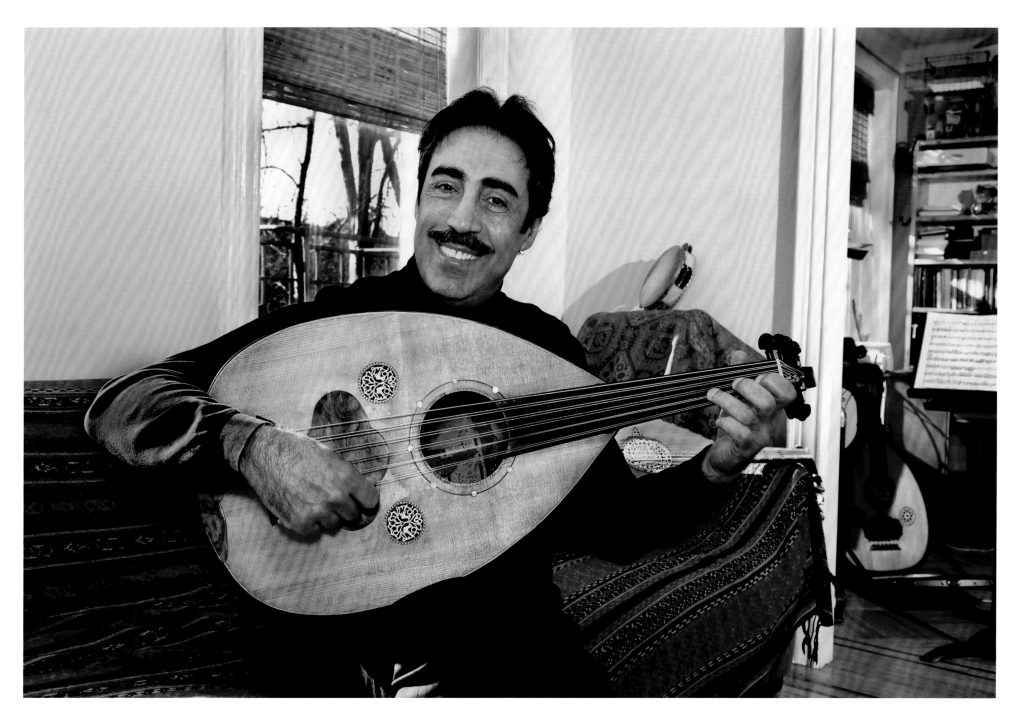

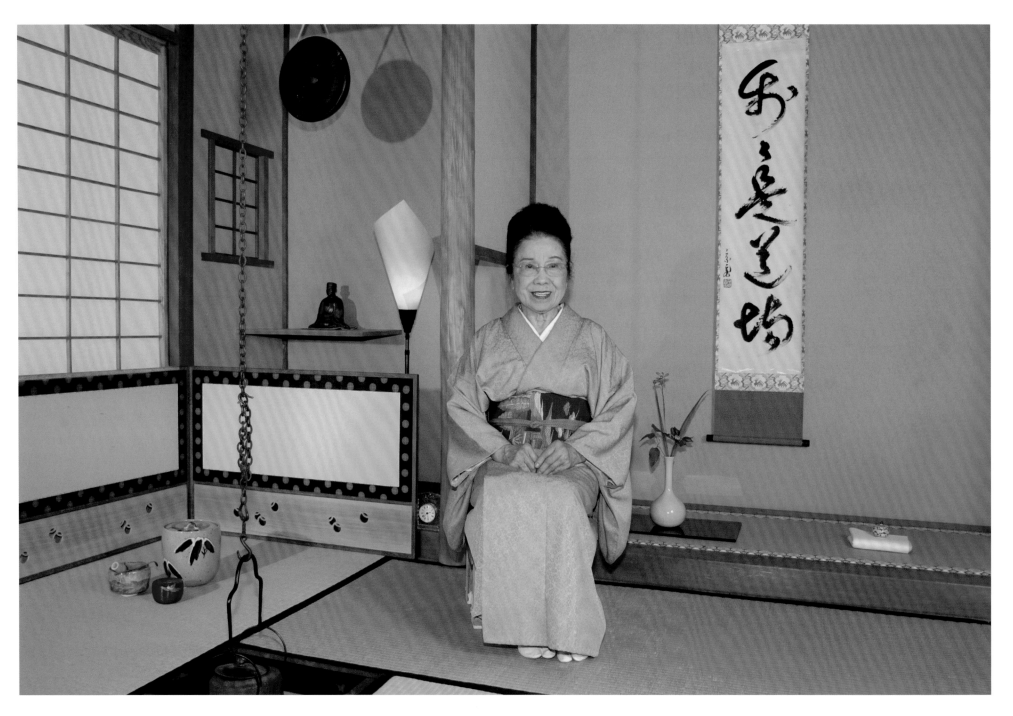

SOSEI SHIZUYE MATSUMOTO

Los Angeles, California | 1994

Heart to heart, / People to people, / With a bowl of tea, /
I give thanks, / For every day is a good day.

After attending the French American Fashion Design School, Sosei Shizuye Matsumoto moved to Kyoto, Japan, where she had the good fortune to study the Japanese tea ceremony with Tantansai, the fourteenth-generation grandmaster of the Urasenke School of Chado (tea ceremony). Study included the full range of subjects, including the tea ceremony, ceramics, architecture, flower arranging (ikebana), and calligraphy. Upon returning to Los Angeles following World War II, she was invited to the signing of the US-Japan peace treaty in San Francisco, where over four days, she served tea ceremonially to more than 3,000 American and Japanese officials, including President Truman and Prime Minister Yoshida. In 1951 she began giving tea ceremony classes and brought further attention to the practice through appearances in film, on television, and at the Olympics in Mexico City. In over sixty years of teaching she has instructed more than 5,000 students, mentored well over 100 fellow instructors, and inspired countless numbers of tea ceremony practitioners.

In the back of Sosei Matsumoto's Los Angeles home is an eight-mat tearoom constructed by her late husband. It replicates those found in Japan and is where she teaches her students. For this photograph, Tom Pich was joined by a number of followers, as well as Matsumoto's granddaughter, who served as an interpreter. The teapot hangs from the ceiling over an open fire pit, while she has carefully arranged the chakin (linen cloth for wiping), tea bowl, tea container, tea scoop, and whisk on each side of her. The scroll hanging in the tokonoma (alcove) displays calligraphy that can be read literally as "Each step is a place of practice," but could be understood as "Every day mind is the way" or "Wherever you are, you can learn what you need." These Zen Buddhist phrases are meant to inspire both teacher and students. The only unexpected item in the scene is the small clock, perhaps used to keep track of time during classes. Following a ceremony, the group moved to her living room, where a meal featuring pastrami sandwiches was served as a gesture of welcome to the visiting photographer from New York.

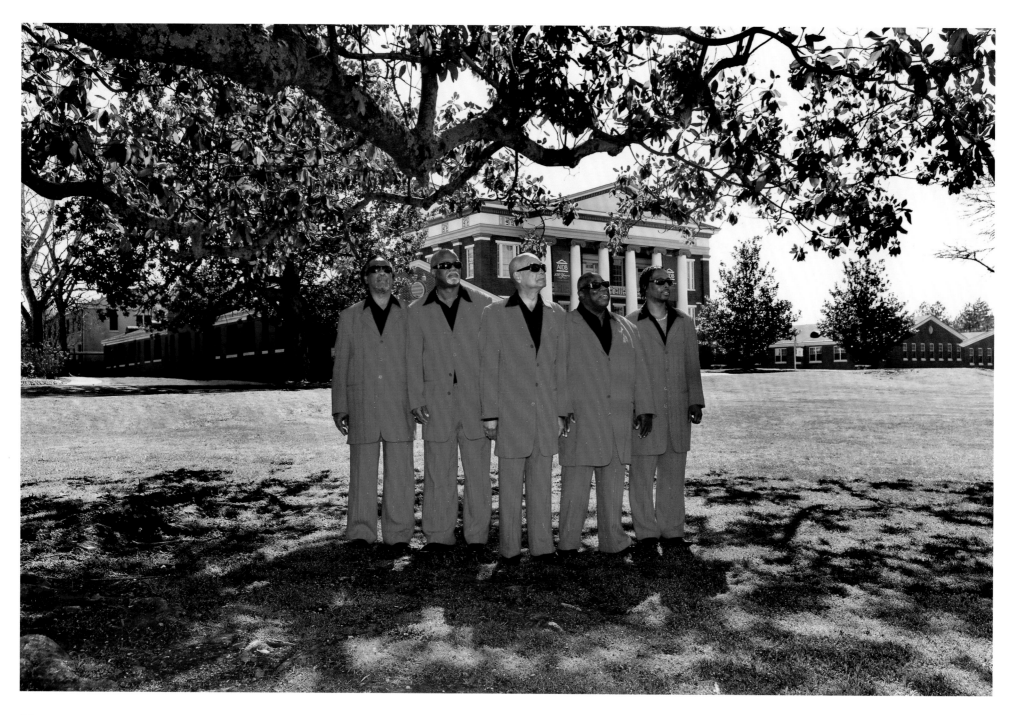

BLIND BOYS OF ALABAMA

Atlanta, Georgia | 1994

We all have limitations. . . . We (in the Blind Boys) show people that no matter what your situation is, you can make it if you try. If you can dream the dream, do the work, and keep the faith, you're going to be all right.
—Ricky McKinnie

The original members of this musical group, with a seventy-two-year history, first sang together around the age of nine at the Alabama School for the Negro Blind. Known then as the Happy Land Jubilee Singers, in 1948 they were booked with the Jackson Harmonizers from Mississippi in what was billed as the "Battle of the Blind Boys." Soon they changed their name to the Five Blind Boys of Alabama, and they have had an extensive recording and touring career since. In 1983 they appeared in the acclaimed theatrical production *The Gospel at Colonus*, and with a revival of interest in their music, the past decades have brought collaborations with artists such as Ben Harper, Robert Randolph, Alan Toussaint, and Lou Reed.

In 2008 the Blind Boys of Alabama were invited to return to the Alabama Institute for the Deaf and Blind to perform for its 150th anniversary. The challenge of photographing a larger group led Tom to look for an outdoor location. The large shade tree just below Manning Hall, built in the 1850s and named for the third president of the school, served to provide both a respite from the summer sun and a visual frame at this historically important site where the group first met. Depicted in this portrait are (*left to right*): Benjamin Moore, Eric "Ricky" McKinnie, Jimmy Carter (an original member), Bishop Billy Bowers, and Joey Williams. There is no small irony in the fact that when the group's original members attended, they lived and learned in segregated buildings and not Manning Hall.

DANONGAN KALANDUYAN

South San Francisco, California | 1995

If you were born in my village you'd hear no Western music, just traditional music. The music was everywhere and for everyone, not just as entertainment, but also as an accompaniment to rituals and ceremonies. I didn't need a tutor, it just automatically came into my head, day and night.

The kulintang, consisting of eight knobbed gongs suspended on a wooden frame, is an instrument popular in the southern Philippine Islands. Danongan Kalanduyan was born in a fishing village in Mindanao and learned to play the instruments of the kulintang ensemble, including the drums and the gongs, from his grandmother, father, uncles, and cousins. He won an island-wide competition in his youth and was soon recognized as a master of the kulintang. In 1976 he received a Rockefeller grant to serve as an artist in residence at the University of Washington in Seattle, and for the next four decades, first in Seattle and later in San Francisco, he was sought out as a performer and a teacher. Today, Filipino Americans and Kalanduyan's many students see the kulintang as an icon of their cultural heritage and continue to affirm his legacy through practice and performance.

Danongan Kalanduyan lived in a modest apartment in a Filipino neighborhood of San Francisco. For the purposes of the portrait, banners were hung to form a backdrop, and Kalanduyan began to play. Given the tight quarters and the size of the instrument, Tom Pich had difficulty capturing a complete view. He commented that the experience was as rich musically as it was visually, as he was able to hear what it might be like to sit in the middle of a kulintang ensemble.

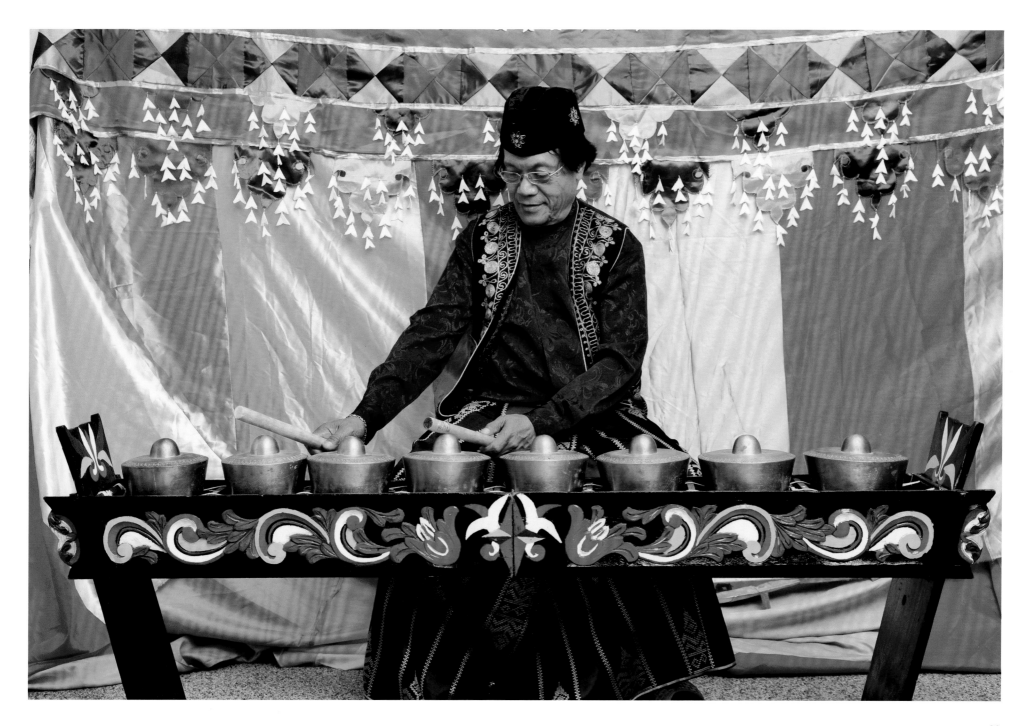

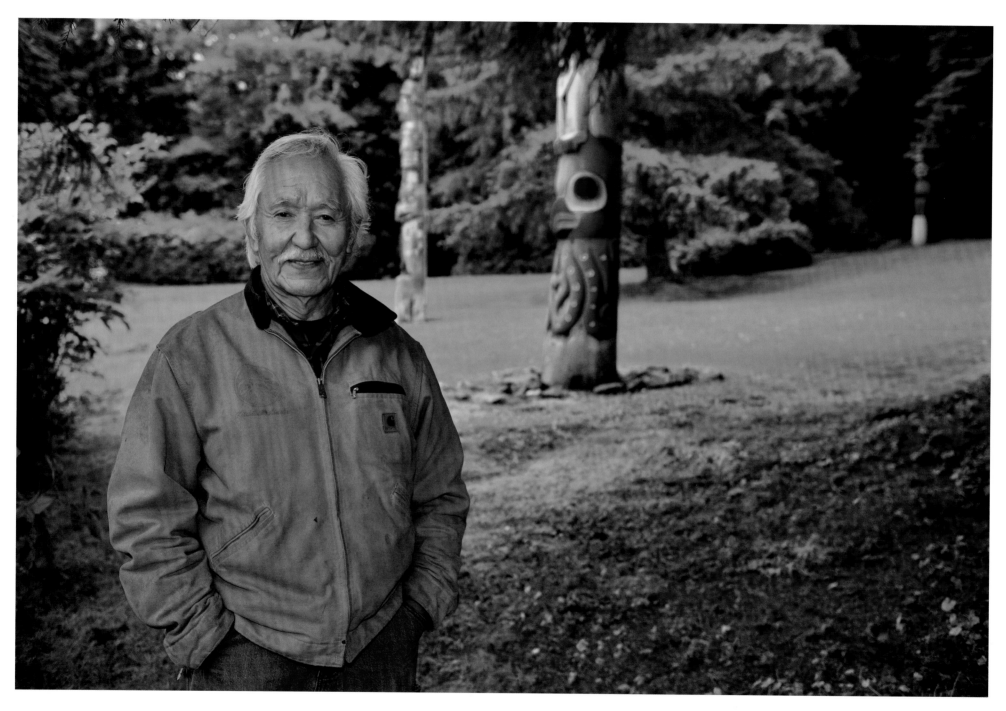

NATHAN JACKSON

Ketchikan, Alaska | 1995

I try to perfect my work and improve as I go along. My aim is to continue working and continue spreading my reputation as a carver and as an artist— as would a person who has any type of job.

Nathan Jackson was born into the Sockeye Clan on the Raven side of the Chilkoot-Tlingit tribe of Southeast Alaska. He learned ceremonial practices and woodcarving techniques from his clan uncle and grandfather. Because tribal values and stories are often manifest in the crests and motifs of the carving, weaving, and beadwork of Alaska Native people, the artist has a special role and responsibility within the community. After military service in Germany, Jackson pursued studies at the Institute of American Indian Arts in Santa Fe, New Mexico, before returning to Southeast Alaska, where he has become an acknowledged master of traditional craft, including the carving and painting of clan panels and totems, as well as the creation of silver jewelry. Jackson has carved over fifty totem poles, many installed ceremonially on tribal grounds in Alaska. He also has created work for the National Museum of the American Indian, the Field Museum, and Harvard's Peabody Museum.

Moisture is the adversary of the totem pole, while in one sense it is the ally of the artist. The gradual depredation of poles by the elements requires an ongoing supply of newly carved figures, not to mention a continual renewal of artistic skills and ceremonial practices. Nathan Jackson was photographed standing in the rain, in front of his Land Otter Totem Pole at Totem Bight State Park just outside of Ketchikan. Jackson carved this pole to replace the original, carved in the 1940s by Haida carver John Wallace. The octopus at the bottom, also known as the devil fish, appears in Tlingit and Haida mythology as a member of the larger Raven clan.

BETTY PISIO CHRISTENSON

Suring, Wisconsin | 1996

As long as pysanky are in the Ukrainian homes there will be happiness and goodness there throughout the year.

Born to Ukrainian immigrants who homesteaded a farm in northern Wisconsin, Betty Pisio Christenson learned egg-painting techniques from her mother. She first saw the traditional painted eggs as a child during the Lenten season and asked her mother where these beautiful eggs came from. Her mother explained the significance of the eggs and initially taught her the krizanki (single-colored) tradition of decorating with natural dyes made from bark, onion skin, and beets. Later Betty began making the more elaborate pysanky (writing on eggs) using commercial dyes and a variety of strongly colored patterns. Christenson gained recognition as a master of this art form, and her work was featured in the seminal exhibition—"From Hardanger to Harleys: A Survey of Wisconsin Folk Art." She has taught her children and grandchildren the art of pysanky and mentored aspiring egg painters at workshops and through the Wisconsin Arts Council's apprenticeship program.

Sitting in the home that she and her husband built, Betty wears the intricately embroidered traditional dress of Ukraine. The fireplace in the background is constructed of large stones collected from places they visited through the years. Like her eggs, the interior of the house displays a decorative and geometric intricacy worthy of her wax-resist designs. The distinct warmth and unique character apparent in her choice of decor seems to visually connect her living space with her personal and cultural heritage.

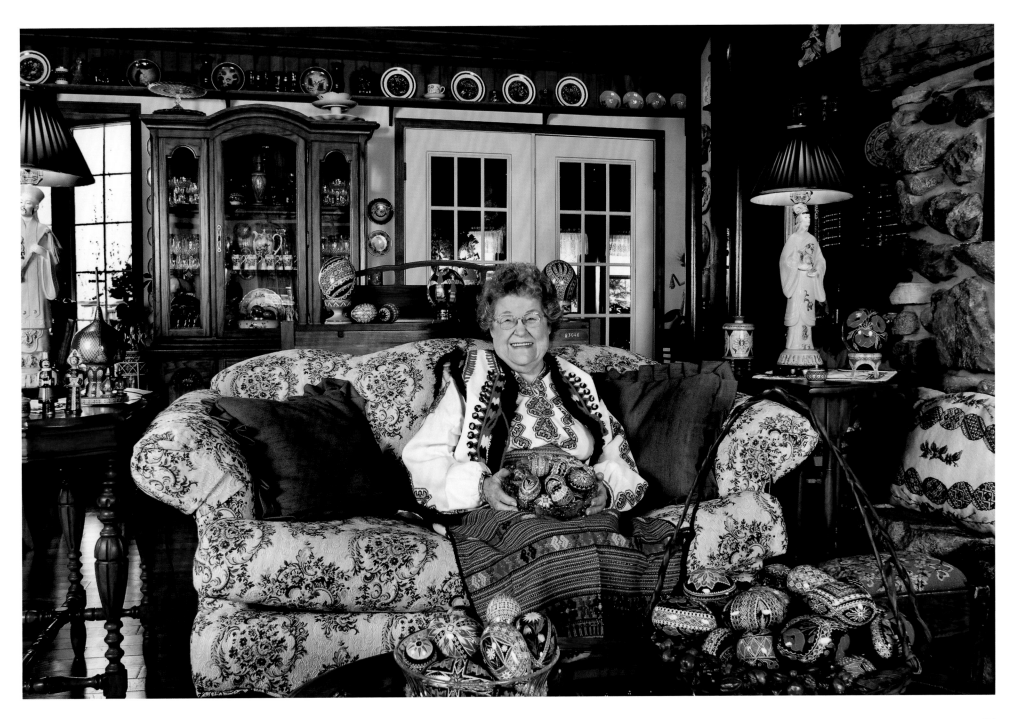

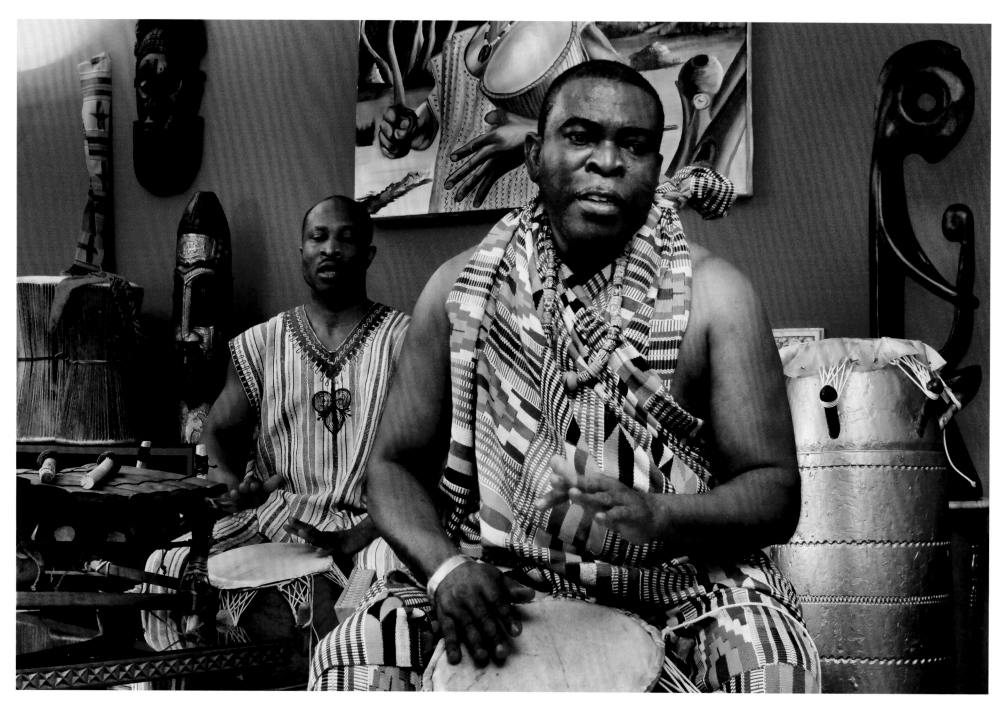

OBO ADDY

Portland, Oregon | 1996

From the time I was a young boy, I knew I wanted to be a musician, and I was fortunate to be able to learn the art from my family.

Obo Addy, the son of a healer, was born into a Ga family in southern Ghana. By the age of six, he was known as a master drummer because he had learned all the elements of drumming for the necessary healing rituals. As a teenager he took up some more popular forms of urban music, such as Highlife, emerging in the capital, Accra. After moving to Portland in 1978, he formed two groups that reflected his eclectic interests: Okropong (eagle), dedicated to traditional tribal music of Ghana, and Kukrudu (earthquake), drawing on popular and jazz musical styles. He founded Portland's annual Homowo (harvest) festival of African music and, through an organization of the same name, he initiated educational and music training programs. Following his death, Addy's family and friends carry on his work under the name Obo Addy Legacy Project.

Obo Addy preferred to have his photograph taken as he drummed, so he invited a friend to sit in with him for his portrait. Surrounded by carvings and paintings, most from his family's Ghanaian village, Addy began drumming. Pich observed that as the music making commenced, Addy seemed unfazed by the presence of a photographer in the room.

VERNON OWENS

Seagrove, North Carolina | 1996

Guess I've gradually moved toward the ways of the older potters who just made pots, not worrying about how great they looked— though they usually did come out right. The older I get the less I worry about it— just let the pot be as natural as possible.

Vernon Owens grew up in the Piedmont area of North Carolina, historically known for its good clay and, not surprisingly, plentiful potteries. As a youth, Owens worked beside his father at a kick-powered pottery wheel in the pottery of his grandfather J. H. Owens. In 1960 he took a job at Jugtown Pottery. At that time, the pottery businesses in North Carolina were flagging and, to make matters worse, the use of lead glazes constituted a hazard to consumers and potters alike. In 1968 a not-for-profit organization, Country Roads, took over the Jugtown Pottery, and Vernon worked with the organization to create safer and more attractive glazes while developing new marketing strategies. A central leader in what became a regional pottery revival, Owens continues to make pots today, and the Jugtown Pottery is one stop on the official "North Carolina Pottery Highway," The

tour meanders through an area that can claim more than 100 active potteries as well as the North Carolina Pottery Center, whose display of work from the region includes pots made by Vernon Owens, his wife, Pam, and children, Travis and Bayle.

When Vernon Owens came to Washington, DC, to accept his National Heritage Fellowship, he demonstrated the raising of a pot on a wheel in front of a large audience attending the annual celebratory concert. In response to the question about how it was going, he replied, "It'd be better at home." His studio provides for the needs of the potter—clay, a wheel, tools, water, shelter, light, and, sans an audience, few distractions from the task at hand. Spotless overalls belie the impression that he had just gotten up from the wheel to have his portrait made.

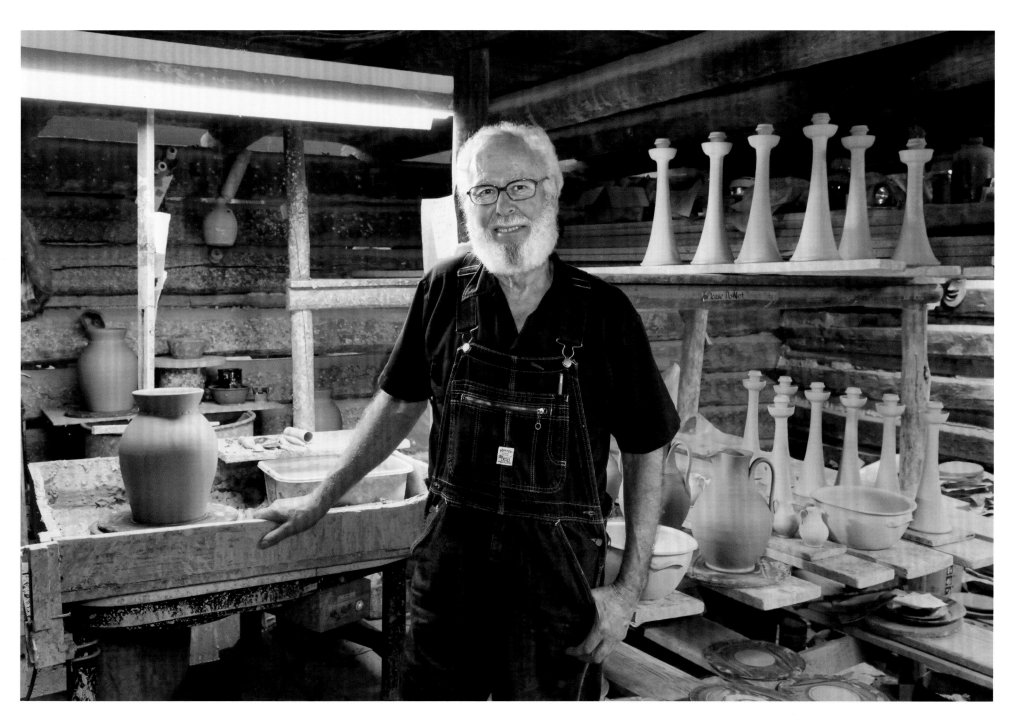

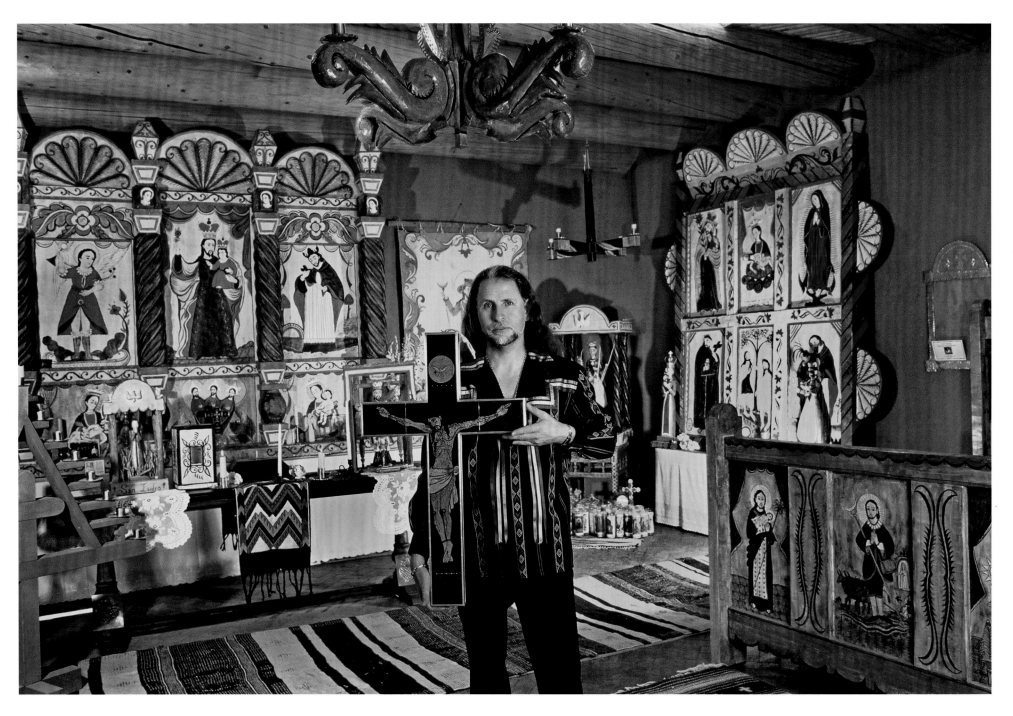

92

RAMÓN JOSÉ LÓPEZ

Santa Fe, New Mexico | 1997

My traditional work lets me see how influenced I really was by my heritage, my history. It showed me my roots in this area—opened my eyes. It's all inspired by my upbringing here, my Catholic religion and my interest in the churches of New Mexico, with all their beautiful altar screens. I want to achieve the level of quality of those old masters—what they captured on wood, emotions so powerful, so moving.

Ramón López, whose grandfather was a renowned santero (saint carver) but had passed away prior to Ramón's birth, was inspired to take up Spanish colonial metalworking in the 1970s. His efforts made a significant contribution to the revival of Hispanic craft in the region but also served as a gateway to the exploration of many craft pursuits on his part. He studied the works of nineteenth-century master santeros, and, using the tools of his grandfather, he began to carve and paint retablos (two-dimensional portrayals of saints and other sacred images), bultos (three-dimensional images), and reredos (painted altar screens). Throughout his career, López has combined his creative and spiritual journeys, found ways to explore new avenues of expression, and addressed contemporary concerns. One of his carvings deals with the issue of DWI deaths plaguing the region. López blends the old with the new when he paints current narratives on buffalo hides or introduces new materials to his creations.

Ramón López is shown holding a cross in the midst of a room attached to his house that serves as both a chapel and a gallery for his work. He is surrounded by reredos, retablos, furniture, and tinwork. To his left is his "Bed of Dreams" a hand-carved colonial-style bed with images of six saints painted with natural pigments. The altar in the rear and the burning candles reflect both the artistic and spiritual character of this space, as each object is transformed into a personal article of faith.

JULIUS EPSTEIN
of the Epstein Brothers
Sarasota, Florida | 1998

Klezmer music dropped dead after the Holocaust. The American-born people wanted rock, swing, jazz. But now they want that music. There's been a tremendous renaissance.

Julius Epstein, along with his three brothers, Max, William, and Isidore, formed the Epstein Brothers Orchestra after World War II, and in the 1950s they became known as the "kings of klezmer." Klezmer music often accompanied dancing and was also performed in Yiddish theatrical productions. Usually led by the clarinet, rendered as if imitating a weeping voice, klezmer ensembles in the United States often incorporated elements of jazz, resulting in their own unique style. With the influx of Hasidic Jews to New York after the war, the brothers were much in demand to perform at weddings, bar mitzvahs, and other family celebrations. They made numerous recordings on small ethnic labels throughout their career. Julius Epstein anchored the band with his performances on drum. Even after retiring to Broward County, Florida, in the late 1960s, the brothers continued to perform at senior centers and synagogues.

By the time Tom Pich reached Julius Epstein's wife, Esther, he was living in an assisted-living facility, experiencing the travails of Alzheimer's disease. Having visited another Fellow under similar circumstances, Pich suggested that they take one of his drums with them on their trip to see him. Although he did not seem to recognize Esther or Tom during the early stages of their visit, when Pich pulled out the snare drum and began to tap on it Epstein suddenly responded by telling stories of playing the drum with his brothers. Soon they moved out into the courtyard for better light, and Julius held the drum—continuing to reminisce. As Pich looked over, Esther, with tears in her eyes, said, "He hasn't talked to me in two years." Following that experience, she continued to communicate with Pich, saying that she took in the drum for each visit to her husband.

ALFREDO CAMPOS

Federal Way, Washington | 1999

I try to make every quirt different and that's part of what also makes it difficult, because you're not doing the same thing, even though you're hitching, the hitching process is the same, your designs are different and I try to make the designs difficult so that it's more interesting.

Although Alfredo Campos spent most of his professional life working with the tools utilized in the construction of aircraft for the Boeing Company in the state of Washington, his cultural roots go back to ranching life in Arizona. As a young man he became fascinated with rawhide and horsehair weaving essential in the work of ranch hands. Campos practiced the intricate skill of hitching horsehair, a feat that in modern times has been more frequently associated with work produced by prisoners with abundant time on their hands. Campos is proud to say that he practiced the skill under other circumstances, but the requirements are no less onerous—pieces incorporate up to 30,000 hitches and most take around two months to complete. An article in *Western Horseman* in 1984 drew national attention to Campos's work, with the writer comparing his creations to a symphonic performance. It became clear that his skill in tightly and evenly hitching the quirts (whips) and reins and the ingenuity in his color designs had taken the craft to a new level of excellence.

Alfredo Campos creates intricate braided pieces at a small table tucked in a corner of his home. His skills as an engineer are evident in his work space—he constructed everything needed for the process of making his pieces, including the workbench and the metal tubes around which he braids the horsehair. The chair he is sitting on is made from a tree that grew on his family's Arizona ranch, and just behind his right hand is the family cattle brand.

ELLIOTT "ELLIE" MANNETTE

Osage, West Virginia | 1999

I always knew in my heart one day / that my work would find its way, I could not tell you how, / there was no one there for me to show the way / but I figured it out. / I figured it all through for all of you to see today.

Ellie Mannette is known as the "father of the modern steel drum." Born in Trinidad, he first played in Carnival at the age of eleven. The steel drum came into being after the British colonial government banned the use of conventional drums, fearing the violence they associated with them, and Trinidadians began using metal household implements in their place. After the Second World War, Carnival was reinstated, and oil drum lids became the preferred raw material for the instruments. Mannette, a machinist by trade, retooled the surface of the lid to make it concave and tempered it with heat to produce a cleaner sound and to better tune the various-sized drums. He also was the first to construct a drum from the larger fifty-five-gallon barrels. In 1963 he was invited to the United States to train the Navy Steel Band, as well as build their instruments. Today, he teaches at West Virginia University training performers and builders and operating Mannette Steel Drums Ltd.

Ellie Mannette sits outside the building where he manufactures drums, astride one of the fifty-five-gallon barrels. Although the scene might just as well be a West Indian island, this is landlocked West Virginia. Arranged behind Mannette are drums of various sizes, with a range of tunings. With the development of new technologies, he now uses strobe tuners, but the hands-on process of shaping the playing surface is the same. The instrument behind his right shoulder displays the markings for the individual notes appropriate for a pan of that size.

FRISNER AUGUSTIN

New York, New York | 1999

The spirits give me the drum. The spirit sees in his mind I'm gonna be good. My mother don't have money to pay the rent. Thanks God, thanks my spirit, that give me that experience to play the drum.

Raised in the Port-au-Prince neighborhood Cité Soleil, Frisner Augustin followed his drummer uncle as an initiate in the Santería religion that involves worship of Yoruba deities blended with Catholic saints called orishas or santos. He started off playing the ogan, a bell-like rhythmic instrument, and by the time he was ten years old he had moved from basic instruments to the master drum. At that point, he went through the initiation ceremony and assumed the responsibility of "making the drum talk". In 1971 Augustin came to the United States, and by 1982 he had assembled a performing ensemble, La Troupe Makandal. This group became a major catalyst for the public exposure and informed understanding of Haitian music and culture.

Because Frisner Augustin lived in Brooklyn, Tom Pich had the opportunity to photograph him over the course of a number of years. In most cases, he visited Voudon ceremonies held in a nondescript building that ordinarily would not attract any special attention. Crowded into this space, drumming, dancing, and singing often lasted for five to six hours, attracting both participants and observers. The photograph captures the intense motion and emotion during one of those moments.

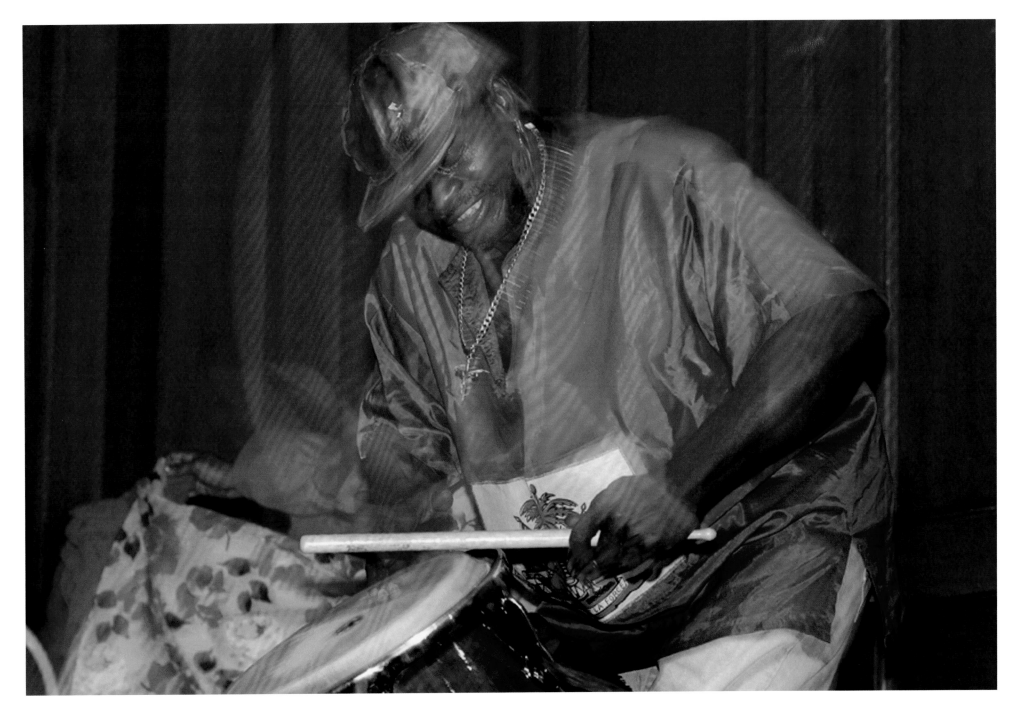

JIMMY "SLYDE" GODBOLT

Hanson, Massachusetts | 1999

You've got to fall and you've got to learn how to get up, gracefully. Like you never fall. Everybody slides sometime.

Jimmy Godbolt's mother wanted him to learn to play the violin. At the age of ten he discovered that across the street from the music school where he was taking lessons was a tap dance studio, and that captured his imagination. Forsaking the violin, in that studio he was able to observe and learn from some of the masters of tap dance, including Jimmy Mitchell, who used the name "Sir Slyde." After a while the two Jimmys began touring New England clubs and burlesque houses as the Slyde Brothers. They became regular dancers with the likes of Count Basie, Duke Ellington, and Louis Armstrong. With the decline of interest in tap and jazz, Jimmy Slyde moved to Europe, where he found more opportunities to perform. In the 1980s he was featured in the production of *Black and Blue* that came from Paris to Broadway, and

his career in the United States was revived. He was able to act as a mentor for many younger tap artists during the tap revival and perform in movies such as *Round Midnight* and *The Cotton Club*.

Taken in the dance studio where Jimmy Slyde taught, this photograph portrays the dancer as he sits looking out the window. What can't be seen is that one of his protégés is dancing behind him. Using only his ears as a guide, Slyde periodically corrects the quality and rhythm of the steps as the young man practices. This is the only portrait that features an artefact of the photographer's presence. In the right edge of the photo behind Slye's left shoulder there is a starburst of light from the camera's flash reflected in one of the dance studio mirrors.

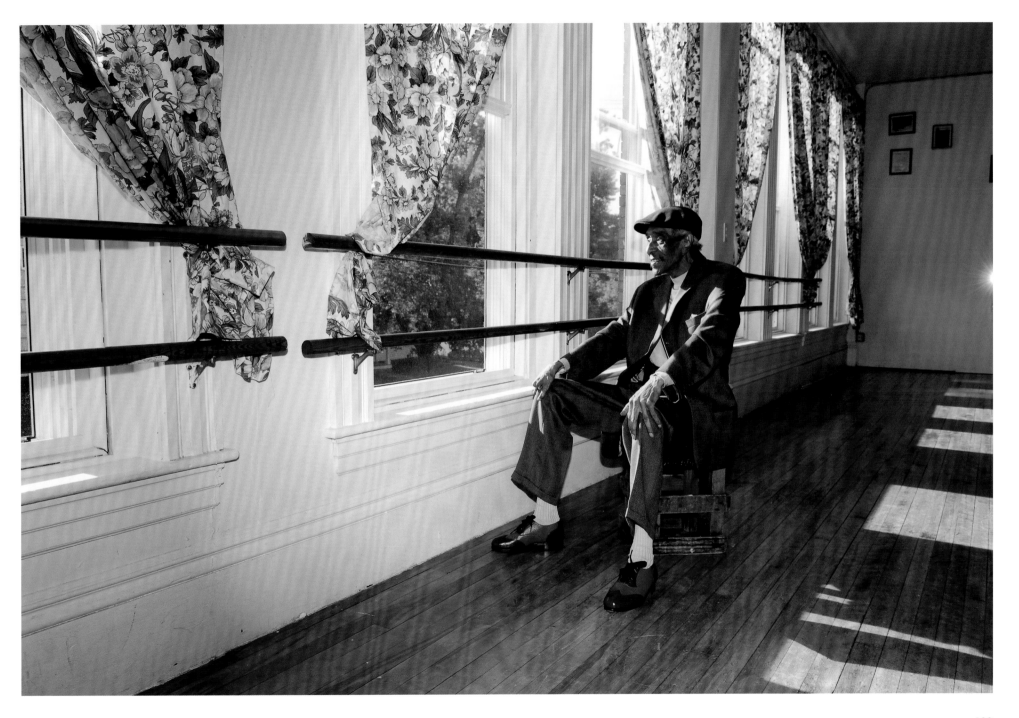

MICK MOLONEY

New York, New York | 1999

When I was starting out, I think a lot of the field recordings I did were examples of affirmative action and cultural protection, because I was in dread that this music would die out in America. But those days have long passed. I think we can feel secure now that the core of the music has been protected, preserved, and enhanced, and that it'll never become a museum piece.

Born in Limerick, Ireland, Mick Moloney took up the tenor banjo at the age of sixteen. Like many of that era, he became a fan of popular American folksingers of the early sixties, but he soon realized that there were great traditional musicians performing in parlors and pubs all around him in the South of Ireland. He performed in folk groups in Dublin in the early 1960s and then joined a group called the Johnstons that went on to have considerable commercial success. He came to the United States in 1973 to study folklore at the University of Pennsylvania. Although he pursued his scholarly studies, attaining a doctorate in the subject, Moloney also became aware that he was surrounded by a vibrant Irish musical culture in the United States. At that time, most Americans felt they had to import musicians and dancers from Ireland to experience "authentic" Irish culture. In 1977 Moloney cofounded a touring group, Greenfields of America, featuring stellar artists from cities like Chicago, Philadelphia, Detroit, and New York, many of whom would later become National Heritage Fellows. He helped initiate a Cherish the Ladies series, drawing attention to the quality and breadth of the music being performed by young Irish American women. He produced over fifty recordings of traditional Irish

artists in America. Moloney teaches in the Irish Studies and Music Departments at New York University and continues to perform and present programs based on his research into the connections between Irish American and African American and Jewish musical traditions. He frequently travels with fellow Irish musicians to Southeast Asia, working with Irish Aid and various nongovernmental organizations on social service efforts such as improving conditions in orphanages and refugee camps in Thailand and ameliorating the lingering suffering resulting from military conflicts in Viet Nam and Burma. In 2013 he received the president of Ireland's Distinguished Service Award for his service to his country of birth and to humanity at large.

This photograph was taken in Mick Moloney's home in suburban Philadelphia, where he was living at the time as he worked with the International House at the University of Pennsylvania. While an accomplished musician on many instruments, Moloney holds a tenor banjo, an instrument that came to be used in Irish music after the turn of the twentieth century and one that he has written about and frequently plays on recordings and in musical sessions.

ULYSSES "ULY" GOODE

North Fork, California | 1999

Putting the basket together [is my favorite part]. It's the culmination of all your work. You see these sticks and stuff out there in the hills and then you put this basket together.

Many tribal groups use handmade cradleboards to hold and carry infants during the early years of their lives. Often the carriers have both functional and ceremonial significance, and today their use makes a statement about tribal heritage and identity. In the case of the Western Mono tribe in California, Uly Goode served as both the maker and the master of identifying and understanding the natural materials essential to the art of basketmaking. The gathering and preparation of sedge roots, redbud shoots, and sourberry sticks provide the basic material for his artistic creations. Goode made over 450 baskets in his lifetime, and his cradleboards were featured in the exhibition *The Fine Art of California Indian Basketry* produced by the Crocker Art Museum.

Holding one of his cradleboards, Ulysses Goode stands in the backyard of his home just south of Yosemite National Park. One of the few males making cradleboards, he was respected for both his basketmaking skills and his knowledge of the various plants harvested by basketmakers around the state of California. The designs in the basket are created through the use of dark winter rosebud—in this case arrow-shaped figures indicate that this item was intended for a baby boy, while a diamond or zigzag pattern would have been used for an infant girl.

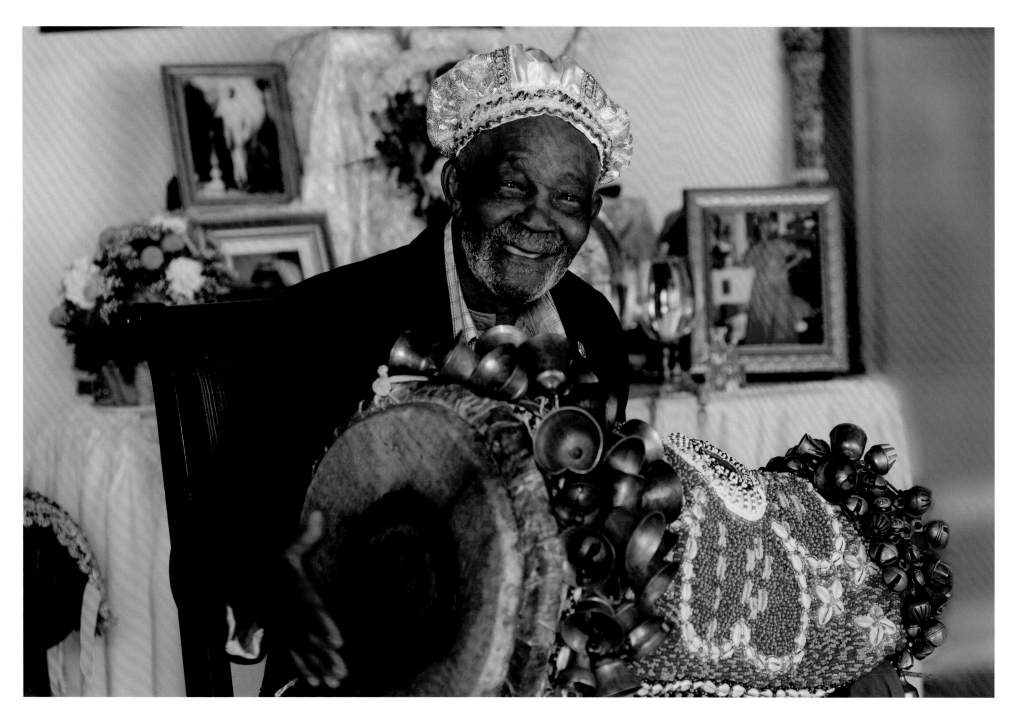

FELIPE GARCÍA VILLAMIL

Los Angeles, California | 2000

So the skin and the drum, that structure has been my life. Because it has given me life, it has given me food, it has given me everything.

Born in Matanzas, Cuba, Felipe García Villamil has a strong connection to three strains of Afro-Cuban rituals and belief—his mother's family included practitioners of the Yoruba-based Santeria religion as well as performers of the province's folk music, the rumba; while his father's side of the family came from the Kongo religion of West Africa. While in Cuba, he directed a folkloric performing group called Emikeke. It is not surprising that Felipe became one of the most versatile and well-grounded artists to come to the United States during the period of the Mariel boatlift. After settling in New York, where he re-formed Emikeke, the group became well known on the East Coast. Later he relocated to California, where he continues to perform. Although known for his musicianship, Villamil is equally famous for his ritual craftsmanship—he makes the three primary drums used in the ceremonies and creates the altars for religious rituals.

For Felipe García Villamil the drum is central to his life and beliefs, and it occupies a prominent place in the portrait. In the early days of the revolution in Cuba, there was an attempt to suppress the religious practice of Santeria, and as a result many of the ritual objects fell into disuse and disrepair. Villamil began making the objects necessary for religious ceremonies, including the drums. In this case, he is holding a batá, the sacred drum used for Santeria rituals. It is covered with a hand-beaded banté, or liturgical garment, that covers the drum during ceremonies. Behind him you see an altar with photographs of his mother and father.

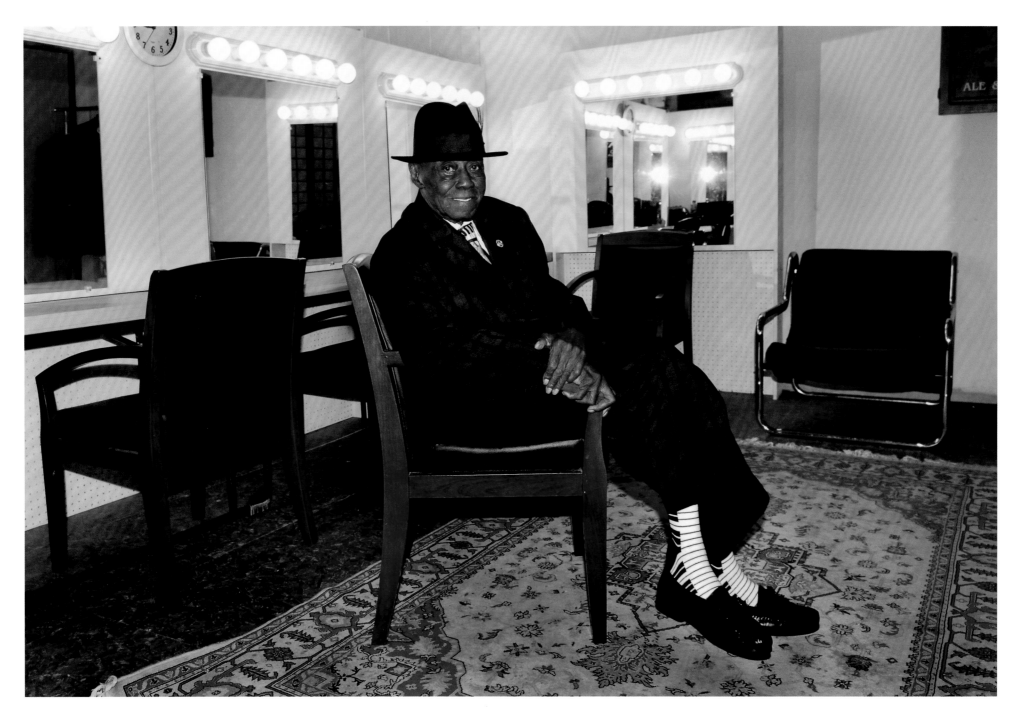

JOE WILLIE "PINETOP" PERKINS

Belzoni, Mississippi/La Porte, Indiana | 2000

Muddy used to say that there were two kinds of players: those who are born talented, and those you can "build with a hammer and nails." I'm sure Muddy was the first kind, and though I may have a little talent and a lot of desire, I'm the second kind. I am indebted to the carpenter.

It is often said that even though the Mississippi River flowed southward, the blues flowed northward. Pinetop Perkins was born on the Honey Island Plantation, just south of Belzoni, Mississippi, and as a teenager played in clubs in the region, earning the nickname "Pinetop" because he was known for playing Pinetop Smith's "Pinetop's Boogie Woogie." His reputation spread as a result of appearances on live radio shows such as the *King Biscuit Time* broadcast from Helena, Arkansas. Eventually his musical journey took him to Chicago, where he became an integral member of Muddy Waters's band. His piano performances animated and defined the sound of Waters's band for over ten years. In the latter stage of his career he recorded two Grammy winning albums: *Last of the Great Mississippi Delta Bluesmen: Live in Dallas* (2008), with Honeyboy Edwards, Robert Lockwood, and Henry Townsend, and *Joined at the Hip* (2010), with Willie "Big Eyes" Smith, that made Perkins, at ninety, the oldest person ever to receive a Grammy.

For a touring blues musician, the dressing room serves as a second home. In this case, Pinetop Perkins is sitting backstage at a musical venue in Fairfield, Connecticut, waiting for his back-up band to finish their warm-up set, before bringing him on stage. His tie and socks leave little doubt about the instrument he will play in just a few minutes.

KONSTANTINOS PILARINOS

Astoria, Queens, New York | 2000

I like people to see my work. I enjoy contributing to the Greek community so that they can see what they have left behind.

Orphaned at the age of thirteen, Konstantinos Pilarinos was sent to a foster home in Piraeus, where, at fifteen, due to an interest in woodcarving, he apprenticed to master woodworkers. Within three years he had his own woodworking shop. In 1974 he came to New York City, where he has continued to carve religious screens, pulpits, and thrones for Orthodox churches in the Byzantine style. Today he estimates that there are fewer than a dozen master carvers in the world who still work in this intricate tradition. One of his *iconostasia* (icon screens), at fifty-six feet long, is said to be the largest of its kind in the Americas.

Konstantinos Pilarinos maintains a workshop, called the Byzantion Woodworking Company, in the Greek neighborhood of Astoria, Queens. There, he works with apprentices and with his daughter Penny, an architect, to design and execute large-scale pieces. A collection of chisels is arrayed on his workbench, while he holds a chisel and mallet in his hands. Behind him can be seen some of the icons that are both the purpose and the inspiration for his work. He says, "The talent comes from religion. So you need to know your religion well in order to become a master of woodcarving. Religion and woodworking come hand in hand, because I tell religious stories through my work."

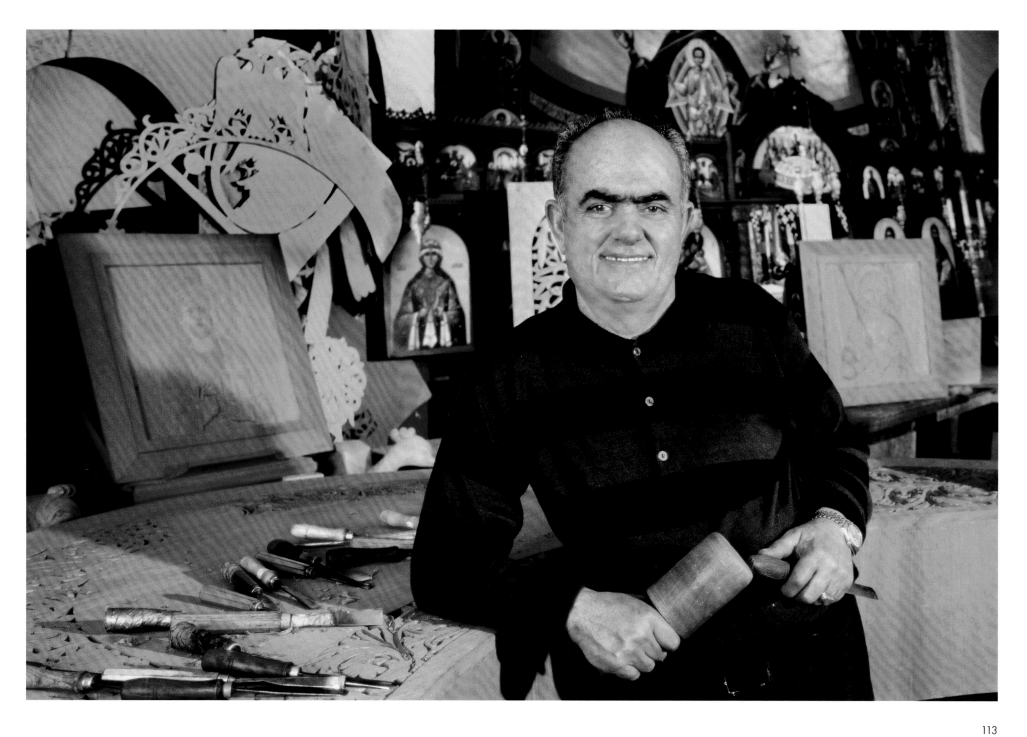

EVALENA HENRY

Peridot, Arizona | 2001

I learned it from my mother. It was very difficult at first to learn how to split the willow. But I wanted to learn so badly. I love baskets.

The San Carlos Apache have become widely known for their basketmaking skills. At the age of fifteen Evalena Henry began weaving baskets, learning from her mother, a master who continued to weave until she was eighty-nine. Evalena's specialty became the burden basket, a large and attractive ceremonial container used in the Sunrise Dance, a coming-of-age ceremony for Apache girls. Burden baskets have intricate designs, sometimes with the girl's name woven in, and must be tightly woven to maintain their shape and bear the weight of the sacred objects placed in them for the ceremony.

When Tom Pich traveled to the San Carlos Reservation to photograph Evalena Henry he met Seth Pilsk, an ethnobotanist working with the tribe to inventory plant life on their lands. Pilsk suggested that he knew the perfect spot for a photograph, and the following day, Tom, Seth, Evalena, and several women who were tribal elders piled into a jeep and drove to a valley on the reservation. There they found an expanse of yellow poppies, estimated at over a million, blooming for the first time in over a dozen years, thanks to the previous winter's snowmelt. The phenomenon lasts for just a few days. After this visit, Pich returned to the reservation several times to help the tribe with a photo-documentation project, completing portraits of all of the San Carlos elders.

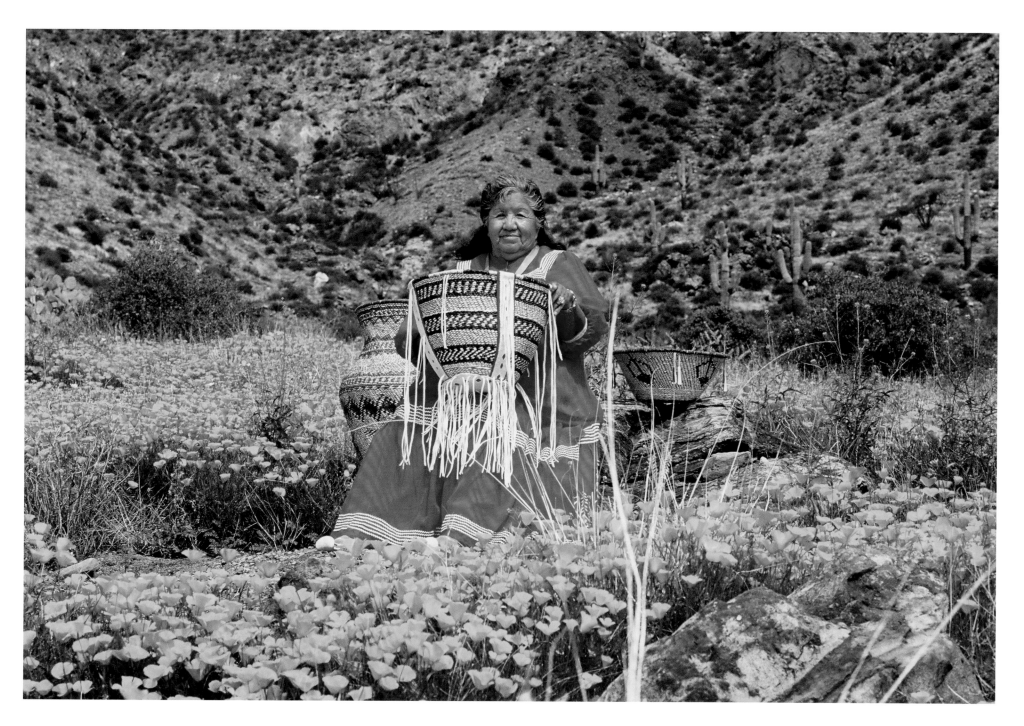

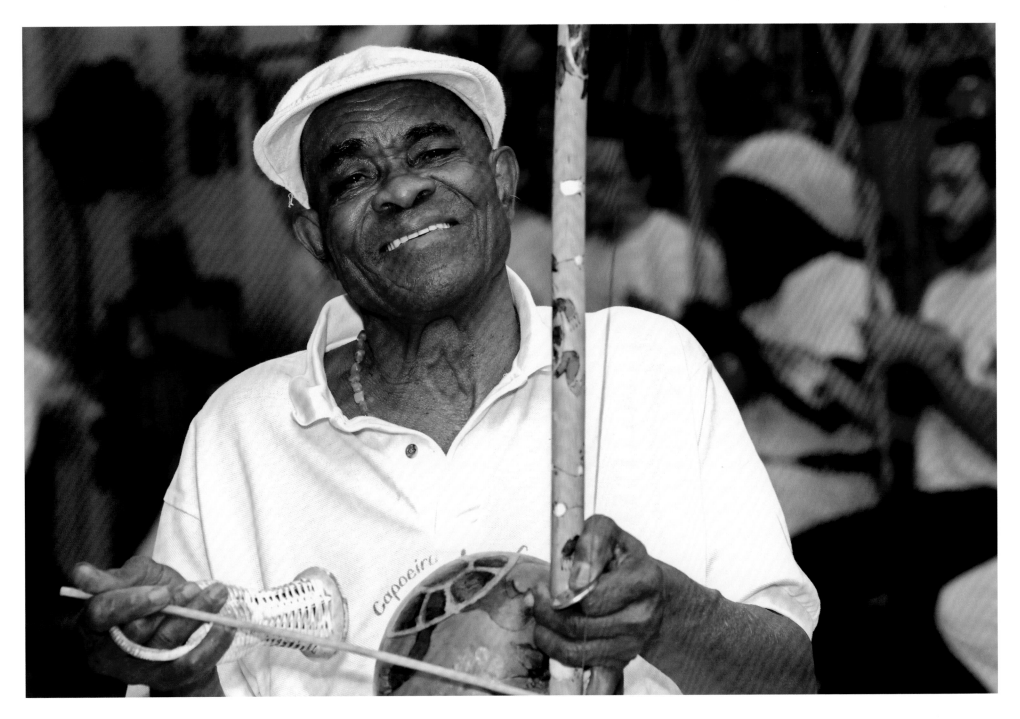

JOÃO OLIVEIRA DOS SANTOS

(João Grande)

New York, New York | 2001

Capoeira is an art, a dance, a profession, and a culture. A capoeirista is a dancer, a poet, and a philosopher. It brings nothing but good for people's body and spirit.

Mestre João Grande is one of only a handful of grand masters of capoeira in the world. Born in the Bahia state of Brazil, he studied with Mestre Pastinha, who had a famous Capoeira Academy in Salvador, known as the birthplace of this Afro-Brazilian form of martial arts that includes music, acrobatics, ritual, and belief. Because he was referred to Pastinha by another player of capoeira named João Pequeno (Little John) he was given the name João Grande (Big John). Capoeira Angola is usually performed or played by two individuals who maneuver in the center of a circle (roda) of musicians who sing and play the berimbau (a bowlike instrument with one string). Today, João Grande runs an academy in New York City, where he has taught thousands of students the philosophical and physical knowledge that constitutes the art of capoeira.

This portrait was taken during one of João Grande's sessions with a group of fellow capoeiristas and students. He holds the berimbau in his lap, while in his left hand is a dobrão, a small coin that is moved up and down on the string to change its pitch. In his right hand are the baqueta, a stick used to strike the string, and a caxixi, a small rattle that accompanies the berimbau.

PETER KYVELOS

Bedford, Massachusetts | 2001

The most exciting thing, of course, is when you've created an instrument and strung it up and it goes into the hands of a professional, and then you see that professional sitting up on a stage playing your instrument. There's a certain amount of pride that you get; nobody has to say anything—I don't even want people asking whether I made it—that's not it. What matters is between me, the instrument, and the person playing.

Armenian musician and National Heritage Fellow Richard Hagopian has called Peter Kyvelos the Stradivarius of oud makers. Kyvelos, born of an immigrant father and first-generation Greek mother, became interested in the oud, a lute-like instrument, when he first heard it played on his father's 78 rpm recordings of Greek music. During his college years he performed on the oud, but his real passion was learning how to make the instrument, and he began working part time in a violin maker's shop. When he returned to Massachusetts, he set up his own shop not far from the Watertown area known as "Little Armenia." Kyvelos was recognized across the United States for the making and repair of ouds and other stringed instruments.

Peter Kyvelos is seen in his shop, Unique Strings, standing behind one of his finished ouds. Behind him are instruments in various stages of production or repair. Kyvelos points out that although his passion is making ouds, the reality is that to earn a living you have to repair the variety of stringed instruments that might be brought through the door. He estimates that each oud requires about 125 hours to make, which amounts to about $7 an hour for his labor.

QI SHU FANG

Woodhaven, New York | 2001

I was very fortunate in China because I was first and foremost an artist. Artists were given privileges and opportunities other people did not have. I was actually appreciated by the government for my work. We were like ambassadors of the culture, sending a good message around the country.

Qi Shu Fang began to study Beijing Opera at the age of four and continued her pursuits at the Shanghai Dramatic School. Beijing Opera, a form of musical theater that incorporates song, drama, martial arts, and exuberant acrobatics, had traditionally been performed solely by males, but after 1949 women began to assume roles, and Ms. Qi was central to that evolution. At the age of eighteen, she was picked by Chairman Mao's wife, Jiang Qing, to play the female lead in the opera *Capturing Tiger Mountain*. She became a star and appeared in numerous operas and films of performances after that time—eventually being awarded the title "National Treasure of China." In 1988 she relocated to New York and founded the Qi Shu Fang Opera Company, which has appeared in performance at Lincoln Center in New York and at the Kennedy Center in Washington, DC.

One of a few "in performance" shots, this portrait was made after a costume rehearsal in Fairfield, Connecticut. Featuring Ms. Qi in full dress and makeup and using stage lighting and supplemental flash, the photograph captures the elaborate costuming as well as the dynamic movement and distinct facial expression that characterizes Beijing Opera. Skilled as both a singer and an athlete, Qi Shu Fang is able to play the role of the wu-dan, martial arts woman, even after nearly sixty years of performance on stage.

SEIICHI TANAKA

San Francisco, California | 2001

Students call me "master," but I feel like I am always a student. . . . You always have to keep learning taiko until it is in you.

Seiichi Tanaka founded the first taiko dojo (taiko school) in North America in 1968. He attended the 1967 Cherry Blossom Festival in San Francisco's Japantown and was amazed to see that there was no taiko drumming. The son of a professional baseball player who also had an athletic bent, he returned to Japan to study with masters of taiko. He came back to San Francisco a year later to perform at the annual festival and to found the San Francisco Taiko Dojo. Taiko is a form of ritual drumming that incorporates meditation, philosophy, martial arts, and choreography. Performance on the barrel-shaped drums of many sizes is accompanied by vigorous movement, shouts, and the playing of woodwinds such as the shakuhachi. Today taiko has become attractive to audiences as a form of performance.

It requires discipline, intense study, and commitment from the thousands of students Tanaka has trained. There are more than two hundred taiko groups in the United States today, most owing their existence to the efforts of Seiichi Tanaka.

Seiichi Tanaka stands in front of the array of drums used in taiko performance. He is holding the bachi, or sticks, used to strike the drums. Over his right shoulder is the Odaiko, a large drum that can be up to twelve feet high and weigh over 700 pounds. It is very difficult to stretch the cow skins tightly enough over these huge drums, made of a hollowed-out trunk of a tree. Tanaka innovated the idea of using car jacks to accomplish this feat.

FLORY JAGODA

Alexandria, Virginia | 2002

I miss the Sephardic people. They saw life different. First of all, they had to run. That was always repeated at home, "you don't know how good you have it now, you should know what our ancestors did," you know, that type of thing.

Born in Sarajevo, Bosnia, Flory Jagoda learned songs from her grandmother, or "nona" as she calls her, who knew the musical traditions passed down through their Sephardic Jewish family. Sephardic Jews, sometimes referred to as Ladinos, settled in the Baltic region after they were forced into exile from Spain and Portugal in the fifteenth century. When Flory was seventeen, her father, becoming aware of the impending danger to Jewish residents, told Flory she had to flee. He gave her a forged train ticket, with a non-Jewish name, and her accordion. Flory says that she played the accordion to allay her fears, and the conductor on the train never even asked her for her ticket. Later she was to learn that forty-two of her family members were killed, including her beloved grandmother. While living in a relocation camp in Italy she met an army officer, whom

she married in 1946, and they moved to northern Virginia. To honor her "nona" Flory has made it her life's mission to preserve the songs, music, and language of her Ladino family.

In her living room, Flory Jagoda is surrounded by instruments connected with her musical heritage. Most important, however, is the accordion resting on the piano bench, for it is the instrument that allowed her to escape from the Holocaust and serves as a material and musical reminder of the family members left behind. In 2014 the Virginia Foundation for the Humanities provided money so that this eighty-year-old accordion that had not been playable for fifty years could again make the music of her youth.

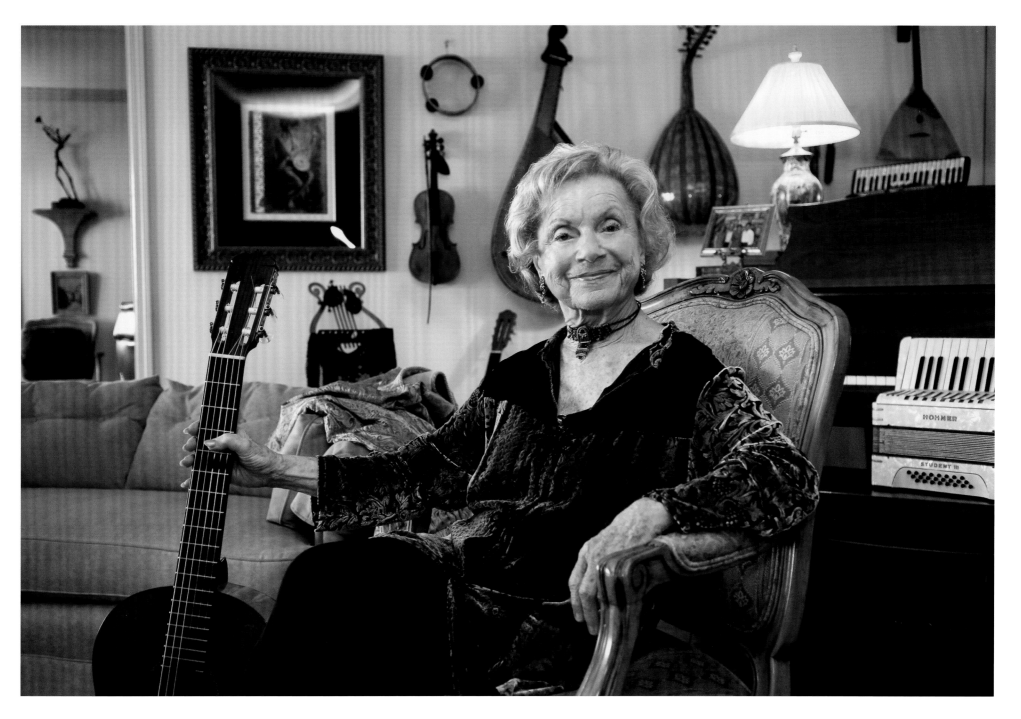

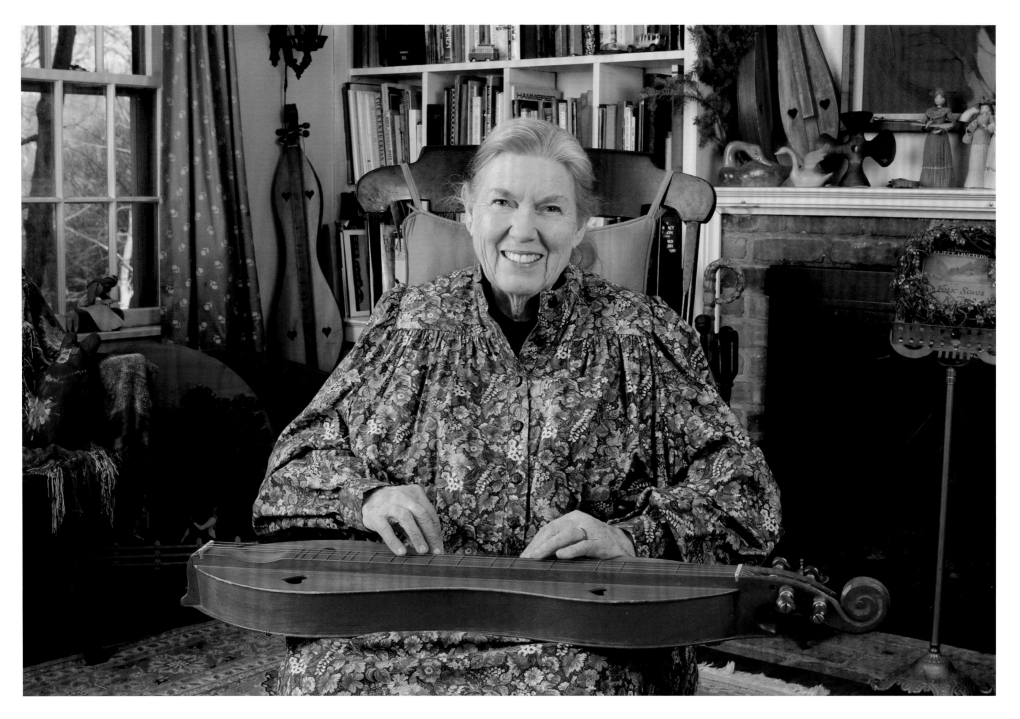

JEAN RITCHIE

Port Washington, New York/
Viper, Kentucky | 2002

I like being just an ordinary person. One of the good things about being ordinary is I never felt that if I don't do something and keep my name before the public and sing every week somewhere, people are going to forget me.

Jean Ritchie grew up in Viper, Kentucky, a coal-mining community in the Cumberland Mountains. Her family sang ballads, play-party (singing game) songs, and religious hymns, accompanying themselves with a variety of stringed instruments, including the banjo, guitar, dulcimer, and fiddle. Although there were limited resources for Ritchie, the youngest of fourteen children, she was able to go to the University of Kentucky, where she graduated Phi Beta Kappa with a degree in social work. Eventually this led her to New York, where she worked at the Henry Street Settlement. There Ritchie connected with the nascent folk revival thanks to meeting Alan Lomax, who encouraged her to perform publicly and to write a book about her life and songs. In 1955 she published *The Singing Family of the Cumberlands* and, through appearances at such events as the Newport Folk Festival, she reached a broader audience for her music. Bob Dylan used the melody from her performance of "Nottamun Town" for his song "Masters of War." Her renditions of ballads, use of the dulcimer as an accompanying instrument, and original compositions of socially conscious songs such as "Blue Diamond Mines" and "Black Waters," referencing the coalmining heritage of Eastern Kentucky, have had a lasting impact on American folksong.

In Jean Ritchie's portrait taken in her Long Island home she holds one of her mountain dulcimers, the instrument that she is credited with popularizing during the folk revival of the 1960s. Although her father, Balis, taught her to play the dulcimer in her youth, this instrument does not play a prominent role in her 1955 family reminiscence. Only later in life, after she had moved to New York and married photographer and filmmaker George Pickow, who made her a dulcimer as a gift, did it become a significant feature of her performances.

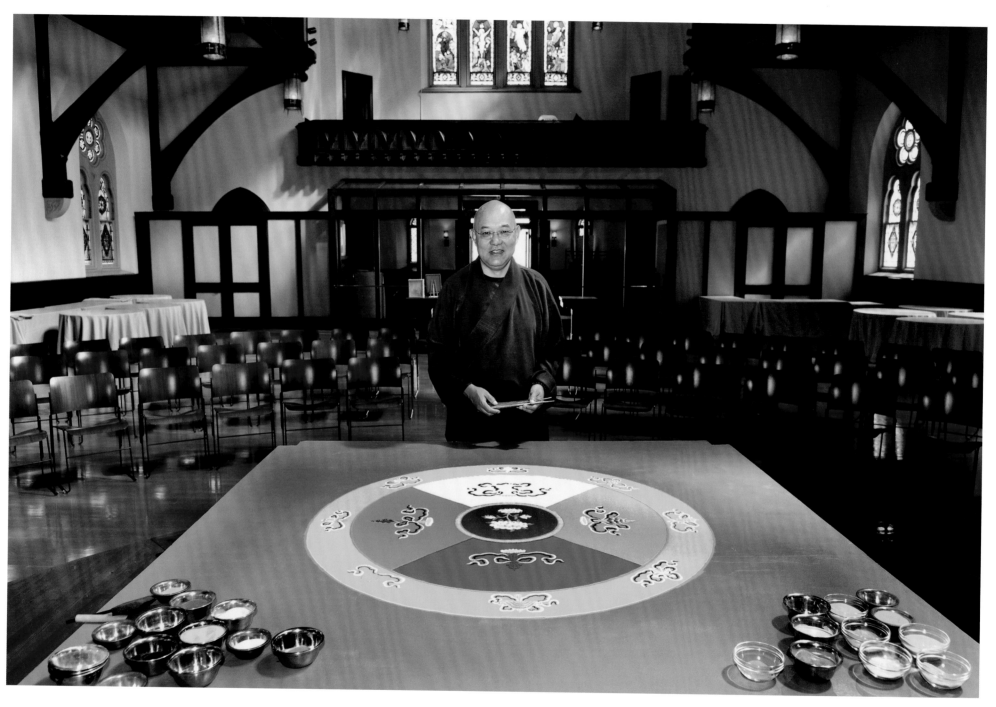

LOSANG SAMTEN

Philadelphia, Pennsylvania | 2002

First and foremost these mandalas are a form of communication through art. They tell stories that have meaning for Tibetans and other Buddhists, and for humanity in general. The witnessing of patience in the creative process helps observers find patience and perseverance within themselves. They also see how each tiny piece matters in the interconnectedness of life. These are important lessons for the next generation, whether Tibetan or not.

Born in Tibet, Losang Samten escaped from the persecution of the People's Liberation Army with his family as a youth, eventually joining exiles in Dharamsala, India. Venerable Lama Losang attended the Tibetan Institute of Performing Arts and later entered the Namgyal Monastery of the Dalai Lama, where he studied mandala painting. Monks and artists who train in creating sand mandalas have to memorize five hundred pages of sacred text and learn the chants and rituals associated with the practice. In 1988 he was instructed by the Dalai Lama to come to the United States to teach this art form, and today he is a spiritual adviser to a number of Buddhist Centers across the United States. He also teaches at a charter school administered by the Philadelphia Folklore Project and shares his skills and philosophy with students near and far. It is thought that there are now fewer than thirty monks who are trained to construct mandalas and qualified to teach the process.

Losang Samten's portrait was taken as he stands behind a mandala that he has created for a ceremony that will take place the following day. The location is a former Catholic Church in Philadelphia that is now used by the local Buddhist community. As is the custom, this intricate sand painting that took hours to complete was dismantled as part of the ritual the next day. Attendees took the sand to the river, where it was dispersed in the flowing water, reflecting the ephemeral nature of life.

NADIM DLAIKAN

Southgate, Michigan | 2002

I love this instrument. I feel like it's a part of my body. I feel very good. With any instrument, not just the flute, if you didn't love it you're not going to make a very good sound. You have to hug it tight to make a good sound.

Nadim Dlaikan, who grew up in Lebanon, was discouraged from playing the nye, an end-blown reed flute, because the instrument was associated with lowly shepherds. In spite of that, he went on to study at the Lebanese Conservatory with the country's premier flute player. After moving to Beirut, Dlaikan traveled throughout the Middle East as part of a folk troupe. In 1969 he performed at a Fourth of July party at the United States Embassy, and this led to an invitation to play elsewhere in the United States. A few years later he came and settled in the Detroit area, home to the largest Arab community in the nation. He is much sought after for performances at celebrations across the region, often appearing with ensembles that

reflect the diversity of the Arab population. In addition, he is known for using the reeds that he grows in his backyard to make flutes played by performers of Middle Eastern music.

Nadim Dlaikan is shown in his living room in Southgate, Michigan, cradling his handmade flute in his hands. The instrument is played by blowing across, rather than directly into, the end of the flute. He brought the bamboo that he uses for his flutes from California, expressing surprise that it survives in Michigan. Dlaikan points out that it is essential, when he makes a flute, to ensure that the placement of the holes is correct, or the instrument will be sold in a curio shop instead of played on stage.

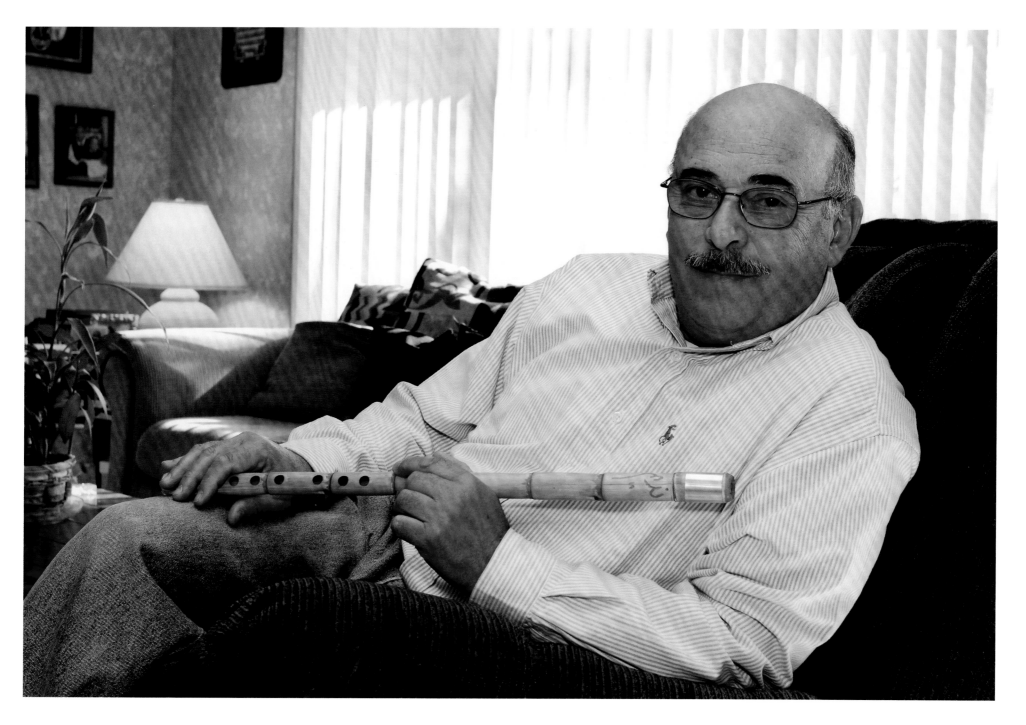

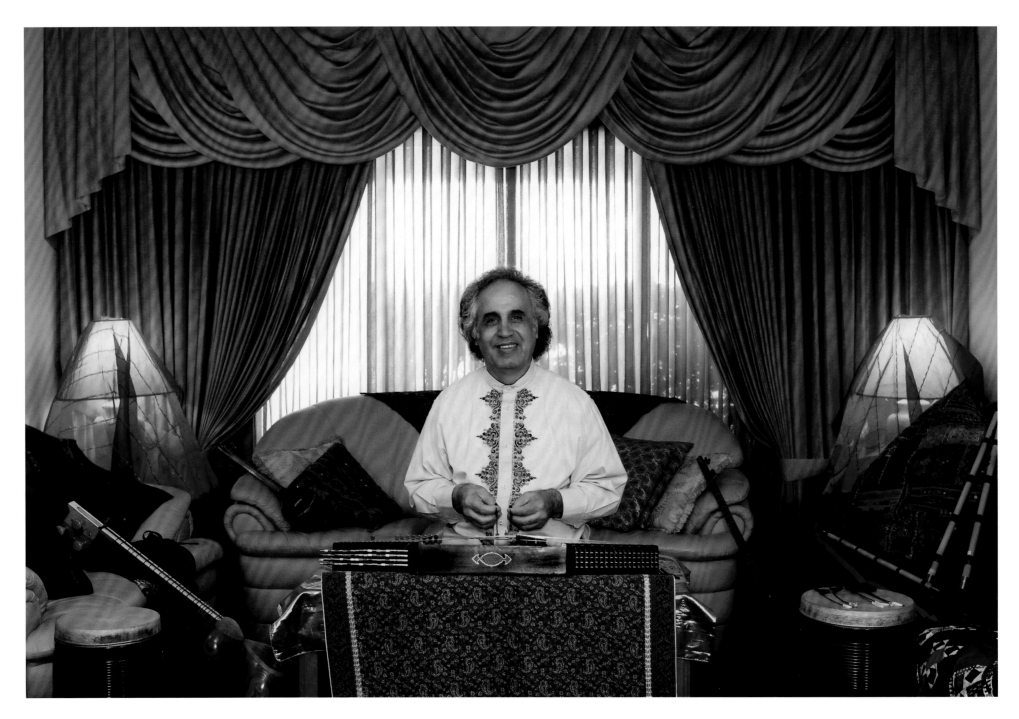

MANOOCHEHR SADEGHI

Sherman Oaks, California | 2003

My art comes from such an intense, traditional long-term art that you can't change it overnight. It's a classical system. While Western classical system has evolved for the last three hundred years, our music has evolved for one thousand years. So I did not have to change it. I just had to present it right.

Born in Tehran, Iran, Manoochehr Sadeghi was attracted at an early age to the santur, a Persian instrument that resembles the hammered dulcimer. He became the star pupil of master Persian classical musician Abol Hassan Saba. By the time Sadeghi was twenty he was serving as a faculty member at the Conservatory of Persian National Music. In 1964 he came to Los Angeles, where he assumed a central role in the large Iranian cultural community. He also has taught in UCLA's Department of Ethnomusicology and maintains a career as a composer and performer of traditional Persian music. In addition, he has collaborated with jazz and classical artists in live performance and on recordings.

The plush curtains in Sadeghi's living room might just as well be found framing a concert stage. Befitting an ethnomusicologist, Sadeghi is shown with a wide variety of Persian instruments, enough to form a musical ensemble. Seen in the portrait are drums, flutes, the tar (waisted fretted instrument), satar (long-necked fretted instrument), and kamancheh (bowed lap violin). Resting on the table in front of him is his preferred instrument, the 72-string santur.

NICHOLAS TOTH

Tarpon Springs, Florida | 2003

My art is a vehicle that is used to transport the viewer back to a time when the dominant metals were copper and brass. When someone looks at my diving helmet, I want them to experience a sense of elegance in its form, while also feeling a sense of curiosity as to who wore these helmets, and why.

In the 1880s the sponge industry was introduced in the city of Tarpon Springs, but not until 1905 did sponge diving become the favored technique for harvesting the product. Settlers from the Greek Islands, where sponge diving is common, soon immigrated to the city. Nicholas Toth's grandfather, Antonios Lerios, who was born on the Dodecanese island of Kalymnos, came to Florida in 1913 and established a reputation as an innovative craftsman of maritime hardware. He designed a one-piece diving helmet made of spun copper that became the preferred gear for Tarpon Springs' divers. Nicholas apprenticed himself to his grandfather, and, although he had studied political science at the University of Florida, he eventually decided to follow in his grandfather's footsteps. He continues to innovate and produce helmets of useful beauty.

While natural sponges are still harvested in the waters near Tarpon Springs, today the tourism industry related to sponge diving has become a more lucrative income producer for residents. Visitors are taken out in boats to witness sponge divers in action, although this is actually a reenactment of the process. In the same vein, today Nicholas Toth's diving helmets are more frequently produced to be viewed in museum displays rather than on the decks of sponge boats. What has not changed very much is the workshop where Toth constructs diving helmets, using tools and techniques his grandfather would find familiar.

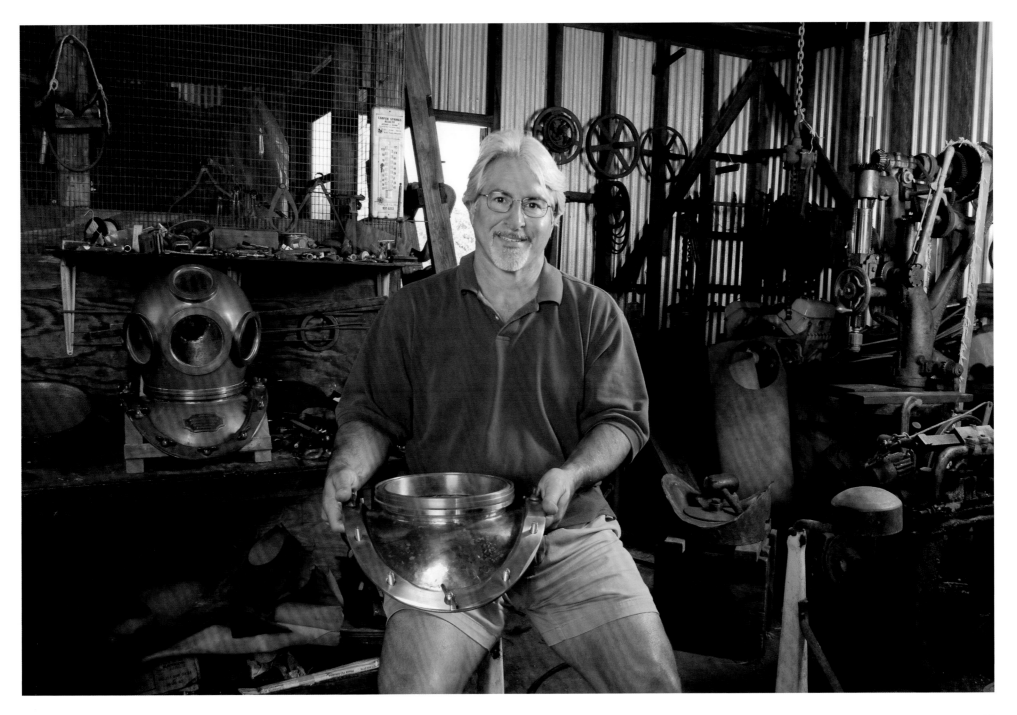

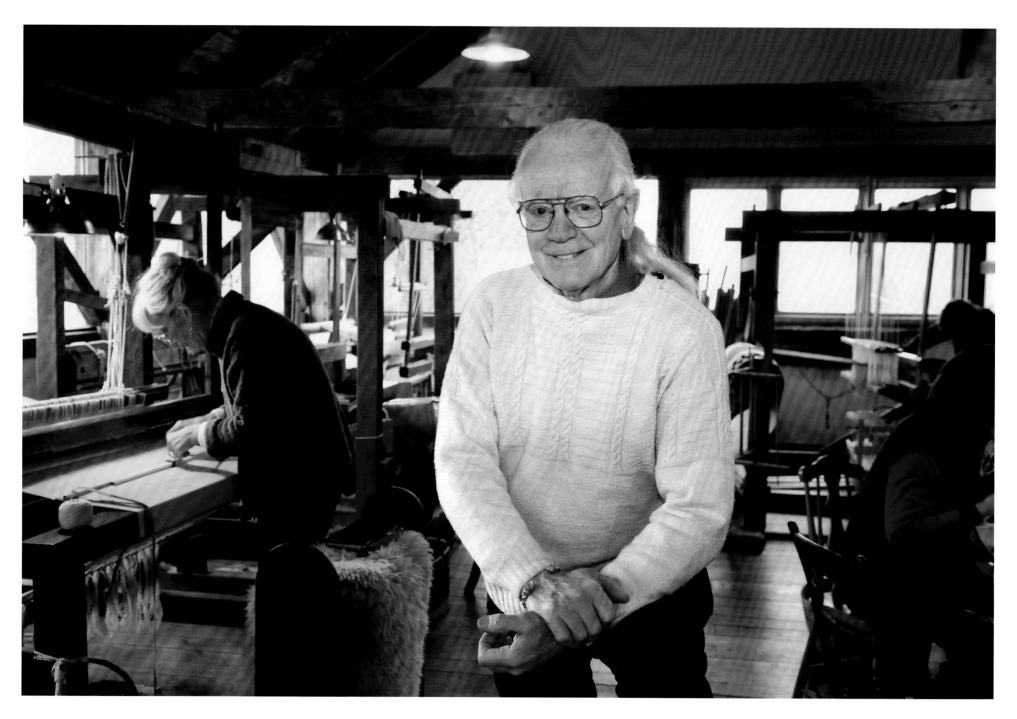

NORMAN
KENNEDY

Marshfield, Vermont | 2003

This style of weaving is from generations past when people were much closer to the truths about what life's about. Too many people weaving nowadays are totally late twentieth century. Folks get really excited about computerized looms and things like that, but I think those who are fascinated by machinery are giving their responsibility to the machine. I'm interested in seeing what people are doing, but much of the new stuff has no taste; it's like bread without salt. The old stuff is salty and tasty.

When Norman Kennedy came to the United States in 1965 to perform at the Newport Folk Festival on a program entitled "Origins of the American Ballad Tradition," he came not only with a wealth of songs passed down from his Scottish family members, but also with weaving skills that he had learned from his travels to the Outer Hebrides islands. A year later, Ralph Rinzler, the director of the Smithsonian Institution's Festival of American Folklife, asked Kennedy to help document traditional crafts in the United States. He eventually ended up in residence as the master weaver at Colonial Williamsburg. In 1974 he founded the Marshfield School of Weaving in Vermont, where he offers lessons in the crafting of traditional textiles, including shearing, carding, spinning, and weaving. Sometimes he also has a group of students participate in the old method of waulking (shrinking) the cloth, teaching them the songs that they must sing to keep a constant and synchronized rhythm in passing and pounding the wet woven material. Those fortunate enough to study with Kennedy also are often able to hear the ancestral ballads and stories he first shared more than five decades ago.

Norman Kennedy is seen standing amid the looms in his rural Vermont weaving school, located in a nineteenth-century barn and containing looms, some of which date from the same era. Behind him some of the local weavers work on their textiles. The school states as its three principles tradition, integrity, and ingenuity.

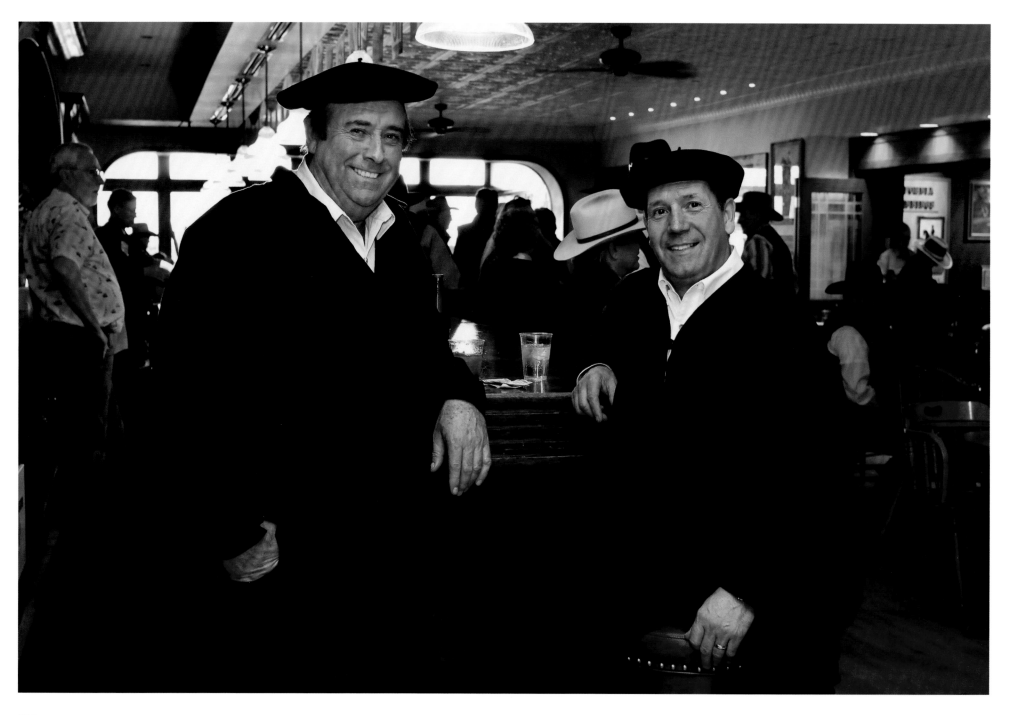

BASQUE POETS

(Bertsolari) Martin Goicoechea and Jesus Goni

Rock Springs, Wyoming, and
Reno, Nevada | 2003

Once you know what you're going to sing about, your preparation is like walking backwards. You find the punchline that you're going to end with, and you find that rhyme. Then you find other rhymes to match it, and you start singing.
—Martin Goicoechea

It is not surprising that language plays a significant role in Basque identity, as many Basques refer to themselves as Euskaldunak, or "speakers of Basque." Basques who came to the western United States to herd sheep brought their language, foodways, music, and dance. Sheepherders often entertained themselves through improvisational poetry (bertsolaritza) featuring two or more competitors who sing rhyming stanzas based on assigned topics related to life or current events. Encouraged or even prompted by their audience, the subjects could be lost love, lost wages, or lost sheep. Martin Goicoechea and Jesus Goni, as well as Jesus Arriada and Johnny Curutchet, who also received the 2003 Heritage Fellowship, maintain this oral tradition and perform at Basque festivals throughout the West.

While at the Cowboy Poetry Gathering in Elko, Nevada, Tom Pich was able to shoot a portrait of two of the four Basque poets. Typical of many of the Basques who came to the West, the career paths of Goicoechea and Goni have taken them away from the campfires of the open range. For instance, Goicoechea went from tending over 8,000 sheep to herding vehicles on the lot of his car dealership in Rock Springs, Wyoming. One common denominator for both cowboys and sheepherders is the time spent in conversation and verbal competition when given the opportunity to socialize. In this case, the scene is not a campfire, but the Pioneer Bar located in the old Pioneer Hotel in Elko, also home of the Western Folklife Center. Behind them is the forty-foot Brunswick back bar, dating from 1890 and made of cherry and mahogany inlaid with mother-of-pearl. The Brunswick Company, a maker of billiard tables since 1845, sold one of its products to pool aficionado Abraham Lincoln in 1850.

JERRY DOUGLAS

Nashville, Tennessee | 2004

I try to think like a singer, to accent lyrics and places where the singer is trying to get a point across and make something more clear. I feel like I'm framing them a little bit, and I try not to get in the way.

Jerry Douglas has performed on more than 1,600 albums since he first took the stage as a teenager. Starting out playing guitar with his father, a steelworker in Warren, Ohio, he took up the Dobro (resonator guitar) after hearing Josh Graves play with Flatt and Scruggs and the Foggy Mountain Boys. Just out of high school, Douglas went to Washington, DC, and was recruited to play with the influential band, the Country Gentlemen. Although bluegrass bands have often treated the Dobro as a backup instrument, Douglas's sensitive ear and broad musical vocabulary have foregrounded his skills both on stage and in the studio. He has been a fixture in bands such as Alison Krauss and Union Station and, more recently, was the founding member of the Flatt and Scruggs tribute band the Earls of Leicester.

Since 1995 Douglas has been involved in the production of *Transatlantic Sessions*, an acclaimed series of musical collaborations for television that is based in Scotland and features musicians from Scotland, Ireland, England, and North America.

While the recording studio is a collaborative space for musical arrangement, for this photograph Douglas's studio became a setting for visual arrangement. The room was cleared, a number of instruments were brought in, and some of the empty wall space was filled with pictures and posters. After Pich finished making the portrait, he asked if he could move things back to their original places and Douglas replied, "No, this is the best this place has looked in a long time."

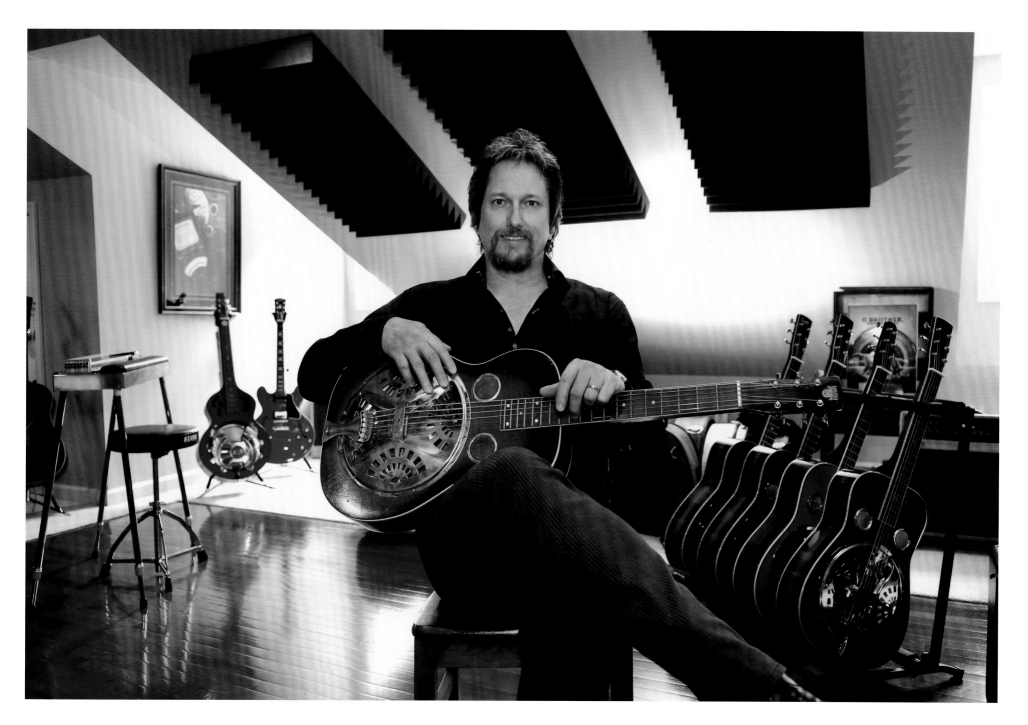

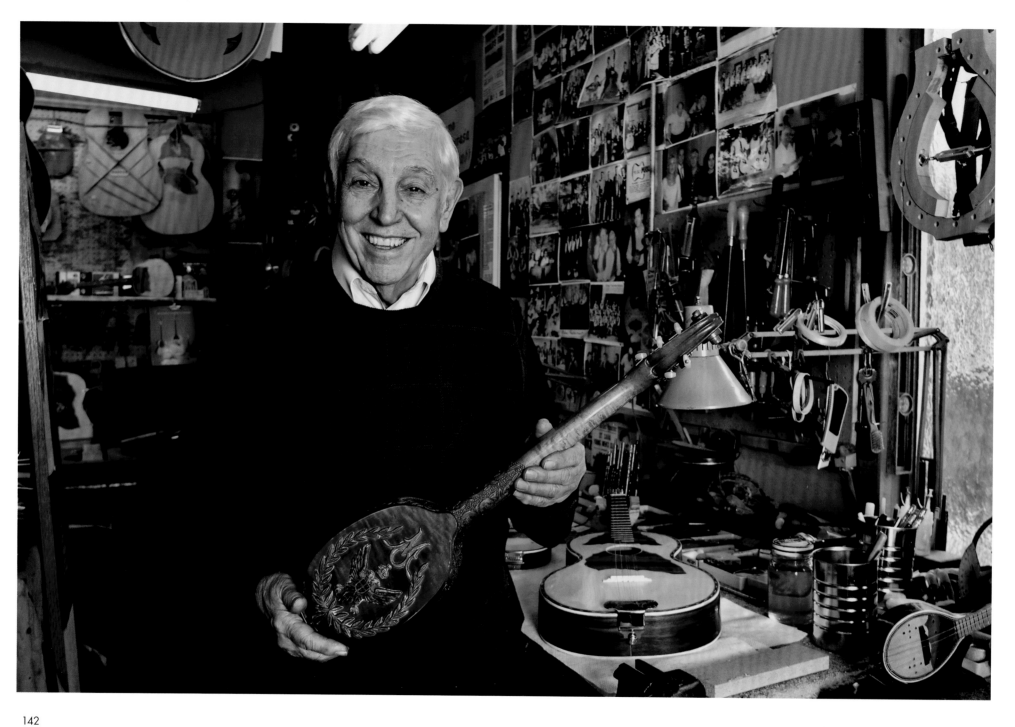

MILAN OPACICH

Schererville, Indiana | 2004

I continue to use the best wood I can obtain—the traditional inlays, the tedious purfling binding, nickel frets, ebony fret boards, mother-of-pearl inlays, superior finishes, and custom-made cases. I do not sacrifice quality or tradition.

Milan Opacich grew up in the Calumet region of Indiana, the son of a Croatian mother and Serbian father. His mother was not able to worship with the Croatian Catholics because she married a Serbian, and the Serbian Orthodox Church would not accept his mother because she was Croatian. At the age of four Milan expressed an interest in music and his father made him an instrument of plywood and rubber bands. Playing country music in the early stages of his teenage years, by the time he was eighteen he renewed an interest in tamburitza, a form of music rooted in Serbia and Croatia, and performed on a variety of string instruments. Because there were few tamburitza instrument makers in the United States at that time, he used his tool and die making skills to perfect his creations. Soon he was sought out by musicians across the country for attractive and, more importantly, easily played and accurately voiced instruments. Reflecting the breadth of respect for his work, both the Renwick Gallery of the Smithsonian Institution and the Roy Acuff Museum have displayed his instruments.

As Tom Pich describes it, in order to get the essence of the experience of visiting the workshop of Milan Opacich, one needs to imagine the smell of wood stains and finishes that permeate the room. Opacich holds a prim, the soprano stringed instrument used in performing the lead melody in tamburitza music. He has turned the instrument to show its back, where he has carved his initials along with an image of the two-headed eagle, a symbol used in Serbian heraldry. Pictures and clippings on his wall illustrate the numerous musicians and acquaintances who value both his instruments and his friendship and demonstrate the success that he had in bridging the gap between the Serbian and Croatian communities in the United States.

YUQIN WANG and ZHENGLI XU

Tigard, Oregon | 2004

To perform with grace is one thing but for the puppet to dance with grace, when it is actually your own energy transferred into the puppet, this is the highest stage.

Prior to coming to the United States in 1996, Yuqin Wang and Zhengli Xu served as puppeteers with the Beijing Puppet Theater. Xu was known for his construction of puppets and as a creator of new stories, while Wang, previously trained at the Beijing Opera School, was lauded as a performer. Their specialty, presenting theatrical pieces incorporating human figures and animals mounted on rods, has a history that dates at least to the Han Dynasty in China. Upon arriving in Oregon, the pair founded their own puppetry troupe, Dragon Arts Studio, and within a year received an invitation to perform at the Atlanta Summer Olympics. Working with their daughter, Brenda, they have performed for thousands of schoolchildren in the Portland area and brought this unique tradition to festival audiences throughout the nation.

Holding two of their rod puppets, Yuqin Wang and Zhengli Xu pose in front of the Tower of Cosmic Reflections in the Lan Su Garden. A teahouse within the tower is considered to be one of the largest in the United States and was constructed in 1999 by more than sixty-five artisans from Suzou, China, the sister city of Portland. The Dragon Arts Studio featured a small shop selling items from China and was situated just across the street from this Chinese garden and the Tower of Reflections.

CHUCK BROWN

Brandywine, Maryland, and
Washington, DC | 2005

If you play music and put the right kind of feel behind it—the kids will dance to it and then begin to listen . . . listen to the lyrics and it tells a story. All the old classic songs . . . can be used in terms of the go-go feel. You keep the kids busy, keep their minds out of the fire, they don't have no reason to get into the negative thing that people have been talking about.

Widely recognized as the "Godfather of Go-Go," Chuck Brown turned a mix of Latin beats, African American call and response lyrics, soul music, and jazz into a unique musical style now identified with Washington, DC. Brown formed a group named the Soul Searchers, and in 1971 they recorded "We the People," incorporating the sound that came to be known as Go-Go. In 1978 an album titled *Bustin' Loose*, with a single of the same name, became a number one seller and exposed the musical style to a national audience. Still largely a regional phenomenon, today Go-Go can be heard in the clubs of the District of Columbia and also on the street corners, as bucket drummers play the loping rhythms and improvised riffs using the syncopation and vocal styling that Brown pioneered more than forty-five years ago. After Brown died in 2012 at the age of seventy-five, local authorities designated a local park as Chuck Brown Memorial Park, and every year on Chuck Brown Day (his birthday) a musical celebration is held there.

Chuck Brown suggested that Tom Pich take his photograph at the Ebony Inn, a bar connected to the earliest years of his musical career. As Brown described it, he started working there in his early teens, first doing odd jobs and being paid with a place to sleep upstairs and some food to eat. Later he earned food and drink as he began to perform, and finally as his career took off he graduated to receiving food, drink, and cash. Arriving at the site, Brown and Pich saw that the club was closed and without electricity. Someone found a key, and Brown's presence soon attracted a crowd. Workmen who happened to be nearby strung some wires and a couple of lights into the building. As a result, Pich was able to adjust the lights well enough to reveal murals, featuring many prominent African American artistic icons, in the background. Brown is holding a Paul Reed Smith guitar, a prized guitar first brought to wider public attention by Carlos Santana, and made on the Eastern Shore of Maryland.

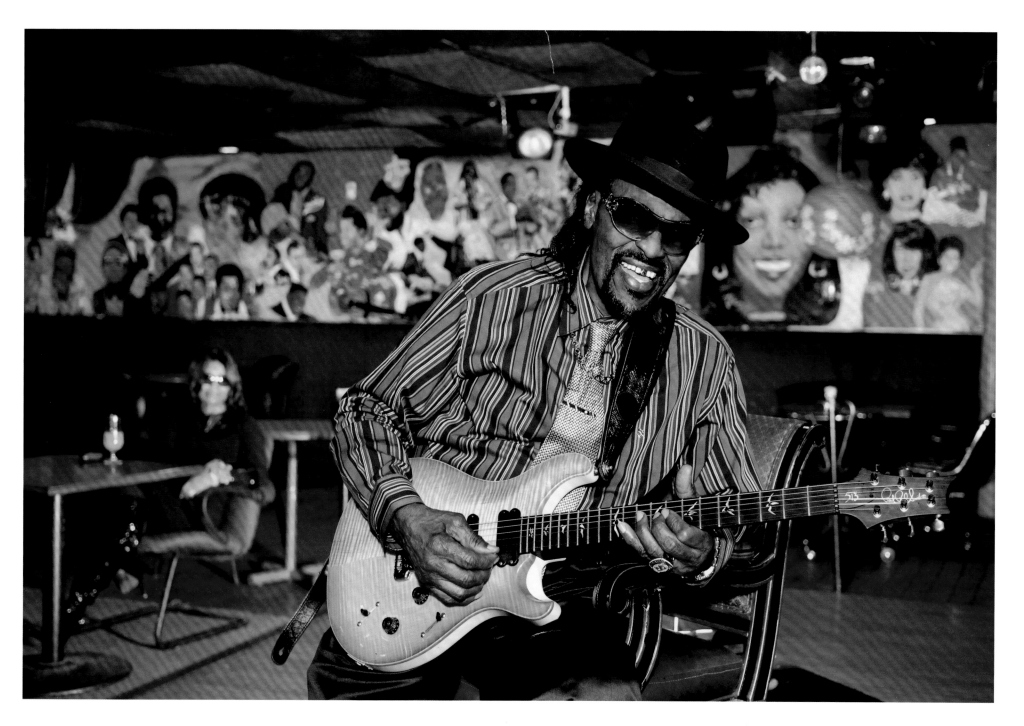

ELDRID SKJOLD ARNTZEN

Watertown, Connecticut | 2005

You need to have a lot of brush control. And the detail work—the line work— is very, very important. That's the icing on the cake. If that's not done well then you could almost say all is lost.

Rosemaling, a decorative technique involving painting on wooden utilitarian objects and furnishings, came to the United States with Scandinavian immigrants in the nineteenth century. Eldrid Arntzen, the daughter of immigrants, grew up in the Bay Ridge area of Brooklyn, home to a large Norwegian population. She started painting at the age of ten, but in her youth she was more interested in portraying conventional subjects, such as still life and landscapes. After seeing postcards of rosemaling from the Vesterheim Museum in Decorah, Iowa, she began to pursue this form of painting. Lessons from teachers in the Midwest and trips back to Norway to study resulted in her mastery of the multiple regional styles and techniques. In 1987 she received the Gold Medal in Rosemaling from the Vesterheim Museum, and in 1996 her work was featured in an exhibition, *Norwegian Folk Art: Migration of a Tradition*, that toured the United States and Norway.

Eldrid Arntzen has pointed out that rosemaling originally provided a way for poor people in Norway to decorate the interiors of their homes, embellishing rather plain handmade objects with pigments made from natural materials found on the farm. From her dress to her furniture, the blue drapes and the china, her home reflects Norwegian heritage. Decorative motifs include the two main regional painting techniques that she uses: Telemark, a lyrical style that features fanciful flowers and is generally not symmetrical, and Hallingdal, a brighter, bolder painting style that is usually symmetrical.

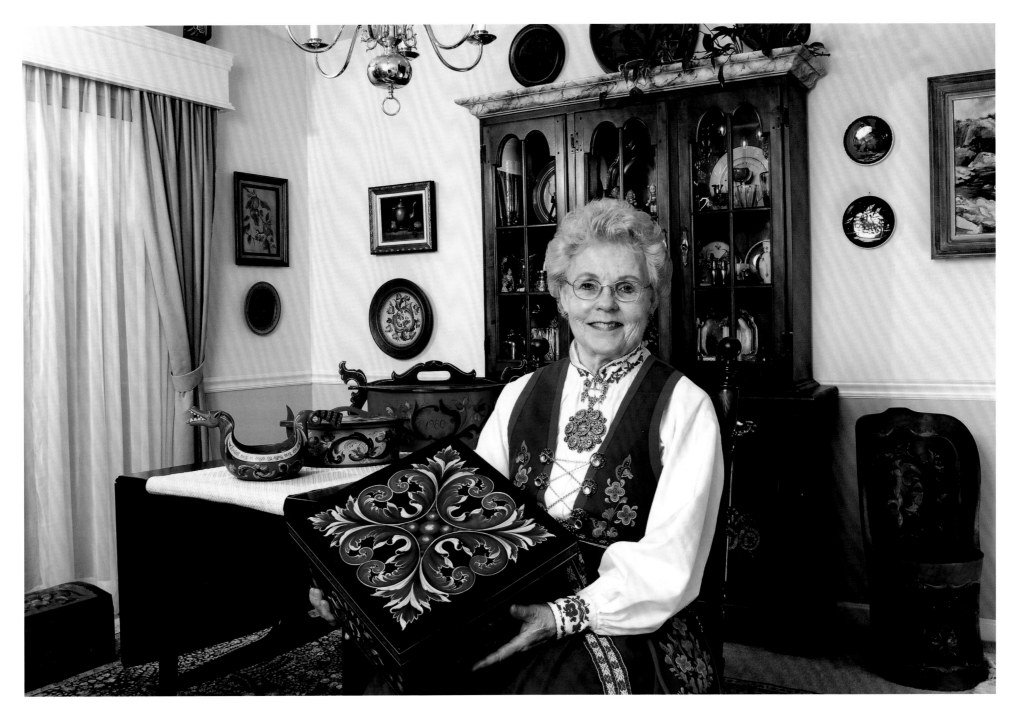

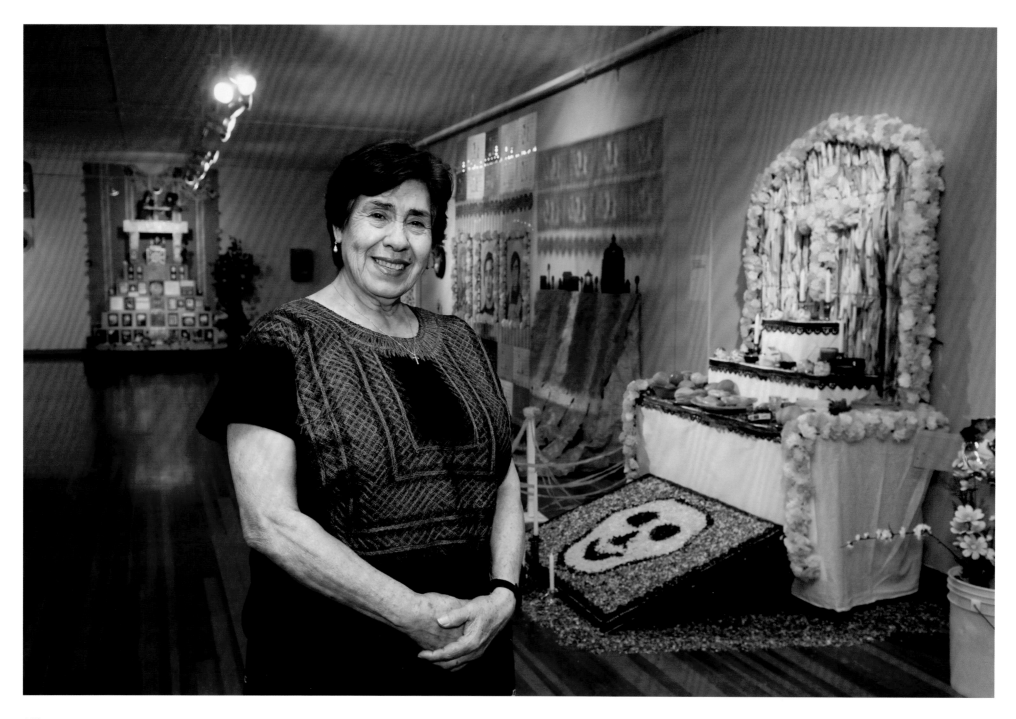

HERMINIA ALBARRÁN ROMERO

San Francisco, California | 2005

In creating my works for Dia de los Muertos, I am joyful as I sense the near presence of my loved ones. When I create papel picado and paper flowers, I again experience those childhood moments near my beloved mother and grandparents who also worked at these crafts. I feel connected to the love they have for me even in death and this is why I feel such a great joy within me.

Herminia Albarrán Romero learned the traditional craft of papel picado (paper cutting) from her mother while growing up in the small Mexican village of San Francisco de Asís. Intricately cut paper designs are used to decorate spaces on special occasions such as quinceañeras (fifteen-year-olds' coming-of-age ceremonies), weddings, and Cinco de Mayo or Dia de los Muertos (Day of the Dead) celebrations. After moving to the Mission District of San Francisco in 1981, she began to teach papel picado to young students and rekindled an interest in Pan para los Muertos (Bread for the Dead) activities. Today she is known internationally for her altar decorations, creating installations at the Berkeley Art Museum, the Heard Museum, and the Oakland Art Museum.

Standing in the Mission Cultural Center for Latino Arts, Herminia Albarrán Romero's portrait was taken with her Day of the Dead altar. Decorated with paper marigolds, the altar features the skull figure commonly used in celebrations, as well as offerings of bread and fruit provided for the spirits of the dead. Annual observances provide the opportunity to publicly demonstrate respect for one's ancestors, but they also mark a time to renew cultural skills and practices deeply connected with a sense of community.

DELORES E. CHURCHILL

Ketchikan, Alaska | 2006

I feel that as a Haida weaver I am just a weaver passing over and under the warp of my ancestors who are the foundation of this art form. . . . [My students] will keep the art alive so it continues long after I am gone and no one remembers my name . . . this art form belongs to all of us.

Delores Churchill was born in the Queen Charlotte Islands of the Northwest Coast and learned weaving from her mother at a time when there were only three active Alaskan Haida weavers. Her mother, Selina Peratovich, one of those three weavers, asked her daughter to burn her baskets for the first five years of her apprenticeship because "I am well known for my baskets. If you say you learned from me, you better be good." Churchill learned well, becoming a master weaver of baskets, hats, robes, and regalia, using spruce root, cedar bark, wool, and natural dyes. In turn, she taught her four daughters and numerous other students of Alaska Native culture. She has said that as long as Native art remains in museums it will be thought of in

the past tense. Today, she makes frequent trips to the National Museum of the American Indian in Washington, DC, to demonstrate and offer workshops on these living artistic traditions.

Although it was snowing when Tom Pich arrived to take her portrait, Delores Churchill wanted to be photographed outside at the Totem Heritage Center in her hometown of Ketchikan. She posed in her button blanket or robe worn in ceremonies. The back of the robe would display her clan symbol outlined in abalone buttons. Atop her head is the tightly woven spruce root hat, twined in a style not unlike that used for baskets.

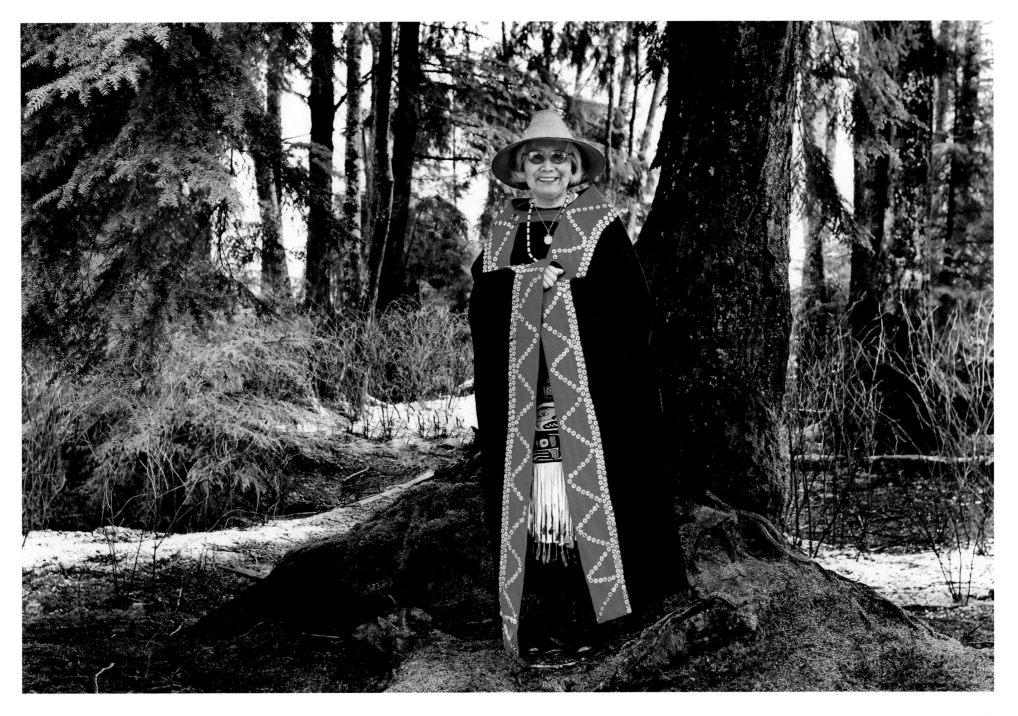

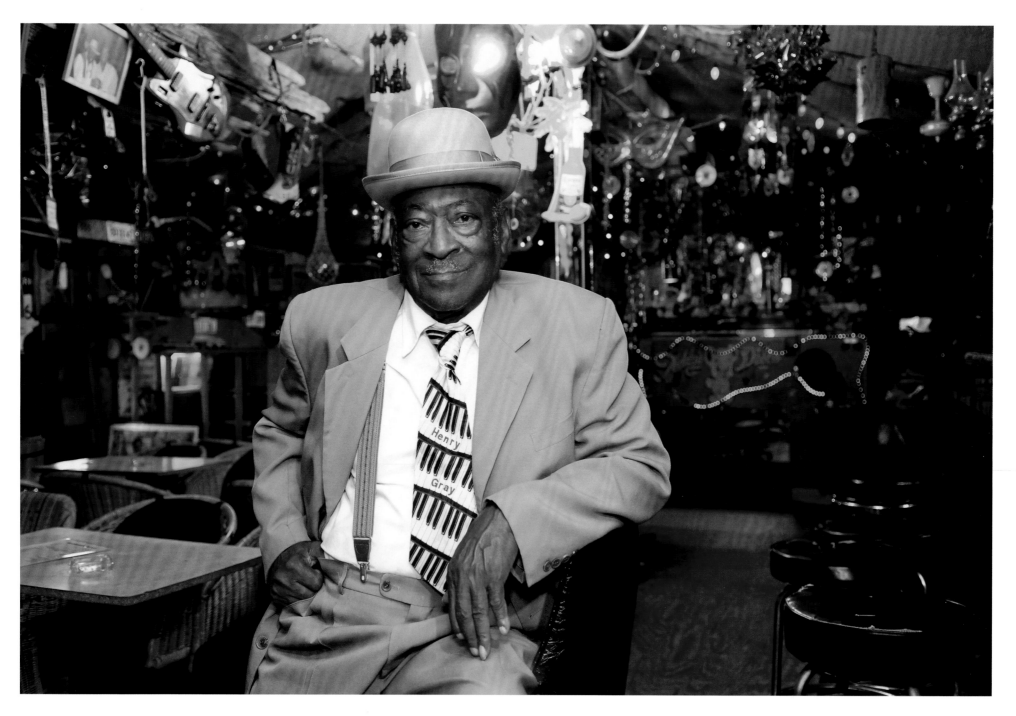

HENRY GRAY

Baton Rouge, Louisiana | 2006

You didn't come on Wolf's bandstand with no shorts or blue jeans, looking like a damn fool. If your shoes weren't shined, he would fine you. . . . I'm the same way with my band. Wolf was a professional and taught me a lot. I loved him for that.

Henry Gray grew up on a farm near Baton Rouge, Louisiana, but by the time he was twelve he had spent most of his time playing piano at juke joints and in churches near home. After service during World War II, like many other Southerners he moved to Chicago. Playing in clubs on the South Side, he encountered one of the formidable blues pianists of the time, Big Maceo Merriweather. Merriweather served as a liaison with club owners and other musicians, and following a period of apprenticeship, Gray joined Howlin' Wolf's band. For the next twelve years he toured and made some of the recordings that today define the Chicago blues sound. He also served as a session musician, recording with blues giants Sonny Boy Williamson, Buddy Guy, and Guitar Slim. In 1968 Gray returned to Baton Rouge and took a day job as a roofer, but he continued his musical career and became an active figure on the "swamp blues" scene. Through festival appearances and the recording of several albums with his own band he has continued to provide a link to both Chicago and Louisiana blues history.

Tom Pich first met Henry Gray at a local Baton Rouge restaurant where he was performing at a senior citizens' luncheon. The following day, Gray drove him out to see the shotgun house where he spent his childhood. However, Gray wanted to be photographed in a spot where had performed off and on since his return to Louisiana—Teddy's Juke Joint in Zachary, just north of Baton Rouge. This popular nightspot is located in what was originally a shotgun house. Crammed with the accumulated décor of more than thirty-five years of existence, it has as one claim to fame, besides good music, the fact that it features Christmas lights 365 days a year. The visual cacophony in the background serves as an interesting contrast to Gray's understated and harmonious mode of dress.

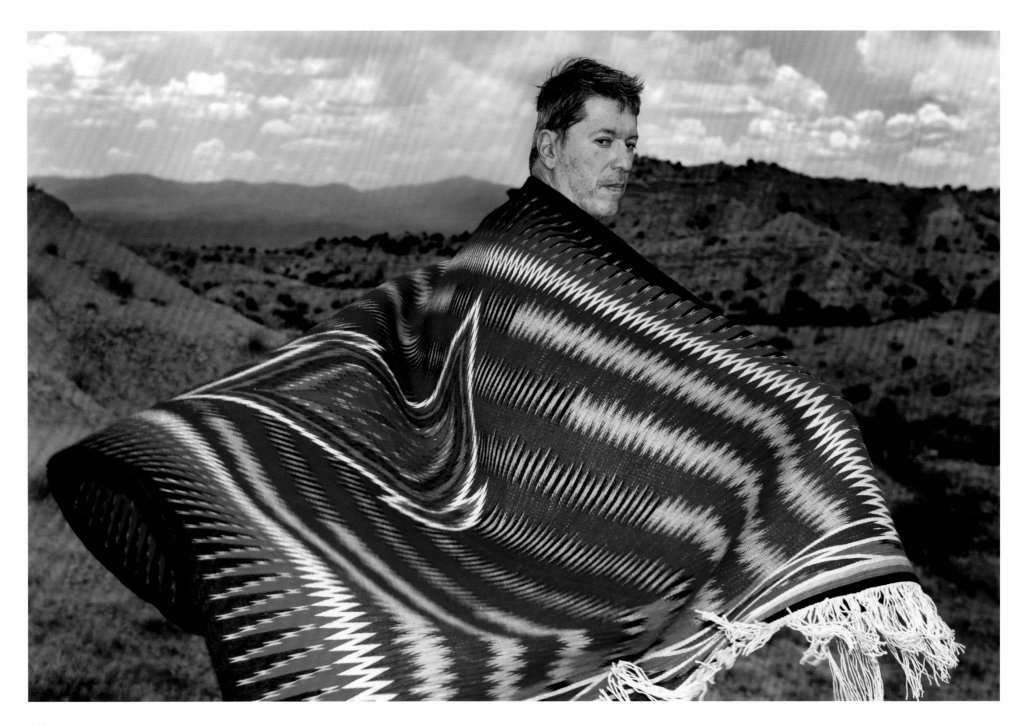

IRVIN L. TRUJILLO

Chimayo, New Mexico | 2007

When I do a major piece it is like putting my life on the line of weft. All my experience goes into it. I am trying to approach the spirit of the old pieces. In doing that, I need to learn from the past, but how to live in my time and environment.

The village of Chimayo, north of Santa Fe, New Mexico, has been a home to textile weavers since the earliest influx of Spanish colonists in the late seventeenth century. In that region, the two names most closely associated with weaving are Trujillo and Ortega, and both appear on Irvin Trujillo's family tree. There is documentation of a weaver, Nicholas Gabriel Ortega, who was an ancestor of his grandmother, weaving in Chimayo as early as 1729. It would be a mistake, however, to understand his weaving skills as rooted solely in the past. Although he started weaving at his father's side at the age of ten, Trujillo graduated from college in civil engineering and initially pursued a career in that field. After he married Lisa, also an extraordinary weaver, in 1982, the couple decided to open the Centinela Traditional Arts Studio. Today their weaving shop is a center for the production and marketing of Chimayo textiles. It serves as a hub for teaching weaving skills and informing the public about the history of the weaving tradition. Trujillo continues to execute complex geometric weaving patterns and produce innovative designs, often referencing contemporary subjects, at his looms near his ancestral home.

Irvin Trujillo took Tom Pich to what he called a "badland" area near Chimayo, where he played as a child. The two walked off the road a good distance, following what Trujillo called coyote trails. Although textiles are often referred to as rugs, most are actually blankets, and Trujillo draped a blanket he was carrying over his shoulders—not an uncommon practice, as a 1935 postcard photo shows Irvin's father spooling yarn with a blanket dangling from his shoulders. As he stood in front of the burnt umber hills, a breeze kicked up to reveal the intricate pattern woven into the textile. The bifurcated close and distant horizon lines behind seem to pass through Irvin Trujillo at eye level, suggesting a vision of past and future.

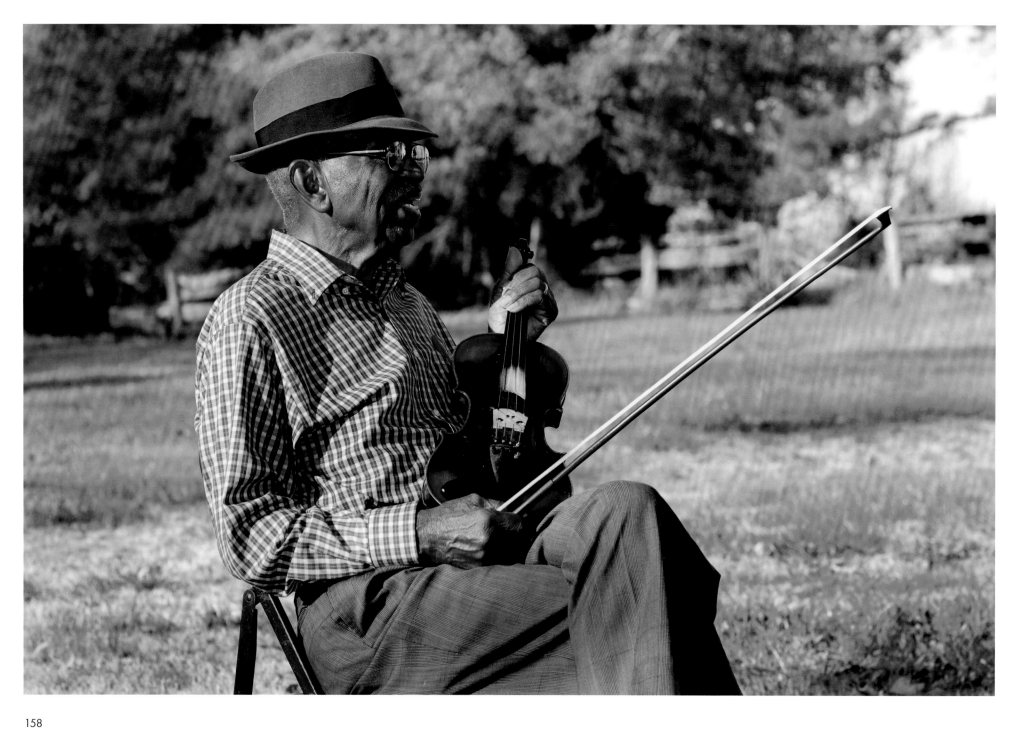

JOE THOMPSON

Mebane, North Carolina | 2007

There's a whole lot to playing music. The main thing is you got to want to do it. You got to have it in your head— "I want to do this." Can't be shabby to do it, got to put on a clean pair of pants, creased up.

While the history of African Americans playing string instruments can be traced to the earliest years of the slave trade and our country's settlement, in the twentieth century it was relatively uncommon to hear African Americans playing string band tunes in the upland South. Joe Thompson and his brother Odell grew up in the Piedmont region of North Carolina and followed in the footsteps of their father, uncle, and grandfather (who was a slave) in taking up fiddle and banjo. Much in demand, they played at house parties and local celebrations. Most of the tunes they played had a syncopated, hard-driving style meant to propel dancers on the floor and were enlivened with interjections of dance calls or sung verses. In later years, Joe Thompson became a mentor to young musicians, including the Carolina Chocolate Drops, who frequently accompanied him on stage.

Joe Thompson took Tom Pich out into the yard in back of his house for his portrait. For a time, he leaned up against the wooden fence seen in the background, telling stories of his experiences living and working in the area. He said that he had been the best "picker" working in the corn and tobacco fields, and recounted an instance when the landowner had gotten him out of a scrape because of his value on the farm. The term "picker" can have a double meaning, however—it refers to agricultural work, but it can also be used to describe a musician. As the stories stretched on into the afternoon, Thompson settled into a chair that Pich had retrieved from near the house, and the photograph was made as he continued to reminisce, fiddle and bow in hand.

JULIA PARKER

Midpines, California | 2007

We take from the earth with a "please" and give back to the earth with a "thank you."

Born into a Miwok-Pomo family in California, Julia Parker was orphaned at a young age and eventually was sent to get her education at Stewart Indian School near Carson City, Nevada. There she met her future husband, Ralph Parker, whose grandmother Lucy Telles was a master Mono Lake Paiute basketmaker who demonstrated her skills at Yosemite National Park. After school, Ralph and Julia moved to the Yosemite region, where Julia apprenticed with the elder basket weavers still working in the area. Soon she was demonstrating in the Yosemite National Park herself—teaching tribal traditions, including the gathering of raw materials, weaving of baskets, and making of acorn meal and mush. Since 1989, in addition to crafting incredibly fine baskets, Julia Parker has been active in the revitalization of basket-weaving traditions, doing groundbreaking work with the California Indian Basketweavers Association.

Severe storms moved through Yosemite National Park on the night before Tom Pich was to photograph Julia Parker. Campgrounds had been evacuated, rivers were overflowing, and boulders blocked some of the roads. Julia and Tom spent some time in the Park Museum and during a brief break in the weather walked around the grounds. At one point as they were walking, she put her hand against a tree and commented, "This is me, I'm also the sky, and also the earth." Parker suggested that they do the photograph in her favorite meadow, where she often gathered materials for her baskets. With the weather still threatening, Tom drove to the spot and found a path through the meadow grasses. Quickly setting up his camera, he returned to escort her into an opening as rain and sleet began to fill the air. Suddenly, behind Julia, a herd of deer stood up and posed for the photo, after which Tom and Julia quickly retreated to the car.

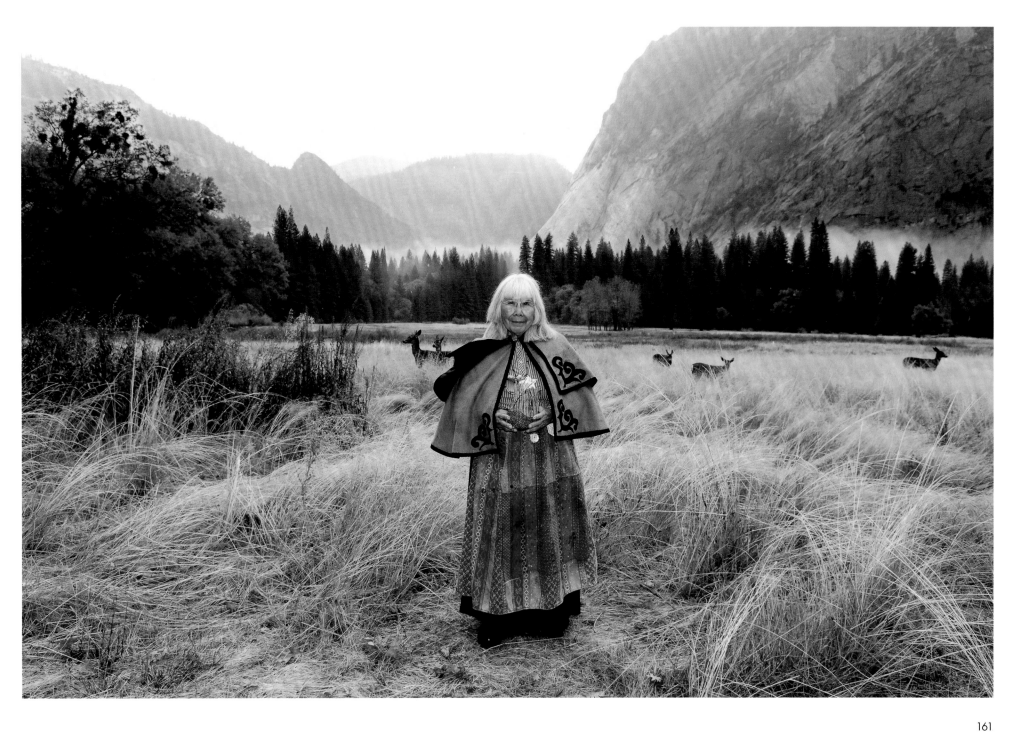

NICHOLAS BENSON

Newport, Rhode Island | 2007

You design the ornament so that it has aspects of weight and occupies a certain amount of space that ties in nicely to the letter form … and the combination of the idea, the tools, and the understanding of material produces this fourth thing which is the net result.

Master stone carver and calligrapher Nicholas Benson plies his trade from a shop in Newport, Rhode Island, that is said to be the oldest continuously operating trade business in the United States, founded by John Stephens in 1705. The shop and tools were purchased by Benson's grandfather in 1926. Nick apprenticed with his father and also spent a year in Basel, Switzerland, learning calligraphy and letter design from European masters. Now recognized as a master himself, his work includes stone carving and lettering for the National Gallery of Art, the World War II Memorial, the Kennedy Center, and the Martin Luther King Memorial in Washington, DC. He was recently featured in *Good Work: Masters of the Building Arts,* shown on Public Broadcasting Stations.

Taken in his historic workshop in Newport, this photograph depicts Nick Benson and his assistants at work. During Pich's visit, Benson's father came in from his workshop nearby to consult on a project. Although his carving can be seen on large-scale buildings and memorials in Washington, DC, at the moment Benson is working on a more traditional headstone, the main source of income for his grandfather, whose tools and inherited knowledge he utilizes to this day.

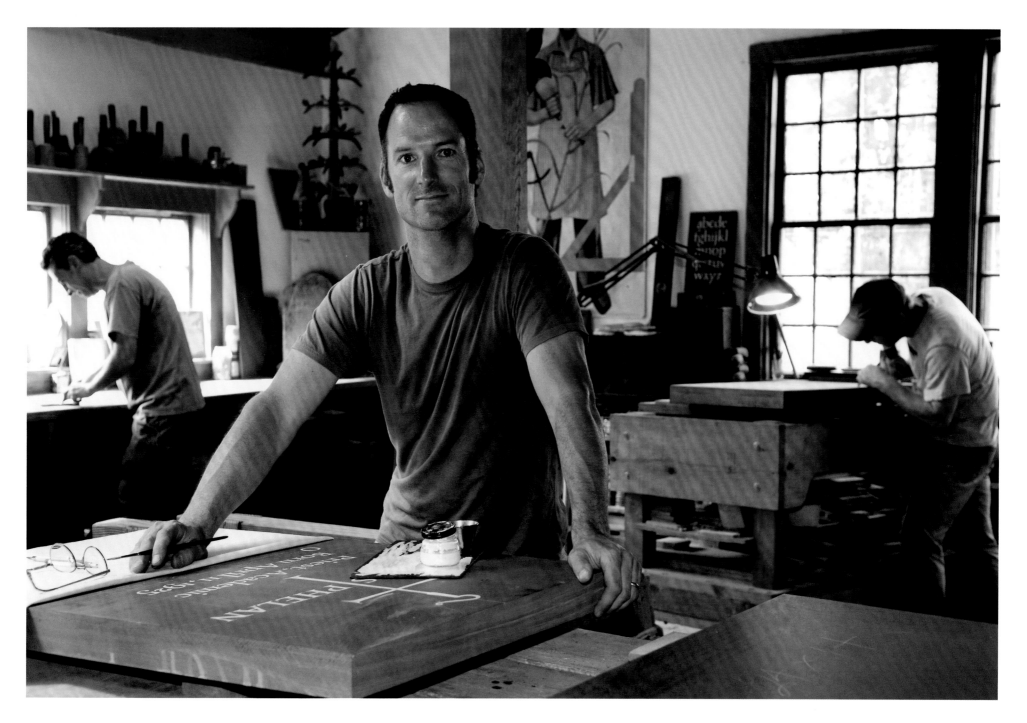

BETTYE KIMBRELL

Mt. Olive, Alabama | 2008

People ask, "How long did it take?" I have no idea; it would probably scare me to death, if I thought about it. . . . If it takes me a year, year and a half, two years to finish, that doesn't bother me, because I know I am going to finish. There's something about a finished product, the satisfaction.

Bettye Kimbrell grew up on a subsistence farm in Alabama at a time when quilting was a practical necessity. Under the supervision of her grandmother, she first learned to make bed covers using scraps of cloth that were then tied to a backing made of feed sacks, with a batting of cotton taken from the fields. Her grandmother admonished her that "stitches reflected your character." She heeded that advice, and by the time she moved to Mt. Olive, a Birmingham department store began referring customers to her to finish quilting their pieced tops. On her own, she began experimenting with more complex patterns and with white-on-white quilts that draw attention to the precise needlework. She developed a method of leaf-pounding on the fabric to stain patterns on the surface of the quilt. Kimbrell also combined good craft with good work—establishing a North Jefferson Quilters' Guild to financially support a community center through quilt shows and raffles.

Kimbrell takes great pleasure in drawing attention to the sewing on her quilts, so she often incorporates muted colors achieved by using natural dyeing methods, such as staining the cloth with tea or chlorophyll from leaves. For Kimbrell's portrait, she posed by a window holding a quilt so that the fine stitchwork can be seen. There may well be no American craft more widely practiced than quilting, and the aesthetic choices of individual quilters vary just as widely. Tom Pich traveled nearly 200 miles north to photograph Bettye Kimbrell after having spent several days with the Gee's Bend quilters. The range of visual expression demonstrated by these two communities covers great distance as well.

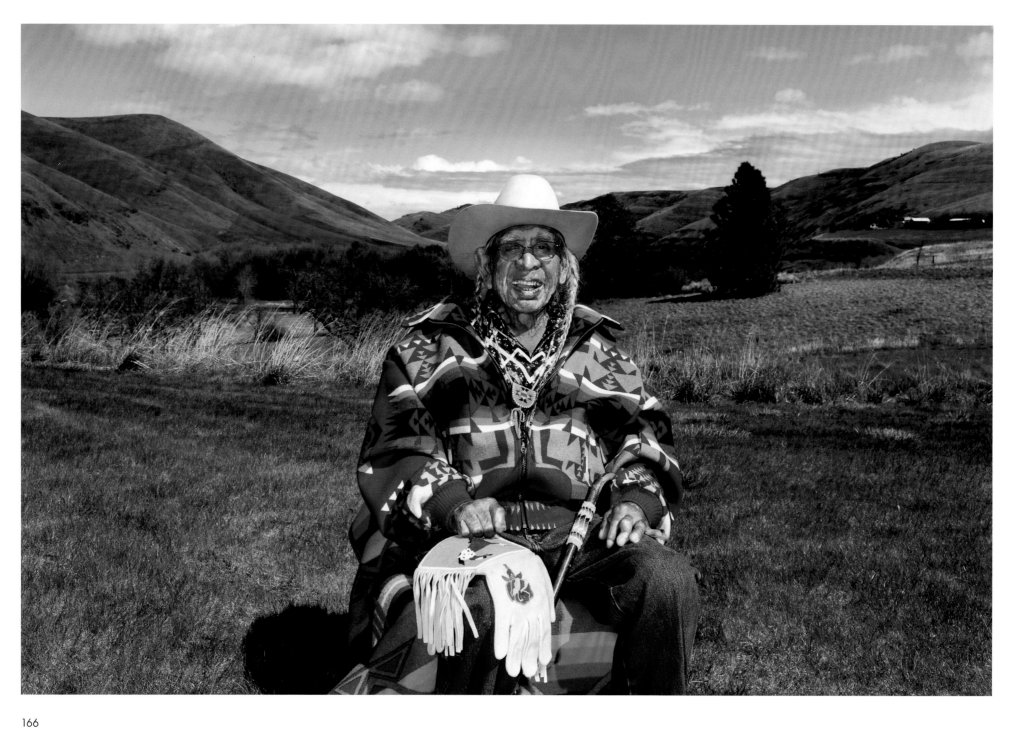

HORACE
P. AXTELL

Lewiston, Idaho | 2008

When I make drums, I always bless them before I let them go out of my house—ask the Creator that they be used in the right ways.

Horace Axtell was an elder and spiritual leader of the Niimiipuu Longhouse. Raised by his grandmother, he spoke only Nez Perce until he went to school. He joined the army when he was in high school to fight in World War II, and his platoon was one of the first expeditionary forces to enter Nagasaki after the atomic bomb was dropped. After the war, he returned to Idaho and worked at the Potlach Mill in Lewiston, while at the same time studying the religious beliefs and practices of his tribe. He began to experiment with making the drums, a central element of Nez Perce traditional ceremonies, and he made a point of learning the songs as well. Eventually Axtell became the spiritual leader of the Niimiipuu (Nez Perce) Longhouse and played a pivotal role in the revival of the Seven Drum Religion within his community. After retiring he taught Nez Perce language at Lewis-Clark State College and coauthored his memoir, *A Little Bit of Wisdom: Conversations with a Nez Perce Elder.*

Horace Axtell wanted to be photographed near the Nez Perce Historical Museum in Nez Perce National Historical Park. The museum in the park, where his grandson works, is dedicated to the history and culture of the Nez Perce tribe. This valley near the Clearwater River is not far from where the tribe hosted Lewis and Clark in the fall of 1805 and again upon their return the following year. William Clark noted in his journal of October 10, 1805: "The Cho-pun-nish or Pierced nose Indians are Stout likely men, handsom women, and very dressey in their way." Axtell, wearing a striking Pendleton-style jacket, sits with a deerskin gauntlet glove resting on his knee. The beaded rose and pony, common motifs on regalia, as well as the quality of the beading on the pouch around his neck and on his cane, demonstrate why Plateau beading is such a respected tradition throughout the West today.

JERONIMO E. LOZANO

Salt Lake City, Utah | 2008

I see myself as a cultural ambassador of the culture of my native Peru. As well as telling the traditional stories and myths of the ancient Inca, I also hope to express the cultural diversity of the experiences of my life.

The retablo, a devotional painting rooted in Spanish Catholicism, evolved in Peru during the twentieth century to become a vehicle for commentary on everyday life. Visual narratives are often presented in a shallow box behind two hinged doors. Jeronimo Lozano, raised in a small village in the Andes, attended a regional school of fine arts and after graduation traveled around the country interviewing traditional artists. He established a studio in Ayachucho, and his reputation as an artist spread, attracting the attention of the "Shining Path" (guerrilla fighters). Fearing for his life, he sought asylum in Salt Lake City while touring the United States with a folk dance troupe. Today he continues to hand sculpt and paint figures, often with themes relating to American life, and fulfills what he sees as his responsibility to demonstrate and teach retablo making to students of the region.

Crowded into Jeronimo Lozano's small apartment are the retablos, crosses, and figures that he takes to craft fairs and community festivals around the West. Just behind the photographer is the small kitchen table where Lozano handcrafts figures out of a mix of flour, plaster, and water. While the subjects of most of his art, including the cross he is holding, depict religious themes, he recently completed a piece depicting the surgery on his ears that restored his hearing. The painting on the wall dates from when he was a teenager interested in pursuing a career in painting. It portrays his feeling about freedom of expression in his home country at that time.

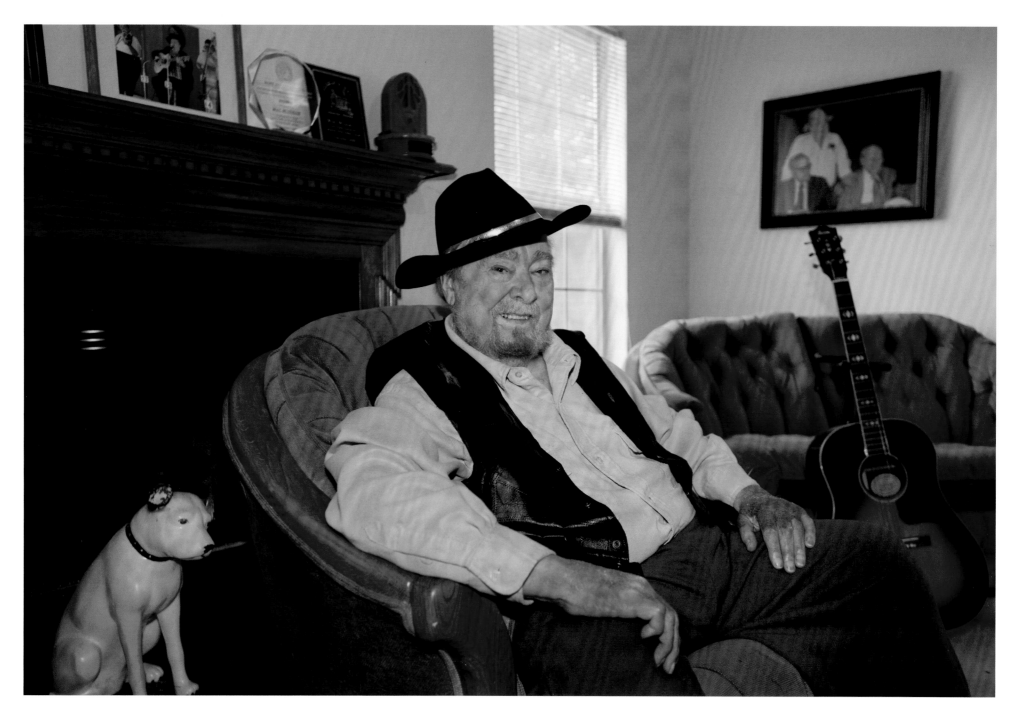

MAC WISEMAN

Nashville, Tennessee | 2008

These songs, when you observe them carefully, they are a slice of life, so to speak. They talk of a true happiness, of love affairs and train wrecks, of sadness and farewell parties when you pass away. People don't change and the situations don't change, we just get a new batch. That's the reason for the longevity of some of these songs. It's all about lyrics you can identify with.

Although his singing skills earned him the title "the voice with a heart," Malcolm B. "Mac" Wiseman is as well-known for his role as a bluegrass and country music advocate and entrepreneur as for his voice. He grew up in the Shenandoah Valley, and by the age of fourteen he was performing the music that he heard from his parents at home and that he was able to pick up from radio broadcasts on the *Grand Ole Opry*. In 1946 country artist Molly O'Day hired him to accompany her, and following that stint he became an original member with Lester Flatt, Earl Scruggs, and the Foggy Mountain Boys, before joining Bill Monroe's Bluegrass Boys as a lead singer. His smooth tenor voice can be heard on many recordings of this era, and in 1951 he broke away to form his own group built around his solo singing. His time as a bandleader and appearances at folk festivals, such as the Newport Folk Festival, brought Wiseman to the attention of a wider audience. But it was his work as an A&R (artist and repertoire) director for Dot Records, a deejay on the Wheeling Jamboree, and a founding member of the Country Music Association that significantly contributed to a broader awareness and understanding of the intersecting histories of traditional, bluegrass, and country music.

Tom Pich's visit with Mac Wiseman, which he expected to last just an hour, turned into an eight-hour storytelling session. Wiseman mentioned that in the 1950s, while on tour, he got a call from his manager asking him to take a listen to a young guitar player named John Cash. Cash toured with him briefly in Florida and then went on to pursue his own career. This was much on Wiseman's mind, because Cash had passed away within the past year and Wiseman had recorded several songs with him just before his death. In this portrait, Wiseman is joined by the RCA Victor mascot, Nipper, featured in ads with the words "His Master's Voice," not an inappropriate accessory for a former record executive and singer who was known to have a voice with a heart.

MICHAEL G. WHITE

New Orleans, Louisiana | 2008

Jazz is part of a way of life of New Orleans. It's an expression of the spirit and the soul and the feelings of the people here. But it also has universal implications, and it's sort of like the New Orleans social, spiritual, cultural language that describes our local version of the universal human experience.

Dr. Michael White grew up in a family of musicians and played clarinet in one of New Orleans' fabled marching bands, but it was his apprenticeship with some of the city's traditional musicians that set him on a course to explore jazz history. He learned from Danny Barker, a banjo player in Cab Calloway's band, among others, and Doc Paulin, leader of one of the noted parade bands marching for funerals and festive events. After obtaining a doctorate at Xavier University in Spanish language, he has continued to perform traditional jazz, often collaborating with Wynton Marsalis and *Jazz at Lincoln Center.* In the process he has accumulated not only knowledge of jazz history but a collection of rare sheet music, antique instruments, and recordings. In 2005 Hurricane Katrina flooded his home, and most of these materials were lost. As devastating as the loss was, he continued to work on behalf of fellow musicians who lost homes and instruments during the disaster.

The original intent was to photograph White in the French Quarter in one of the clubs where he performed. The venue was closed, so the portrait was made at a streetside table nearby. White posed for the photo, fingers on clarinet, and street life provided a backdrop, including the dog intently observing the scene. Wrapping up the session, Tom Pich noticed several individuals dressed in band uniforms gathering across the street. It turns out that members of the Treme Brass Band, recipients of a Heritage Fellowship in 2006, had begun assembling to play in a funeral parade for a local musician. As a result, Pich was able to follow the crowd and document another group of Heritage Fellows in action.

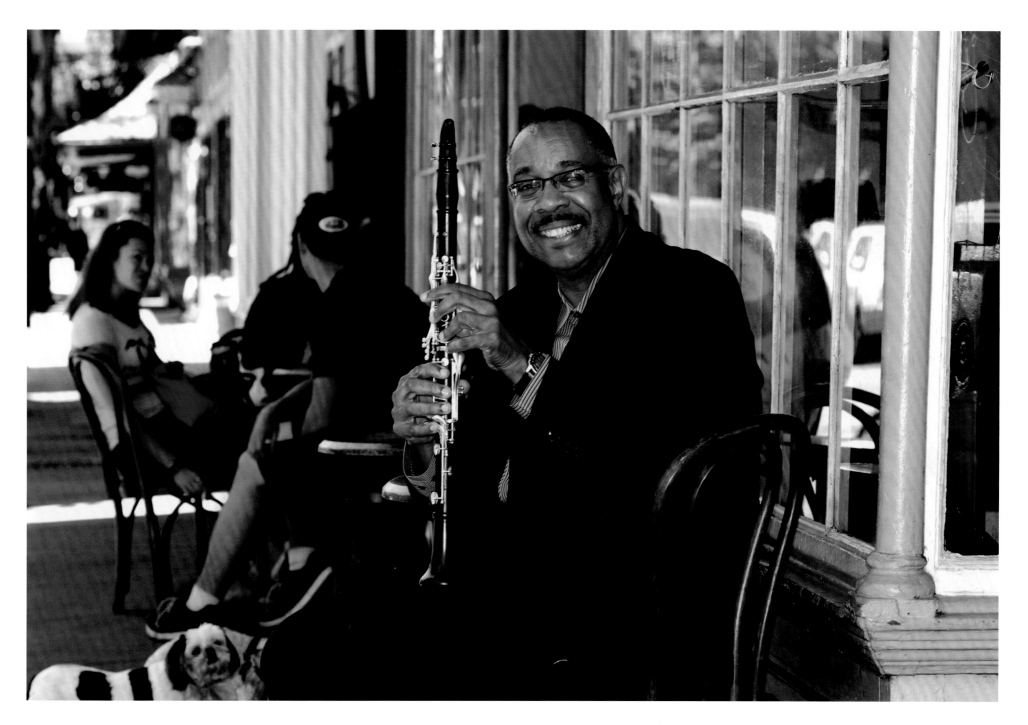

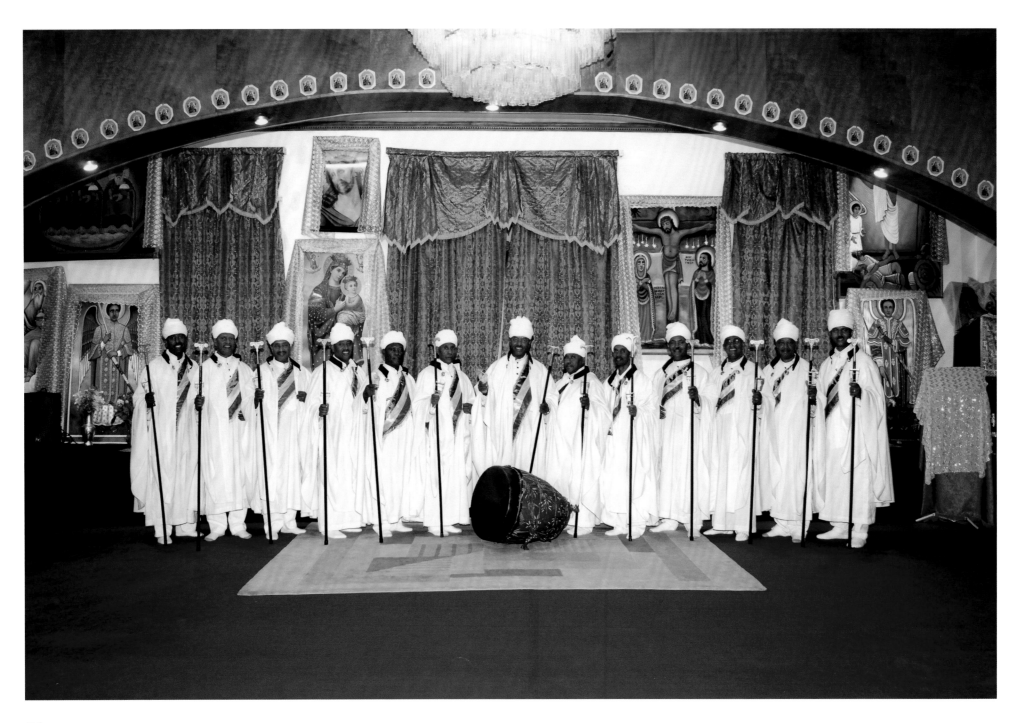

MOGES SEYOUM

Alexandria, Virginia | 2008

When I was in my country, my education motivated me to serve in the church. For the future, I am very motivated to write a lot of books about sacred music. I have a lot of paperwork to do.

Moges Seyoum is the director of liturgical services at an Ethiopian Orthodox Christian Church in Washington, DC. Granted asylum, he came to the United States in 1982, where he is acknowledged throughout the Ethiopian diaspora for his knowledge of church music and ritual. Seyoum's father, a church musician, initiated his son's training when he reached the age of eight. By the time Seyoum was seventeen he received the title ganygeta ("the leader of the right hand side") because he was considered qualified to lead one of the two choirs in his church in Ethiopia. Today, it is said that he can perform from memory the complete Ethiopian psalter, and he is known as the only US expert in choreographing the elaborate movements of the prayer staff. Seyoum's recordings of the majority of the most complex selections from the annual liturgy serve as resources for Ethiopian religious practice around the world.

Moges Seyoum requested that Tom Pich photograph him with the group of religious leaders who had come together to perform at the National Heritage Fellowship concert. In this case the portrait was taken at his home church—the Debra Selam Kidest Mariam Church in Washington, DC. Seyoum stands in the center, flanked by fellow elders and performers of the music and movement that characterize their religious tradition. The prayer staff each man holds is considered a symbol of authority, and it references the biblical staffs of Joseph and Moses. The staffs also serve to mark rhythm, as they are moved in time to the chants and sometimes are pounded against the floor, to keep tempo along with the large drum.

SUE YEON PARK

New York, New York | 2008

When I dance I can show my inside—very deep, deep feelings. I forget me, right away, and I'm completely another person.

Sue Yeon Park studied with two masters of Korean dance and music, Yi Mae-bang and Ti Chang-bae, both recognized as Korean "Living National Treasures," an honorific award similar to, but predating, the National Heritage Fellowships in the United States. After coming to New York in 1982, she formed a dance group specializing in Buddhist ritual dance, shaman ritual dance, and Korean folk songs and music. In 1993, she founded the Korean Traditional Performing Arts Association in order to teach students and present Korean arts and culture. In addition, she teaches classes at Camp Friendship in New Jersey, which serves Korean-born adopted children.

This photograph is different from most in that it was taken during her performance at the concert featuring the 2008 National Heritage Fellows. She is wearing the long white dress of the sulpari (shaman dance). This connects with the early history of her interest in performance, because at the age of eleven she attended a gut, a shamanic ritual, and became so enthused that she began to dance. The shaman told her mother that she would either become a kanshing mudang, shaman with no hereditary ties, or a dancer. It turns out that she became both.

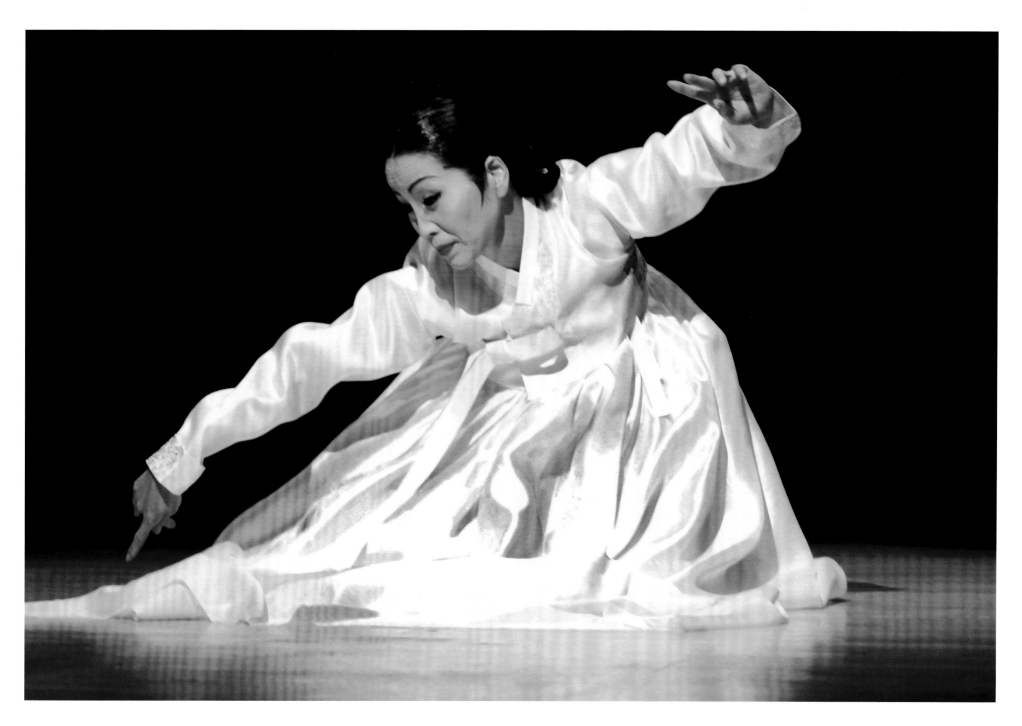

WALTER MURRAY CHIESA

Bayamón, Puerto Rico | 2008

The hundreds and thousands of master craftsmen, charcoal burners, musical instrument makers, mask makers, and basketmakers were anonymous throughout more than four centuries. Well, the recognition of the craftsmen, the anonymous craftsmen, that's the greatest thing for me.

Walter Murray Chiesa received the Bess Lomax Hawes National Heritage Fellowship for his efforts to draw attention to and support the craft traditions of Puerto Rico. His work led to a renaissance of craft activity on the island and a deeper understanding of cultural knowledge that was being lost. He traveled around the island documenting craftspeople and then initiated programs aiding and featuring traditional artists. Chiesa founded the Office of Crafts Development, which later became part of the Puerto Rican Industrial Development Corporation. Through this organization, he instituted an annual Month of the Craftsman and the designation of a Master Craftsman of the Year. He also created a master-apprentice program and developed a Crafts Tool Bank to give needy artists access to tools for use in their practice.

Tom Pich photographed Walter Murray Chiesa doing what he most liked to do—visiting a craft artist in his studio. In this case, he is spending time with cuatro maker and National Heritage Fellow Julio Negrón Rivera, who can be seen in the background sanding one of his instruments. The most telling clue that he is at work is the fact that his left pocket is unbuttoned—Chiesa always kept a small notepad in his pocket, on which he scribbled notes as he conversed with the artists he visited.

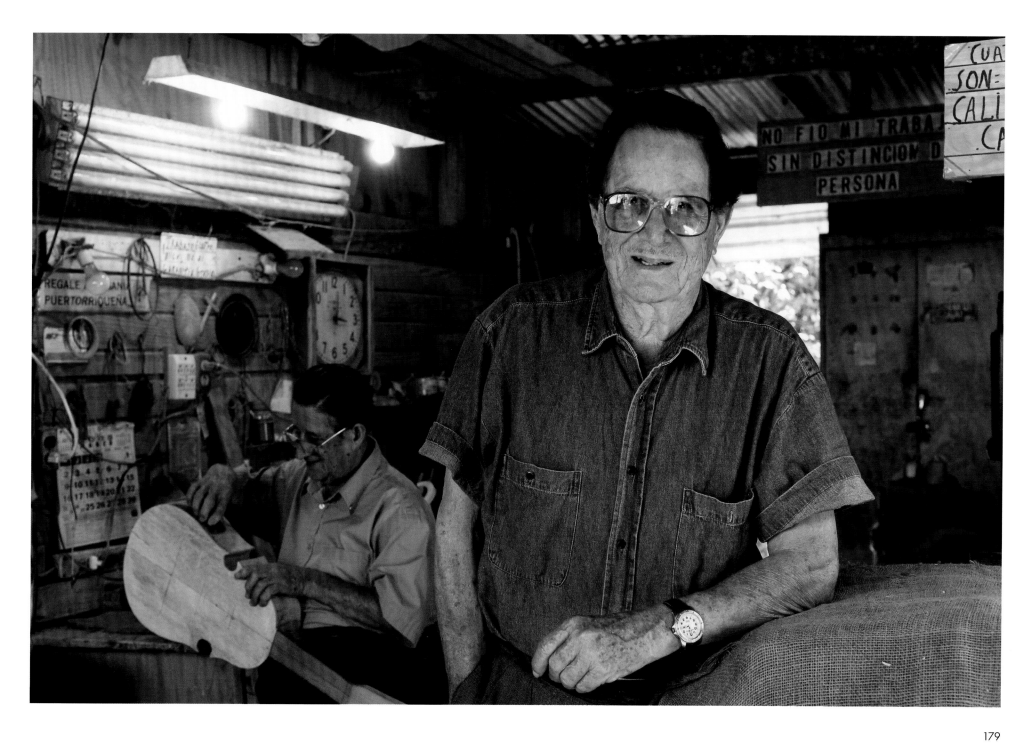

CHITRESH DAS

San Francisco, California | 2009

I believe that if you have a very strong sense of education and background in your dance, then you can be open to the world out there because you're maintaining your traditions. On one hand our teachers are maintaining the traditions and then, on the other, they're innovating and experimenting. They're educating. They're bringing the world together.

Pandit (Master) Chitresh Das traveled to the United States in 1970 with eight dollars in his pocket. He had received a Whitney Fellowship to study modern Western dance and teach his own Kathak dance techniques. Kathak, a Northern Indian dance style, conveys stories through dramatic facial expressions, vigorous gestures, and percussive foot movement. In his twenties, Das had been given the honorary title pandit, or master, as he had grown up absorbing dance and cultural knowledge and skills in his parents' dance school in Calcutta. After a year teaching at the University of Maryland, Das was invited to join the school of sarod master Ali Akbar Khan in California as a teacher. In 1979 he founded his own school, Chhandam School of Dance, as well as the Chitresh Das Dance Company. Over the following thirty-five years, he choreographed numerous dance presentations and gained attention for incorporating jazz, tap, and flamenco dance styles into his creations.

Another word for Kathak is Natawari Nritya, or dance of Lord Krishna, a central figure in these choreographed stories. In his backyard, Pandit Das assumes a pose that represents Krishna standing on the head of a water serpent, Kalia, that he has just defeated in an underwater battle. One hand grasps the tail of Kalia, while with the other he is playing a flute. Thanks to digital photography, Das was able to check the angle of his hands and feet—he wanted the positioning to be just right. Although Das started on the flagstone behind him, Pich said that the process took long enough that in order to stay in the sunlight he had to continually move forward, reaching the location captured in the photograph.

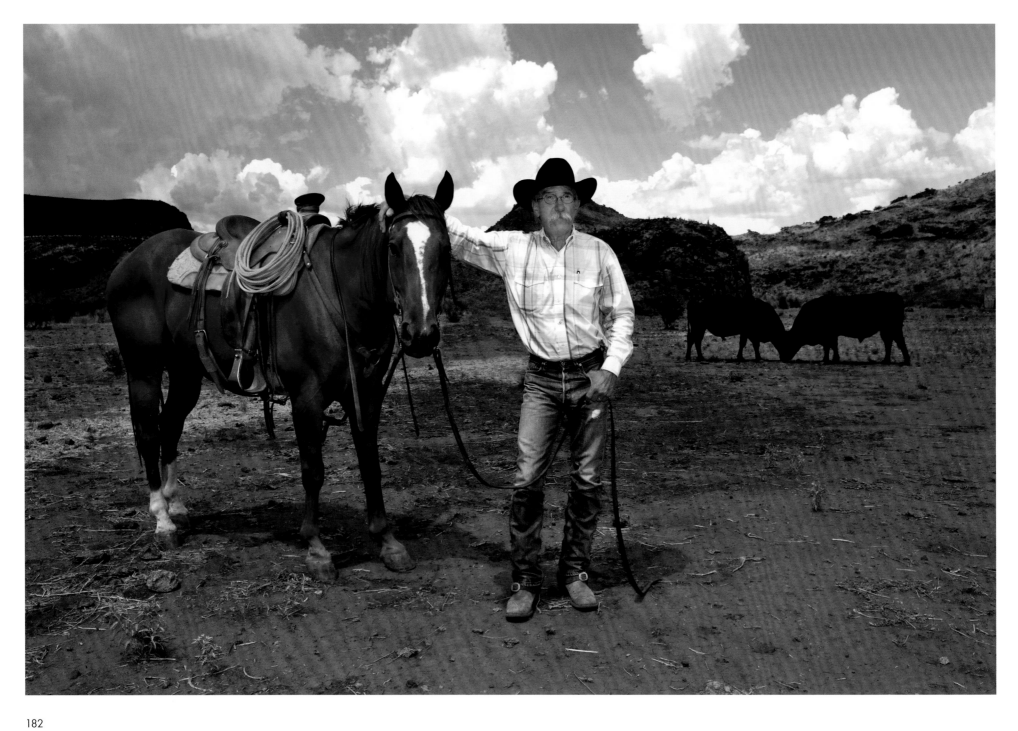

JOEL NELSON

Alpine, Texas | 2009

My lifestyle inspires the poetry and the poetry strengthens my belief in and love for what I do.

The son of a rancher, Joel Nelson has worked as a cowboy at the 06 Ranch near Alpine, Texas, as a custom saddlemaker, as a packer in Wyoming and Montana, and as a horse breaker for the King Ranch in Texas and the Parker Ranch in Hawaii. He is a reciter and writer of cowboy poetry, reflecting his experiences with cattle and horses. A lover of classic and contemporary poetry, he writes verse about the general human condition. His recording *The Breaker in the Pen* is the only cowboy poetry ever nominated for a Grammy. Today he and his wife, Sylvia, operate the 24,000-acre Anchor Ranch in Alpine and raise Corriente cattle.

For the photograph, Joel Nelson took Tom Pich and his daughter, Eliza, across his ranchland on horseback. A storm blew up and lightning flashed on the rim of the canyon, so they decided to pause for a moment. Joel dismounted and stood by his horse as Pich photographed. Working on the photograph, Nelson pointed out that it would be very important to capture the horse with its ears erect and alert. Nelson's arm is thrown casually around his mount's neck as if standing with an old friend. The profile of the saddle and Joel's hat seem at one with the horizon line of the landscape. Behind Nelson and his horse two steers have moved into the frame and test one another's resolve.

TERI ROFKAR

Sitka, Alaska | 2009

Decades of weaving have opened my eyes to the pure science that is embedded in Tlingit art. The arts and our oral history together bring knowledge of ten thousand years of research to life. My goal is to continue the research, broadening awareness for the generations to come.

Teri Rofkar, born into the Raven Clan, spent a lifetime researching Tlingit material culture. She wove spruce and cedar root baskets and was known for her depth of knowledge of the flora used in basketry, often instructing students in the process of gathering raw materials in the forests. One of her great contributions to Alaska Native cultural heritage was her research into and revival of the weaving of the Ravenstail robe. These intricate robes, most of which require between 800 and 1,400 hours of work, are woven using spruce root and mountain goat wool in abstract geometric patterns that require both consistency of design and precision of execution. Not content, though, to merely pay homage to this 6,000-year-old tradition, as her last project she planned a "Tlingit Superman" series of three robes, the last of which was to be made of Kevlar and other bulletproof materials to comment on the militarization of our homeland.

By the time Tom Pich was able to photograph Teri Rofkar she had been suffering the painful effects of bone cancer. Still, she wanted to have her portrait taken out near the coast. The robe she is wearing is the first of the Tlingit Superman Series—it is the first Ravenstail robe made entirely of shed mountain goat wool, most of which was collected over a period of seven years from the bushes on the mountains behind her. This robe incorporates a double-helix pattern reflecting the genetic code of the Baranhof Island goats. On the lower right side you can see a space filled with red fiber, which represents a basket of berries that her granddaughter spilled while she was working on the blanket. Although it was painful, Rofkar wanted to swirl to show off the robe and tails, as she often did when displaying the robes. She frequently referred to these textiles as "dancing baskets" because the technique of twining baskets was very similar to the twining of spruce root and wool in the robes.

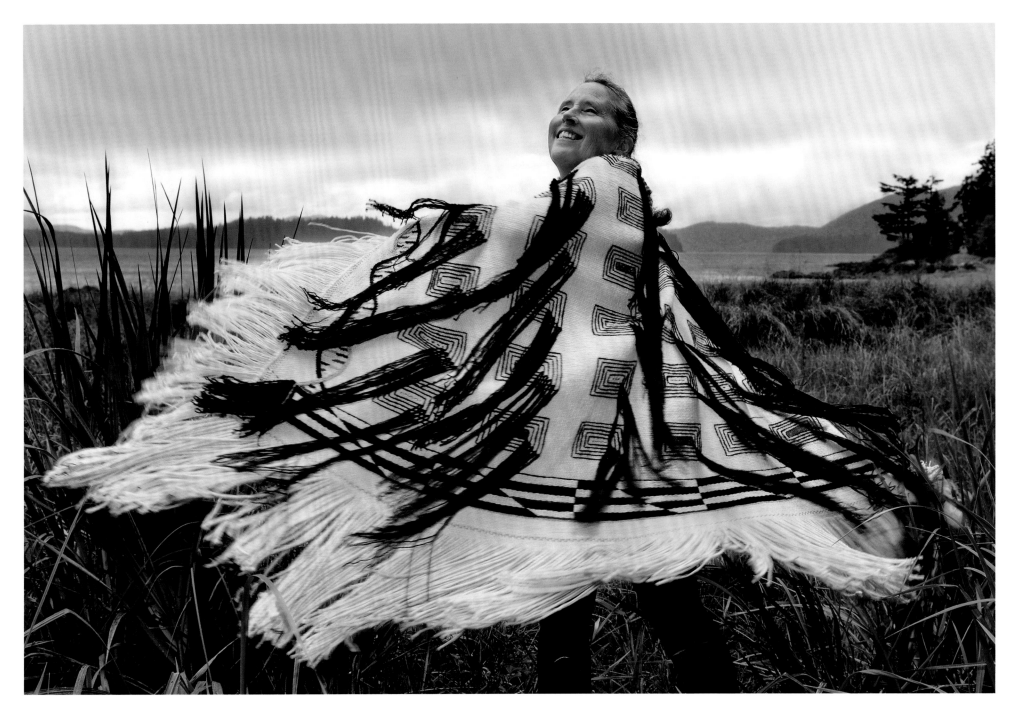

JIM "TEXAS SHORTY" CHANCELLOR

Rockwall, Texas | 2010

I have had quite a few people ask me to come in and teach and I enjoy meeting the young people . . . I teach those students just like I learned. I sit down with them note for note and we play the tunes until they get it by ear.

Jim Chancellor started his musical career at the age of nine, playing the mandolin with his brother on a radio station in what was called *The Texas Al and Shorty Show*, thus his nickname "Texas Shorty." As a teenager, he heard the legendary fiddler Benny Thomasson and soon was studying with him. The state of Texas has a long history of fiddle contests and contest fiddlers. Chancellor is credited as the youngest fiddler, at the age of sixteen, to win the World Championship Fiddle Contest at Crockett. He went on to win the contest the next two years and, as a result, was "retired" from the contest while still a teenager. Subsequently, he was inducted into the Texas Fiddler Hall of Fame. While Chancellor went on to pursue a career in management in the airline industry, he has continued to play and dedicate himself to training younger fiddlers, much as Benny Thomasson mentored him.

Because Jim Chancellor was performing in Nacogdoches, Texas, on the evening that Tom Pich visited, the two traveled there to have his photograph taken. Chancellor is standing in front of the General Mercantile and Old Time String Shop—a building over 100 years old that used to house Stone's Café, where Bonnie Parker waitressed before joining Clyde Barrow on their infamous crime spree. Standing in the doorway is Steve Hartz, proprietor and a musician himself.

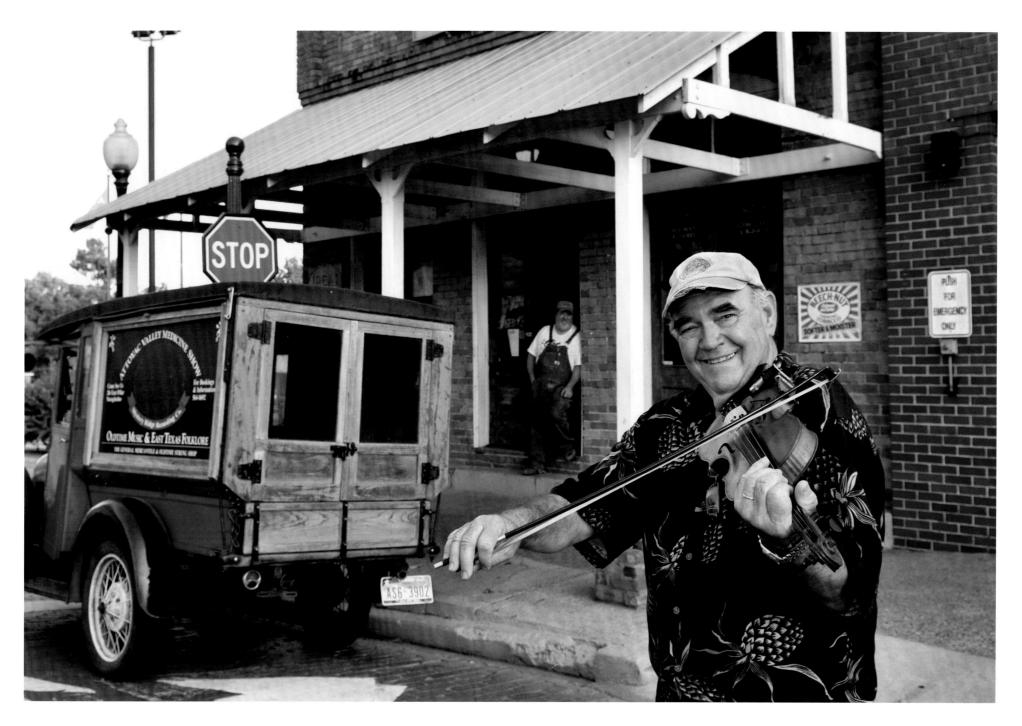

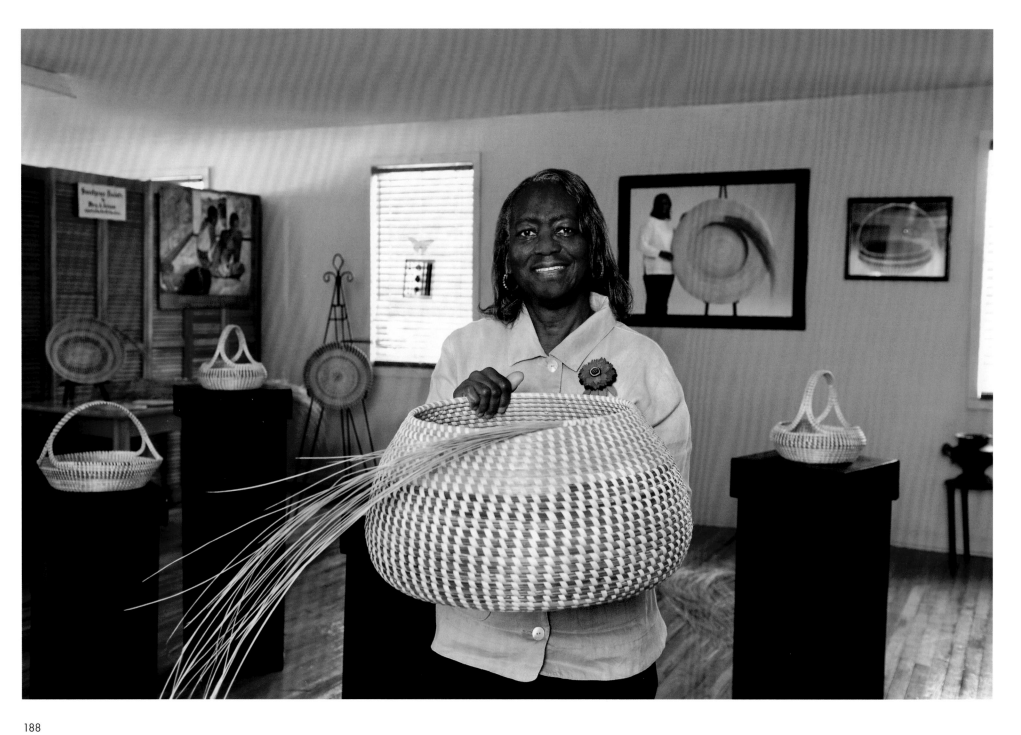

MARY JACKSON

Johns Island, South Carolina | 2010

My grandmothers used to sell their baskets, sometimes in the city market with their vegetables. But I also wanted to bring my work into the art world where it has never been before.

Although Mary Jackson initially learned the art of sweetgrass basketmaking from her mother and grandmother at the age of four, she left Low Country South Carolina after high school to attend secretarial school in New York, settling there to work ten years for a life insurance company. Ultimately, she moved back to her home state and took up basketry again. Her return coincided with and energized a revival in this regionally significant craft. Jackson innovated on traditional forms, drawing the attention of collectors around the world. As a founding member of the Mount Pleasant Sweetgrass Basketmakers, she speaks eloquently about environmental issues that have a significant impact on access to materials essential to the perpetuation of basketmaking in the region.

Although sweetgrass basketmakers in the Charleston, South Carolina, area often displayed their wares on the street corners in town and in makeshift stands along the highways, Jackson has taken her baskets into museums and art galleries. She is photographed in her gallery and workshop, with the individual baskets displayed on pedestals to attract the attention and respect these artistic works deserve. On the floor behind her is sweetgrass, known as the basketmaker's gold, perhaps collected for Jackson's next project.

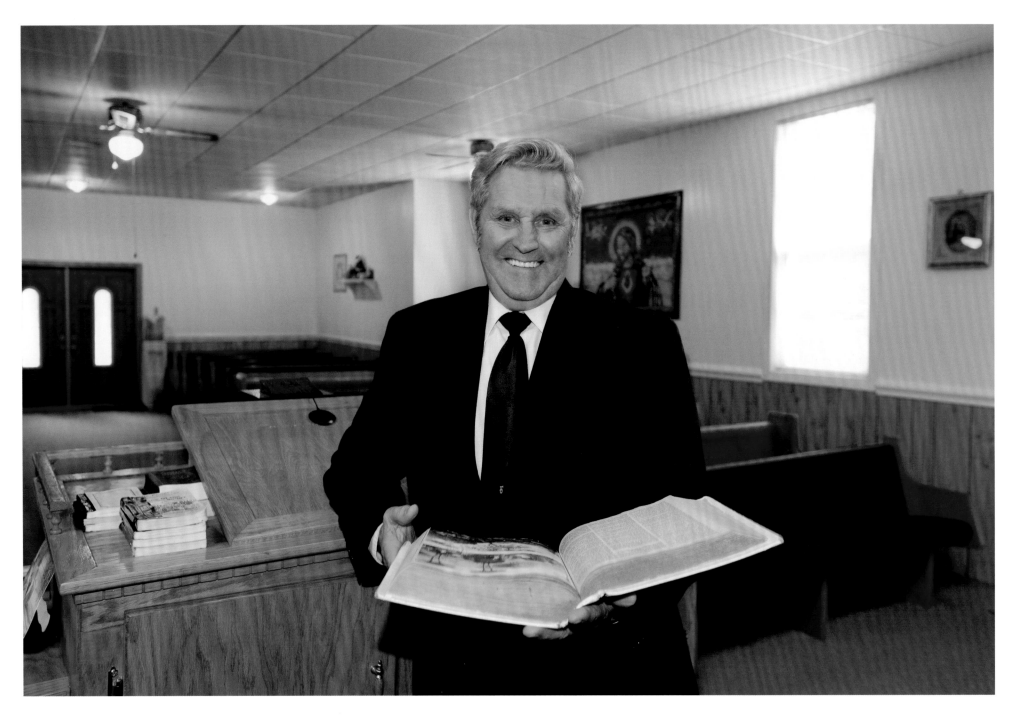

FRANK NEWSOME

Haysi, Virginia | 2011

And the more I sung, the more that I got my life into it and asking the Lord to help me, give me understanding and wisdom. I don't have education. I can't read music, I go by the sound. There's nothing like the sound when God blesses you with his spirit to sing with. It sets you free.

Frank Newsome worked in the coal mines of southwest Virginia for seventeen years, drilling into the overhead surface of tunnels to test whether they were safe. Not surprisingly, he developed black lung disease, and he left the mines to serve as a minister in the Old Regular Baptist Church. Known throughout the region for his singing ability, Newsome performs religious hymns in the old a cappella style of lining out that can be traced to Scottish Presbyterianism. It dates to a time when congregants either didn't have or couldn't read hymnals and involves the song leader's chanting or singing the words of a line, followed by the congregation rendering the verse in a slow mournful but ornamented refrain. Newsome gained some attention when one of the people who attended his church and was steeped in the same singing tradition, Ralph Stanley, a 1984 Heritage

Fellow, invited him to perform at his Hills of Home Bluegrass Festival. The connection eventually led to a recording of his singing and a following beyond the church and subsequent years of festival performances. In 2012 Newsome and Stanley sang together at the Richmond Folk Festival, and the combination of their striking voices and heartfelt singing brought the crowd to its feet. Appropriately, when Ralph Stanley passed away in 2016, it was Newsome who preached his funeral.

Frank Newsome stands near his pulpit at the Little Dixie Church, where he presides on Sunday mornings. Although his black lung disease requires that he carry an oxygen tank with him, after the portrait was taken, he sang several unaccompanied hymns for Pich before they left.

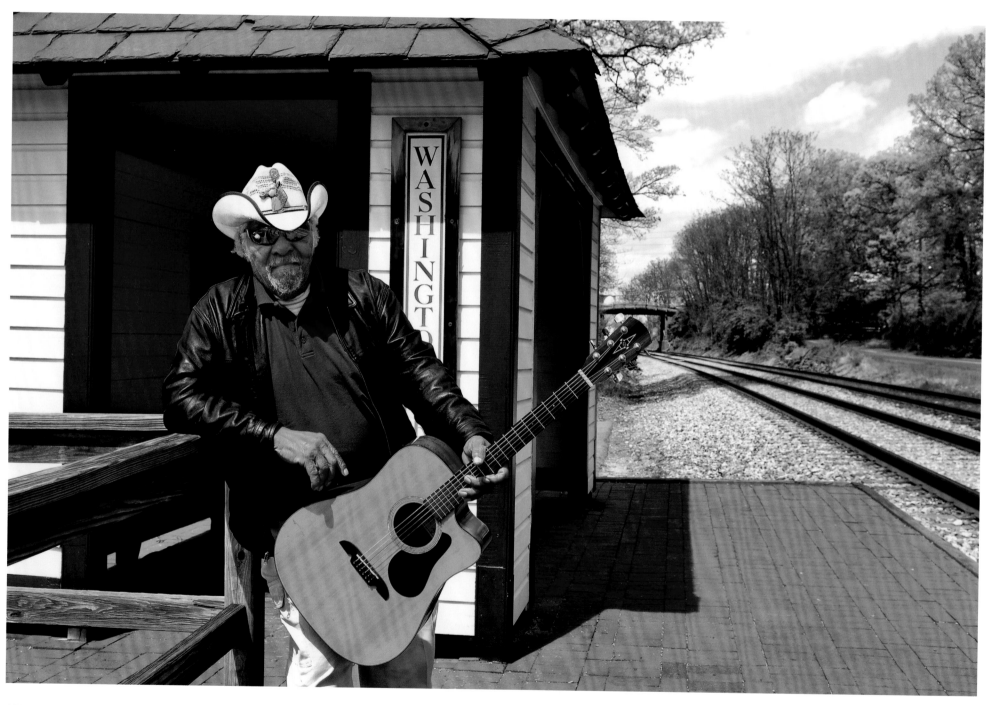

WARNER WILLIAMS

Gaithersburg, Maryland | 2011

Since I was four years old I've been picking guitar. I was gifted for it and my daddy was a music teacher. . . . It runs in the family. Anything I hear, I pick it up and just go and play it. A whole lot of songs I'm playing now were out before I was born, but I still remember them.

Often referred to as a "songster" due to his eclectic repertoire and broad-ranging musical stylings, Warner Williams grew up in the suburbs of Washington, DC, a cultural and geographic crossroads. His father played guitar, fiddle, and piano, while his mother sang hymns, so it is not surprising that he and all eight of his brothers and three sisters performed music while growing up. Most often Warner's fingerpicking technique on the guitar draws from older Piedmont blues styles, but his choice of songs might range from country and western to deep Delta—Hank Williams to Big Joe Williams, if you will. Because he doesn't care to travel great distances from home, he remains a local and regional favorite, often performing with a trio called Little Bit A Blues.

Washington Grove, Maryland, near Gaithersburg, considered a near suburb of Washington, DC, was originally a rural agricultural settlement known as Log Town. In 1873 the B&O Railroad built a train station, and over the next one hundred years the village was transformed into a city and grain elevators gave way to high tech industries strung along the interstate's technology corridor. The train station, while a throwback to a previous era, still serves a commuter train line. As Tom Pich was setting up his tripod for the portrait, several Amtrak trains barreled through, shaking the camera and shaking up the photographer. When Williams arrived, they quickly got the shot, keeping a wary eye on the tracks in both directions.

HAROLD A. BURNHAM

Essex, Massachusetts | 2012

Up into the last few years I considered building boats something that I wanted to do, and now I feel like it is something I want to preserve. Like an endangered species, once it's gone it can't be recreated. And so, I am happy to share what I have learned with anyone who takes an interest, in the hope that these skills will be carried on long after I am gone.

The town of Essex, Massachusetts, where the Burnham family has lived for eleven generations, has been a shipbuilding hub since the 1630s. Most of the 4,000 ships built over a period of 400 years were for the Gloucester fishing fleet, but after World War II, steel and fiberglass vessels began to replace those made of wood, and the knowledge and skills of wood-frame construction went into decline. Harold Burnham, a graduate of the Massachusetts Maritime Academy, initiated the revival of wooden shipbuilding techniques with the completion of a sixty-five-foot Gloucester schooner, the *Thomas E. Lannon*, in 1996. The *Lannon*, built for cultural tourism, was intended to convey both the practical and cultural importance of these fishing vessels. The attention that resulted from this achievement has led to other commissions for historic watercraft, and now Burnham Boat Building is the only shipyard in the country that regularly designs and builds sawn-frame vessels of this type.

This portrait was made on the water during a test voyage of the recently finished boat the *Ardelle*. It is a fifty-eight-foot, forty-five-ton pinky schooner, a locally favored small fishing vessel that gets its name because the stern is "pinked," or pinched together. Within a week, Harold Burnham and his crew would be departing on this boat to sail to Washington, DC, to attend the National Heritage Fellowship events. This was to be the first and only time that a recipient of the award arrived under sail power. The *Ardelle* made it down and back and now sails out of Gloucester, serving to educate visitors about wooden boat construction and maritime history.

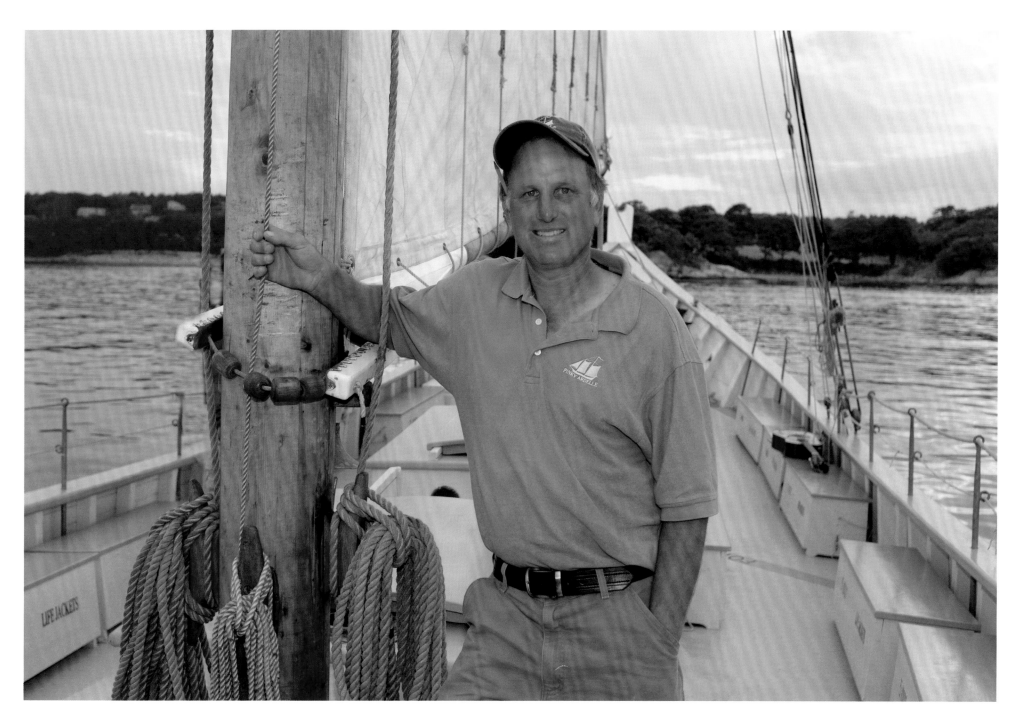

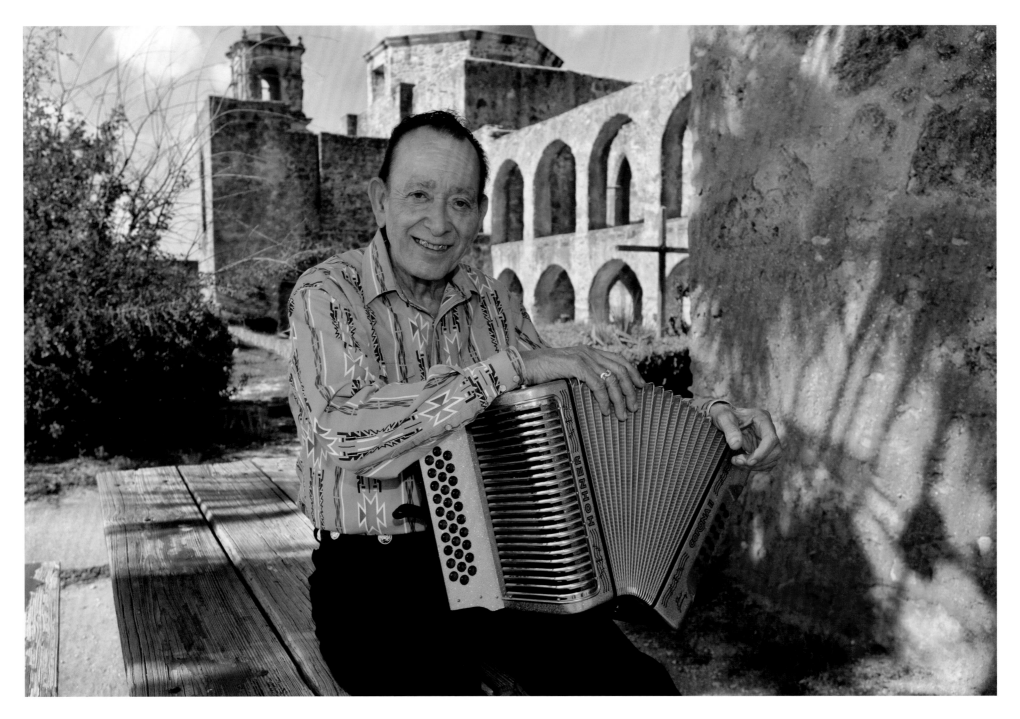

LEONARDO "FLACO" JIMÉNEZ

San Antonio, Texas | 2012

American roots music is the sharing and blending of different kinds of music, like a brotherhood thing. It makes the world rounder.

Flaco Jiménez learned to play the accordion at the side of his father, Santiago Jiménez Sr., a pioneer of conjunto tejano or norteno music. This style of music, sometimes called Tex-Mex, features the accordion as the lead instrument and combines Mexican traditions with German, Polish, and Czech musical sounds and repertoire. Flaco, or skinny, a name he inherited from his father, built his reputation playing in bars and dance halls in San Antonio. In the 1960s he entered the rock and roll realm, performing with Doug Sahm in a group called the Sir Douglas Quintet. This led to performances and recordings with other popular musicians, including Ry Cooder and the Rolling Stones. In the 1990s he joined a super-group called the Texas Tornados with Sahm, Freddy Fender, and Augie Meyers. His 2014 Smithsonian Folkways recording, *Flaco & Max: Legends and Legacies*, made with bajo sexto player and

leader of the Texmaniacs, Max Baca, garnered an Independent Music Award in the Latin Music category, to complement Flaco's five Grammys. In 2015 he received a Lifetime Achievement Award from the Grammy Foundation for his contributions to both Tejano and American musical heritage.

Flaco Jiménez wanted to be photographed at the historic Mission San José near the San Antonio River. The structure, completed in 1782, is now a National Park Service Historic Site, but it also serves a congregation. Because this fortress-like mission was a major social and cultural center during its time, it became known as the "Queen of the Missions," not a bad backdrop for someone often referred to as the "King of Tex-Mex Accordion."

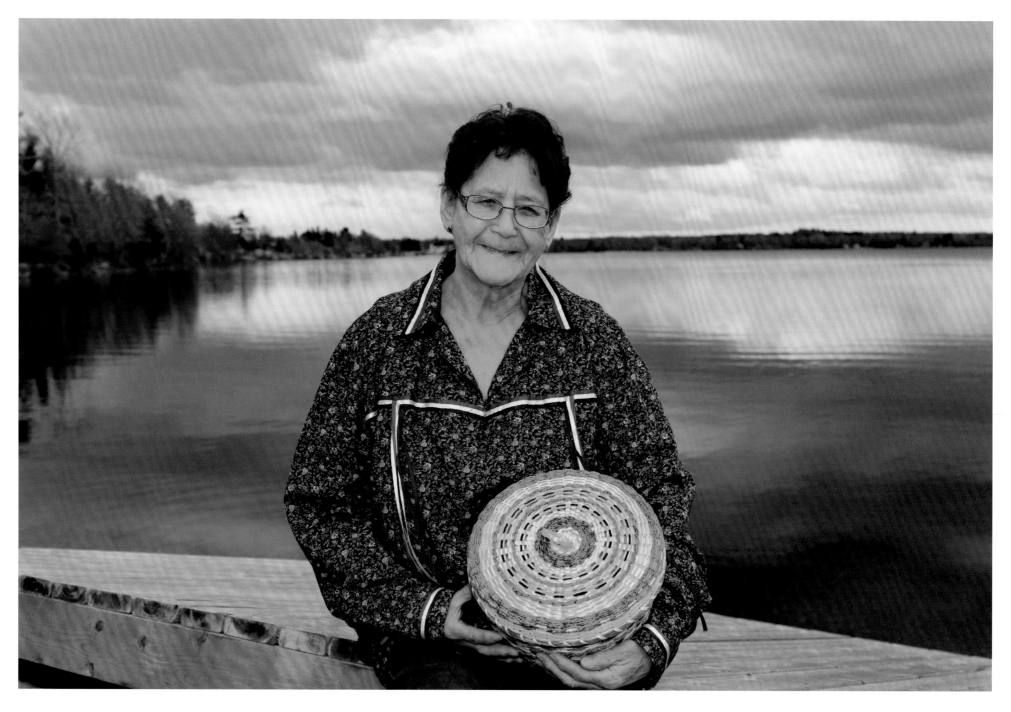

MOLLY NEPTUNE PARKER

Princeton, Maine | 2012

I see baskets in my sleep. The shape of things around me and the designs in nature have become my teachers, just as elders and fellow basketmakers have inspired me. It is the year-in, year-out practice that makes the artist out of the craft.

Born in Indian Township, Maine, Molly Neptune Parker traces her basketmaking roots to her great-grandmother, grandmother, mother, and aunts. Originally, this tradition involved the harvesting and pounding of the black ash tree and then splitting the growth rings into thick strips to make functional baskets. At one point, she and her husband, George Neptune, were weaving one hundred scale baskets a week, containers used in the fishing industry for collecting fish scales, an ingredient of nail polish. Today, Parker is best known for her inventive use of ash and sweetgrass to make highly decorative "fancy" baskets in the shape of acorns or strawberries, as well as others designed to be used as sewing baskets, with distinctive flower patterns on the lids. She has served as the president of the Maine Indian Basketmakers Alliance and taught in their apprenticeship program. Her efforts in educating the young, including four generations of her own family (nine children, thirty grandchildren, and sixteen great-grandchildren), have made her a key figure in the renaissance of Passamaquoddy basketry and language.

Tom Pich traveled to the Passamaquoddy Reservation in northeastern Maine in the month of February. One day prior to making this portrait, Pich and Parker attended an "ice out" ceremony to mark the date when the ice breaks away from the shore, the first hint that spring might be on the horizon. Schoolchildren came to the edge of the lake, and elders distributed packets of tobacco to be put on fragments of the ice and pushed away from the shore. It is thought that tidal currents will carry away disease and adversity along with the ice. This photograph taken behind Parker's house on Lewey Lake reveals calm waters already well free of the ice that was there the previous day.

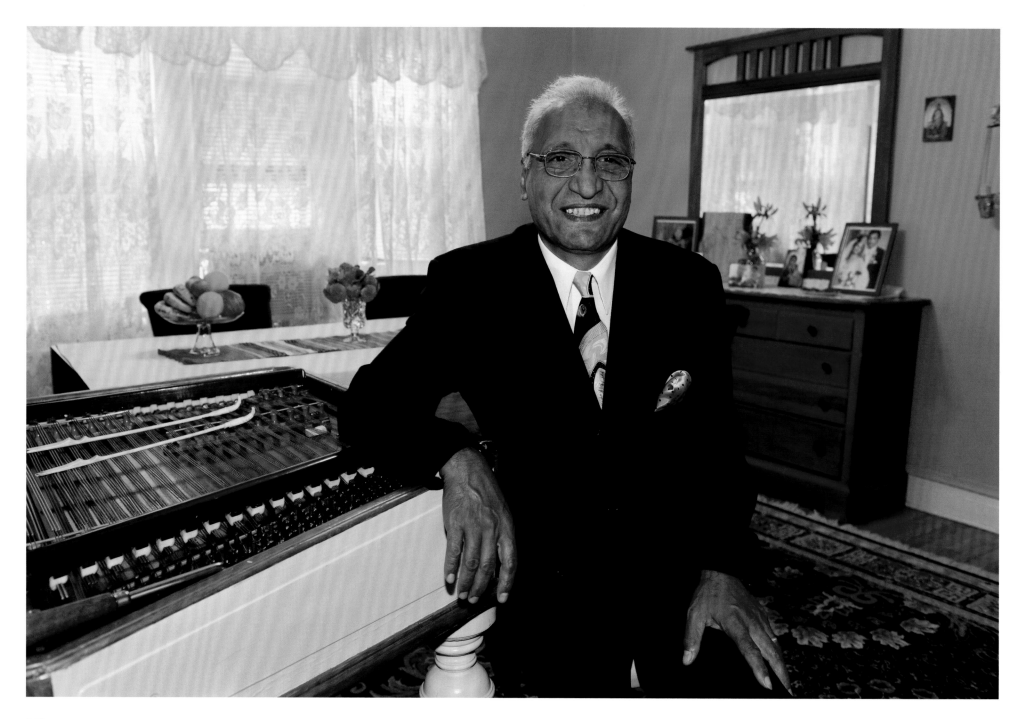

NICOLAE FERARU

Chicago, Illinois | 2013

I tell you the truth, when I play, I forget everything, if I am sick or I am hungry or I have problems with other things. And when I die, I will die with this instrument in my dreams. This was my life.

Born in Bucharest, Romania, Nicolae Feraru learned the music of the minstrels, or lautari, of Roma culture. Feraru's father, who was also a musician, warned him about taking up music because it would mean repeated, sleepless stretches performing for weekend-long weddings. Nicolae ignored the advice and became known as a master musician on the cimbalom, an instrument resembling a hammered dulcimer with 128 strings. For many years he played in restaurants in Bucharest and made influential recordings. When the political situation in Romania began to deteriorate, especially for Roma people, he seized an opportunity in 1988 to tour Canada and the United States, where he sought political asylum and eventually settled in Chicago. He continues to perform at festivals and in academic settings, as well as for family and community affairs, although he says he is thankful that today's weddings do not last quite as long as those his father described.

Tom Pich recalls of his visit with Feraru how proud he was to have received recognition from the United States government, especially in light of the indignity that he experienced under the previous Romanian government. He had once been filmed and recorded for a program by Romanian state television, but the producers had substituted an actor for the broadcast because they felt that he looked "too dark," or as he described it, too much like a "Gypsy."

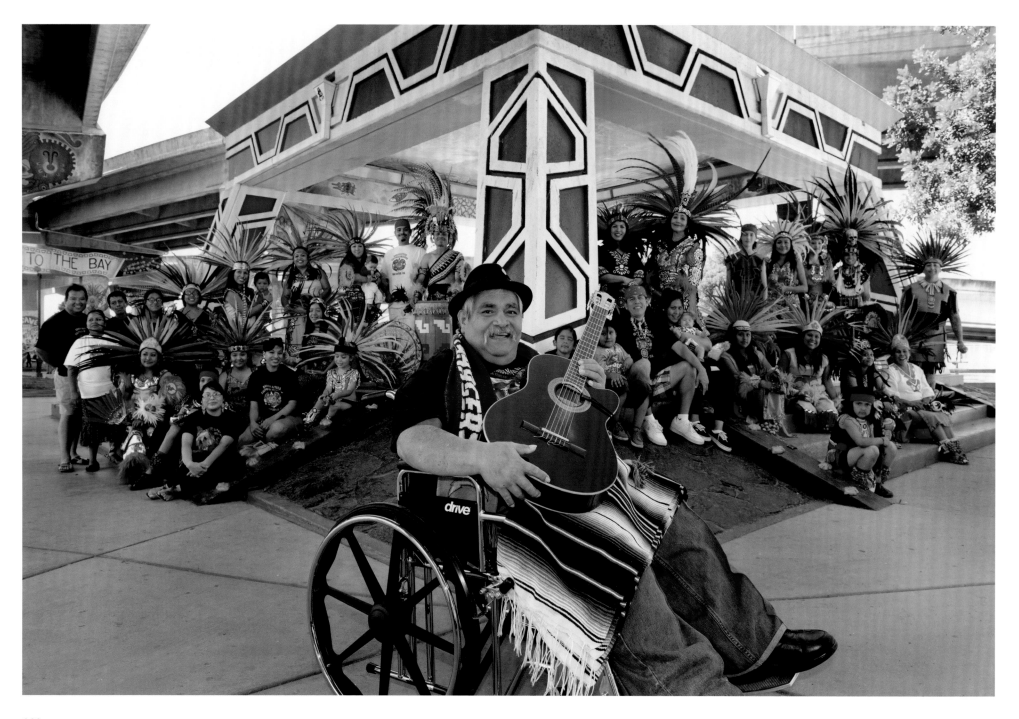

RAMÓN "CHUNKY" SÁNCHEZ

San Diego, California | 2013

I sing for people who are trapped in injustice, for education, history, heritage, everything that has to do with learning and studying.

The child of farmworker parents, Ramón "Chunky" Sánchez grew up working in the fields and listening to music that articulated and propelled the causes of the laborers in the fields. As he himself began to compose and sing songs of the movement, he was often asked by César Chávez to perform at United Farm Workers union rallies and marches. While attending San Diego State University, he joined folkloric musical groups, eventually founding, with his brother, an ensemble, Los Alacranes (The Scorpions), that proved to be central in the emerging Chicano music movement in southern California. He was also active in saving a small plot of land under the San Diego Coronado Bridge that had been scheduled for development but instead became a park for barrio residents. Today that park displays murals featuring Chicano heroes, including Sánchez himself. He went on to become a community mentor, working with local youth through sports programs and as an educator and gang intervention counselor.

Chunky Sánchez wanted to be photographed in Chicano Park where his activism as a student at San Diego State University had first launched his socially active career. As Tom Pich prepared to set up for the photograph, he noticed that cars filled with families were pulling up and unloading at the site, many sporting Aztec dress. Thinking there was to be a celebration or parade, he asked what might be happening. It turns out they were friends of Sanchez and members of Señor Flores's Danza Azteca Grupo Mexica, which performs Aztec dances, and they were there to support Chunky and witness the photo shoot. Sánchez agreed that the picture would not be complete without the community, and this photograph is the result. In 2017 Chicano Park was designated a National Historic Landmark on the National Register of Historic Places.

VERÓNICA CASTILLO

San Antonio, Texas | 2013

Since my parents conceived me, I have had an intimate and intense relationship with clay, as well as a fluid connection and contact with the earth and water that give shape to my art, a gift endowed at birth that has given my family its artistic legacy in folk art.

Verónica Castillo was born in the Mexican state of Puebla into a family that has been known for generations for its achievements in the ceramic arts. Her great-grandfather produced functional clay candelabras and incense burners, but relied on farming to earn a living. It was her grandmother who revived the pottery business and expanded the process of pottery making to include decorative pieces. Her father created figurative pieces, most famously those called "Tree of Life" sculptures. Originally meant to be wedding gifts, Tree of Life sculptures depicted Adam and Eve and portrayed scenes of community life. Verónica Castillo, who emigrated to the United States at the age of twenty-four, has been active as a teacher of ceramic arts and is known for her imaginative and complex clay figures. Her work often incorporates commentary on today's social and political issues.

It was not difficult to find a backdrop for Castillo's portrait; her home is filled with her artwork. After posing for the photograph, Castillo walked with Pich to an abandoned hardware store in the neighborhood that she wanted to convert into a community arts center. In July of 2014 she celebrated the opening of Ecos y Voces de Arte (Echoes and Voices of Art), a gallery dedicated to the work of underrepresented artists of the community. The altar at the dedication featured ceramic work from Castillo's grandparents and father.

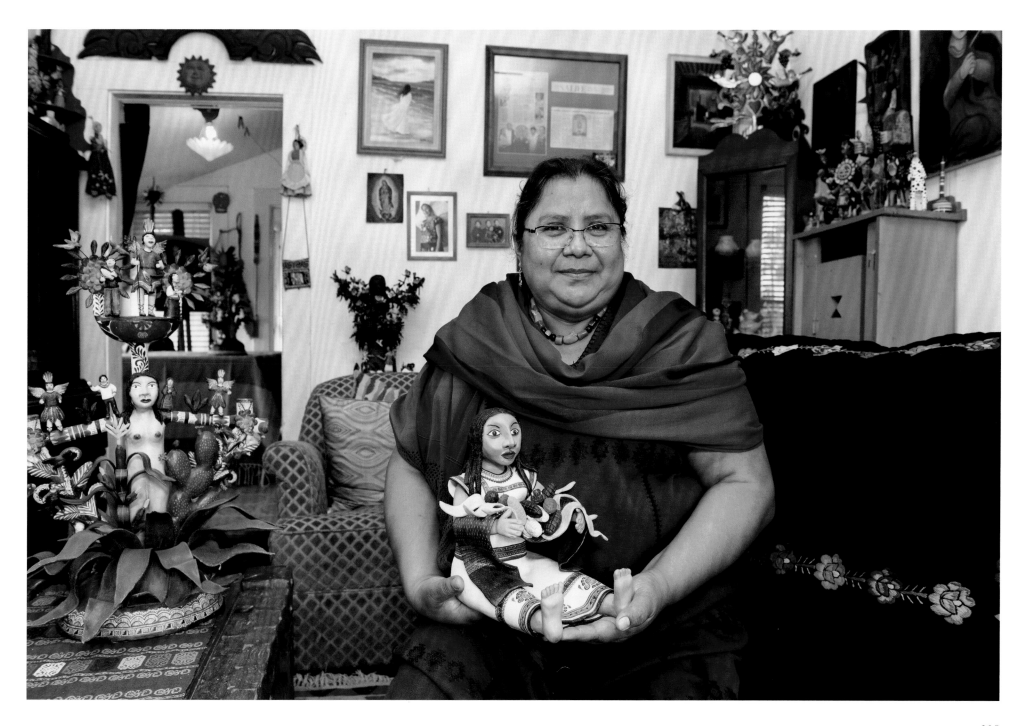

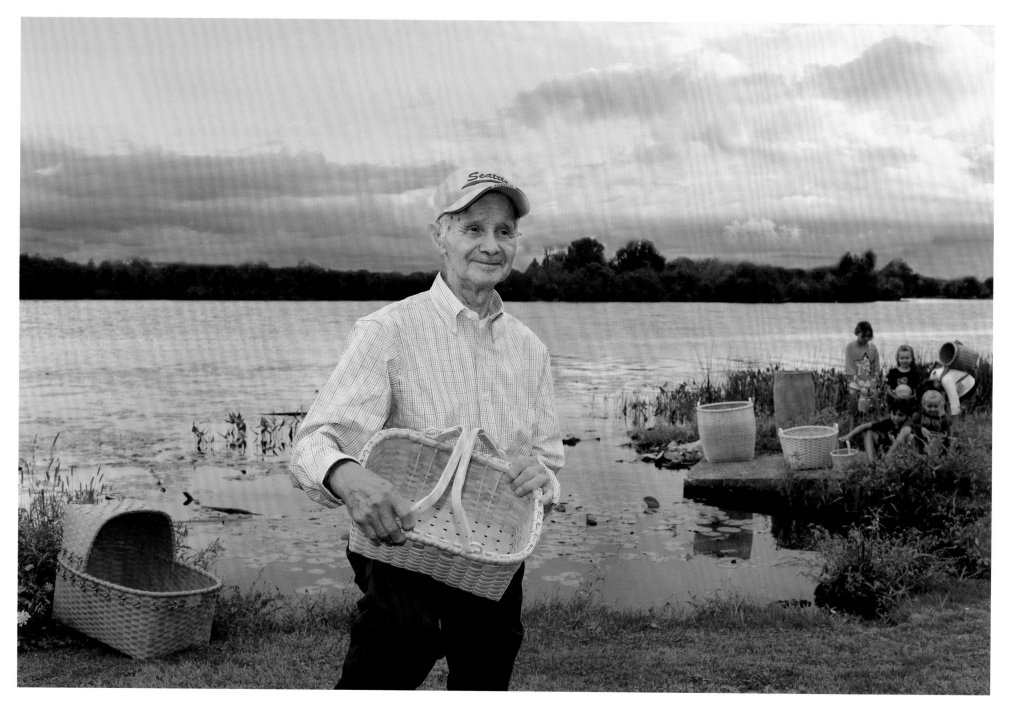

HENRY ARQUETTE

Hogansburg, New York | 2014

I make work baskets, not the fancy baskets that women make. I'm leaving that for them, because they can do that much better than I can.

Henry Arquette was a retired ironworker who, like many young Mohawk men, worked on the construction of skyscrapers and bridges in the northeastern United States to earn a living, supplementing his income by constructing ash baskets. Most were utilitarian pack, laundry, picnic, and corn-washing baskets made out of black ash. After Arquette retired, he returned to the Akwesasne Reservation near the border between New York State and Canada and taught basketmaking skills at cultural centers and in museums around the region. Because the black ash tree has become threatened due to overharvesting and insect infestation, Arquette was also an active advocate for protecting forest resources. In 2001 he received the Ralph Silversides Forestry Award from the National Aboriginal Forestry Association for his work on behalf of the environment.

For this portrait, Henry Arquette's grandchildren helped carry some of his baskets to the St. Regis River just behind his home on the Akwesasne Reservation. Arquette holds a small picnic basket, while his grandchildren play near a variety of carrying baskets. The child leaning over has a small pack basket on his back. Baskets play a significant role in Mohawk culture, including their use in wedding ceremonies, when the bride and groom traditionally exchange baskets as a sign of mutual commitment. The bassinette positioned to Arquette's right might be considered the Mohawk version of a cradleboard.

DOLLY JACOBS

Sarasota, Florida | 2015

Believe it or not, the higher you go the less you feel the gravity for some reason and I don't know if it's just in your mind but you ask any aerialist and they'll tell you the same. When you're down low you feel heavier and when you're up high you feel much lighter, and it's always good to feel your weight.

Not unlike many traditional art forms, the knowledge and skills of circus performers are passed along through families. Dolly Jacobs, a circus aerialist who is known as the "Queen of the Air," was born to parents who were part of the Ringling Brothers and Barnum and Bailey circus community. The face of her father, Lou Jacobs, is perhaps the most recognizable of the circus clowns', as it became the iconic image for Ringling Brothers and Barnum and Bailey and was depicted on a US postage stamp. Dolly specialized in high-flying and ballet-like performances on the rings and gained a reputation for her physical strength and expressive grace. In 1997 she and her husband, Pedro Reis, who handles her rigging

and acts as ringmaster, founded a school of circus arts to pass along these demanding circus skills to a younger generation.

Tom Pich visited Florida to photograph Jacobs in performance at her home base, Circus Sarasota. A tent full of acrobats, jugglers, and clowns, not to mention an enthusiastic audience, presented a particular challenge for a photographer. Shooting from a position in the audience, Pich was able to capture the sculptural beauty of a spiraling Dolly Jacobs and demonstrate both the physical strength and the fragile interdependence required in aerial art.

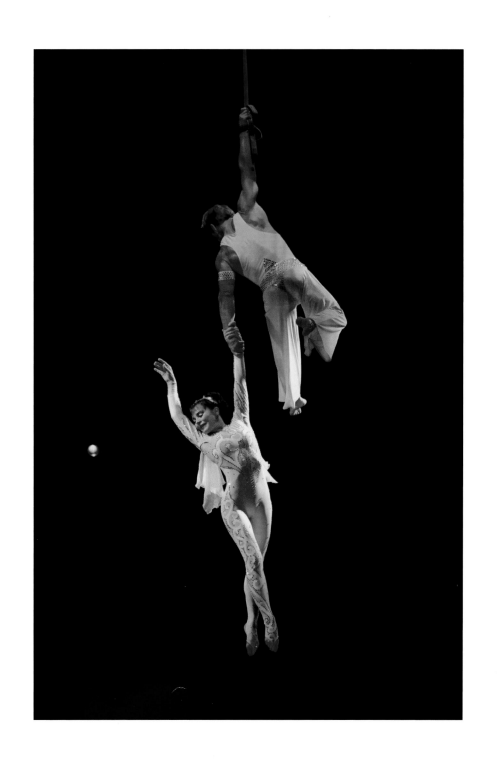

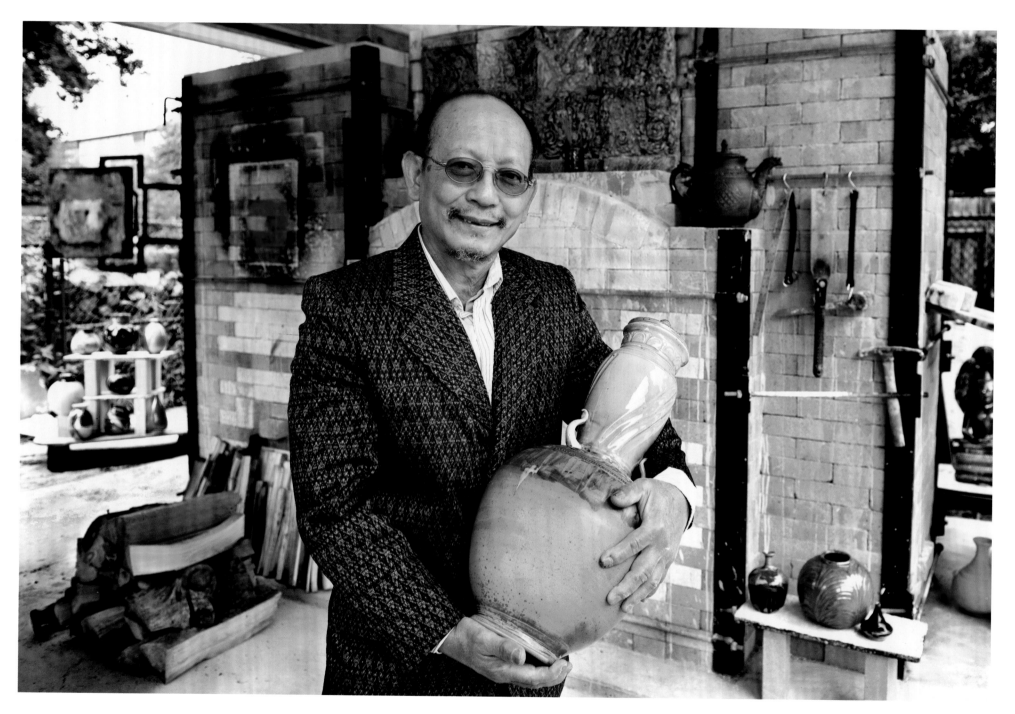

YARY LIVAN

Lowell, Massachusetts | 2015

When gain is not the focus, there is no cheating, just pure, honest expressiveness. Artwork is no liar.

It is thought that Yary Livan is one of only three Cambodian master ceramicists to have survived the Khmer Rouge genocide in the 1970s. His knowledge of building kilns and firing roof tiles saved his life, because members of the Pol Pot regime realized that they needed his skills to make roof tiles for the purpose of construction. After escaping from his oppressors, he moved among refugee camps until coming to the United States in 2001, seeking political asylum. Having matriculated at the Royal University of Fine Arts in Phnom Penh, by 2002 Livan became a visiting artist in the Ceramics Program at Harvard. He taught traditional and contemporary Cambodian sculptural techniques, including modeling, carving, and casting. In 2012 he built a wood-fired kiln so that he could continue to teach and practice Cambodian traditional techniques that date to the sixth century.

Lowell, Massachusetts, has the second-largest population of Cambodians in the United States, and Yary Livan has become an artistic leader in that community. When Tom Pich arrived for his visit, Livan and a group of volunteers had stacked wares and rebricked the opening of his kiln prior to firing. The photo was taken the following day in front of the kiln, already being stoked and tended by Livan and his friends. Scattered in the background are a number of finished pots, while a stack of wood rests near the kiln opening, ready for later use.

QUILTERS OF GEE'S BEND
Loretta Pettway, Lucy Mingo, and Mary Lee Bendolph
Boykin, Alabama | 2015

My quilts looked beautiful to me, because I made what I could make from my head. When I start I don't want to stop until I finish, because if I stop, the ideas are going to go one way and my mind another way, so I just try to do it while I have ideas in my mind.
—Loretta Pettway

Nestled in a bend of the Alabama River, the community of Boykin has been known as a center of quilt making since the early nineteenth century, when female slaves sewed together strips of cloth to fashion bedcovers. Some quilters from Gee's Bend, as Boykin was formerly known, joined the Freedom Quilting Bee during the 1960s as part of that civil rights–era economic initiative. In 2002 the Museum of Fine Arts in Houston put together an exhibition, *The Quilts of Gee's Bend*, that displayed these handmade bed coverings as artistic statements. Opening in Houston, the exhibition toured to the Whitney Museum of American Art and the Museum of Fine Arts in Boston. Among the quilters featured in that exhibition, Mary Lee Bendolph, Lucy Mingo, and Loretta Pettway represent the inventive excellence of the Gee's Bend quilting tradition. In 2006 the US Postal Service honored the Gee's Bend quilters with a series of postage stamps depicting their work.

After several days visiting with and photographing Bendolph, Mingo, and Pettway individually, Pich made a group portrait in front of Loretta Pettway's home. Each woman displays one of her quilts. When not posing for photos, Pich said, the quilters enthusiastically shared stories and songs, as they might do when quilting together. The housing in Gee's Bend has a connection to documentary photography projects of the Depression era. In 1937, Arthur Rothstein was instructed by Roy Stryker, director of the Farm Security Administration photography project, to document the housing conditions in Gee's Bend. Many of the photographs he recorded were of residents with the name Pettway, including a photo of a quilter named Jorene Pettway. The photographs, many depicting log cabins, resulted in a Resettlement Administration–funded building project to construct what were considered to be more modern living quarters, including the home behind the quilters.

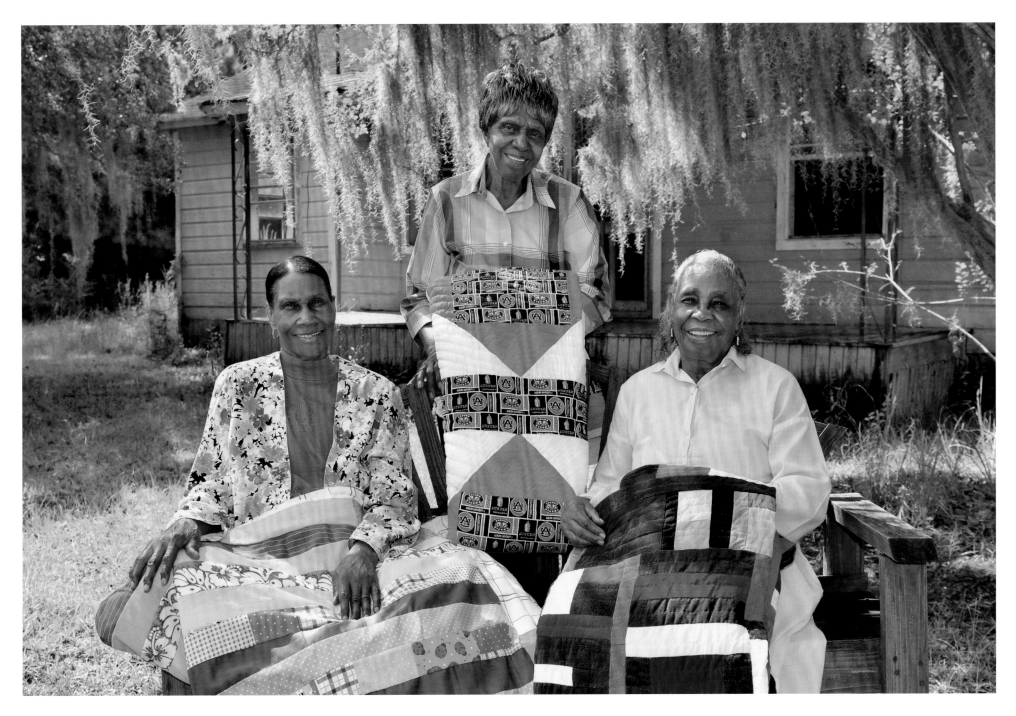

BILLY McCOMISKEY

Baltimore, Maryland | 2016

I guess the beautiful thing about the music is it's self-sustaining, and you fall in love with it. You have to have it. It becomes who you are.

In his musical journey from Brooklyn to Baltimore, Billy McComiskey was rarely very far from a button accordion, or "box" as he calls it. Growing up surrounded by Irish musicians in New York, he had the opportunity to meet some of the masters who had come to the United States in the first wave of immigration. His godfather owned a pub in the Catskills, often referred to as the Irish Alps because it is where Irish families vacationed in the summer. On one family trip to the Catskills, McComiskey heard the great accordion player Sean McGlynn and said it was like a "horse kicking my head." McGlynn became his musical mentor and dear friend, and soon McComiskey was winning All-Ireland championships. In the mid-1970s McComiskey, fiddler Brendan Mulvihill, and guitarist Andy O'Brien became the house band at the Dubliner in Washington, DC, in the shadow of the capitol. After McComiskey married, he settled in Baltimore, and although he worked at a day job, he became a central figure not only in the local scene, but in Irish music in America.

Tom Pich met Billy McComiskey while he was teaching accordion classes at an Irish music camp in suburban Washington, DC. The musician said that he would be driving back home to Baltimore that evening to perform at an Irish bar as a favor to its owner, who was having difficulty attracting clients in a neighborhood that had experienced some recent unrest. Pich took McComiskey's portrait in front of that venue during a break in the action. Toward the end of their evening together, McComiskey drove Pich back to his car and they spent some time reminiscing about another great accordion player and National Heritage Fellow whom Pich had photographed, Joe Derrane. Derrane had been another inspiring model for McComiskey, who mused that although Joe had written an accordion tune for him and named it after him, he had never been able to play it as well as Joe. The following day, McComiskey called Tom to let him know that Joe Derrane had passed away that evening.

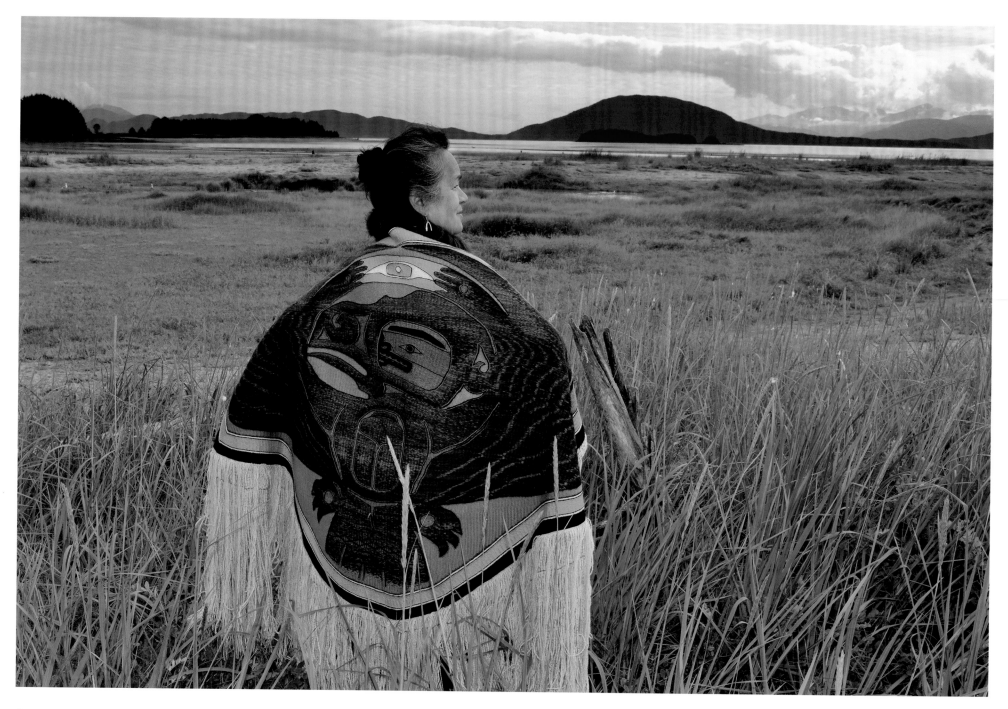

CLARISSA RIZAL

Juneau, Alaska | 2016

After learning Chilkat, I gained the art of patience, the way of gratitude, and the act of compassion. The universe opened its doors with a flood of information, the kind of information not definable, yet powerfully written in our Native art, in the ways of our people, and in our commune with nature.

Clarissa Rizal received training in Chilkat blanket weaving from 1986 NEA National Heritage Fellow Jennie Thlunaut. At the time, Thlunaut, 95, was the oldest woman still practicing this art form. Rizal took up her mentor's challenge to not only learn the skills and knowledge needed for Chilkat weaving, but also to accept the responsibility for teaching others this endangered technique. The Chilkat, the northernmost of the Pacific Coast tribes in Alaska, used twined cedar bark and mountain goat wool to weave rugs that usually depicted animal and clan symbols. In 2016 Rizal organized a "Weavers Across the Water" project, creating a robe composed of fifty-four squares woven by forty weavers and sewn together to celebrate the opening of the Huna Tribal House in Glacier Bay National Park.

Tom Pich was able to catch up with Clarissa Rizal in Juneau on her way to deliver the Weavers Across the Water robe, which turned out to be her last project, to the Huna Tribal House. She wanted her portrait taken in the landscape that informed her work, so they went to Eagle River Beach near Juneau. Rizal donned her recently completed "Egyptian Thunderbird" Chilkat robe and turned, facing away, as participants in ceremonies so often do, to introduce themselves and to reveal their clan lineage to fellow community members. The color and pattern of the robe blend perfectly with the landscape, illustrating Rizal's beliefs about the deep connection between her artwork and her natural surroundings.

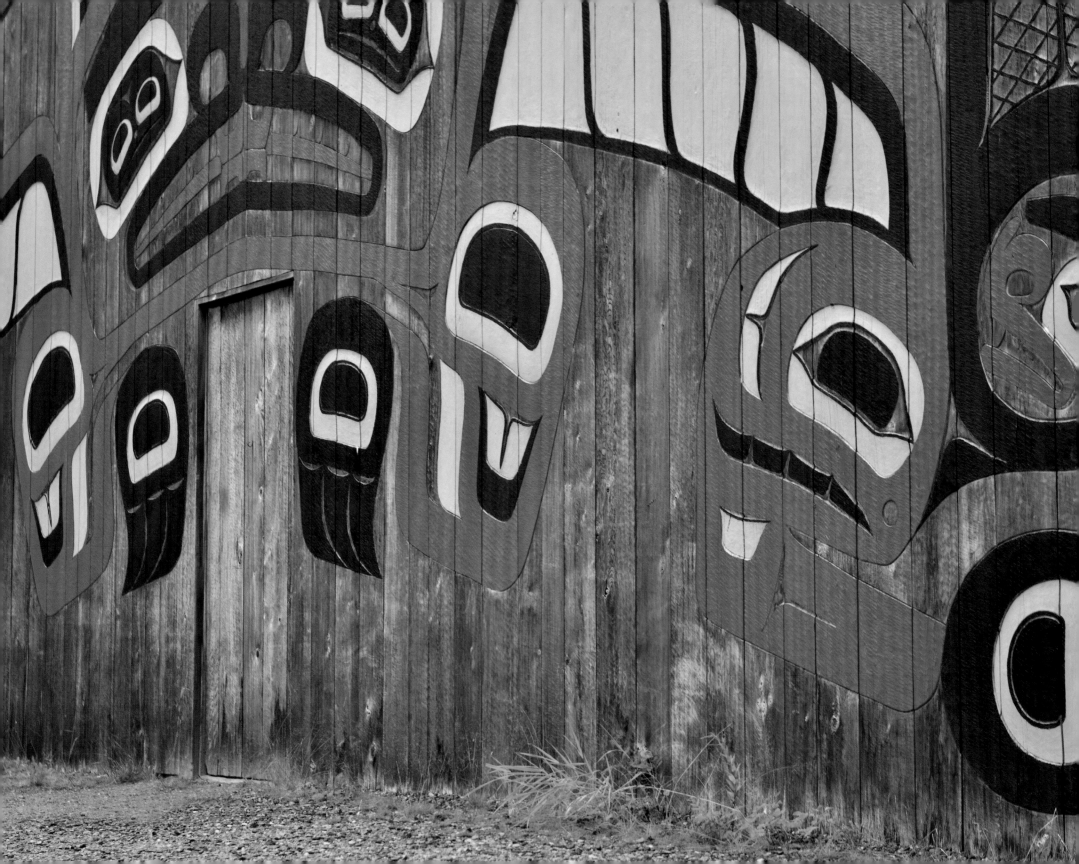

Exterior of Beaver House at Saxman Totem Park, Ketchikan, Alaska, carved and originally painted in the late 1980s by 1995 Heritage Fellow Nathan Jackson.

ACKNOWLEDGMENTS

FIRST AND FOREMOST, I would like to thank my wife, Tara, for without her support over the past twenty-five years, this project would never have happened. One of our first outings together was an excursion looking for an eighty-year-old painting on the side of a barn in northern Connecticut's tobacco country. In 1995, she gave me a copy of the book *Charles Kuralt's America*, and perhaps that was an omen of things to come. Kuralt's book included accounts of visits to two National Heritage Fellows, Philip Simmons and Wally McRae, and by that time he had emceed the Heritage concert for four years. Tara has been a constant source of encouragement and ideas throughout this journey.

When I set off on my first trip, our daughter Catherine was a one-year-old and Eliza was not yet born. Our daughters have grown and matured along with this portfolio of Heritage portraits, and in later years each has accompanied me on my travels. Catherine came along to photograph cuatro-maker Julio Negrón Rivera in Puerto Rico and was instrumental in helping me conceive of how to photograph him in his workshop. During a ten-day excursion to Texas, it was the playful interaction of Eliza with cowboy poet Joel Nelson that inspired me to look beyond the viewfinder and reframe my perspective. I believe that her photographs of Joel and his wife are still some of the most striking ones taken on that trip.

Thanks also go to my extended family. My grandmother, Eileen Mitchell, told stories of growing up in Ireland that sparked my interest in wanting to know more about the people outside my neighborhood. Little did I know that that neighborhood would morph into the entire American landscape. I constantly pestered my mother, Ann, and brothers, Peter and Kevin, with my picture

taking as I continued to practice my craft. I am grateful to my sister, Donna, who supported my desire to go to art school even though that was an unusual career path for my family. My dad, sending me off to a photography program at Rochester Institute of Technology, took me to Penn Station in New York early one Sunday morning and put me on the train, saying, "Good luck and call your mother." He was supportive, even if unconvinced that I was on the right track.

Learning about the National Heritage Fellowship program put me in touch with many dedicated and helpful people in Washington, DC. It was Marjorie Hunt's story in *National Geographic* featuring National Heritage Fellows that piqued my interest in these artists. She is now a program curator at the Center for Folklife and Cultural Heritage at the Smithsonian Institution, and her friendship and support is valued and continues to this day.

Rose Morgan, the first person that I spoke with at the National Endowment for the Arts, suggested that I come to Washington, DC, and following my knock on the large oak door leading to the Folk Arts program's offices, Rose led me to the corner office of then-director Dan Sheehy. Dan embraced my desire to meet and photograph these master artists, and that encouragement started me down this path. He introduced me to Mark Puryear, who assisted me with contact information, locations, and directions in every region of the country.

Lifelong friends Michael Singer and Michael Nash have been with me from the beginning. At times I'm sure that we were an amusing trio, three guys from the Bronx exploring the highways and byways and interacting with communities that we knew only from books and movies. We have shared our stories with Creole fiddlers, Native American basket weavers, and Ukrainian egg painters, and we have listened to the stories of the artists and their families, neighbors, and friends. The result has been a far greater appreciation of the diversity of American geography and culture. A special thanks to Michael Singer, who, after retiring from the postal service, has devoted much of his time to traveling and documenting with me, and coming to Washington, DC, each September to help in the photographing of the Heritage events.

My thanks and appreciation goes to Madeleine Remez from the National Council for the Traditional Arts, who welcomed me and my family and provided a front-row seat to witness some of the most talented and unassuming artists we could ever imagine.

I also want to recognize the folklorists at the state and regional arts agencies across America who have helped me in contacting National Heritage Fellows. People such as Carol Edison, then based at the Utah Arts Council; Charlie Seemann, past executive director of the Western Folklife Center in Elko, Nevada; and Amy Kitchener, director of the Alliance for California Traditional Arts, and their many colleagues, have been of great assistance.

I first met Mick Moloney while he was being honored in 1999, and from the moment I shared my vision with him, he has encouraged me to continue documentation. A trip with him to Ireland was one of my most educational, not to mention enjoyable, adventures.

Dana Gioia, chairman of the NEA from 2003 to 2009, honored me by displaying my portraits of Heritage Fellows and NEA Jazz Masters on two floors of the Old Post Office on Pennsylvania Avenue in Washington, DC. In 2004, he asked me to reenact the famous 1958 *Esquire* photograph taken of fifty-eight jazz musicians entitled "A Great Day in Harlem" with twenty-three of the contemporary NEA Jazz Masters. That was a great honor.

Many thanks to Joe Wilson and Kathy James. Their door in Fries, Virginia, has always been open for me, and I am one of a long line of visitors who has benefited from their wisdom and hospitality. In September of 2009 I came to Washington to attend events surrounding Joe's Living Legend award from the Library of Congress.

A distinguished panel discussion on the following day included Virginia folklorist Jon Lohman and "American Routes" radio host Nick Spitzer, followed by Joe Wilson. As Joe spoke about how he approached documenting folk artists, their words, their music, and their environment, I realized that my work had fallen short. From that time forward, I rededicated myself to spending more time with each artist and doing a more thorough job of documentation beyond simple portraiture.

The Public Affairs Office at the NEA has been a great help. Liz Auclair has been my constant contact for work related to the National Heritage Fellows. Victoria Hutter has worked with me on both the Heritage Fellowships and the Jazz Masters program. Donald Ball was the first to include my photographs in NEA publications. Josephine Reed does wonderful work with interviews and podcasts related to Heritage, and David Low has generously given me a visual presence on the NEA website.

The Folk and Traditional Arts staff at NEA continues to be a partner in this work. Cheryl Schiele has been a friend, a colleague, and wonderful source of information. Cliff Murphy, since his appointment to the director's position, has embraced my efforts. Bill Mansfield and Michael Orlove have also been supportive through the years.

My special thanks to a couple of friends, Tom Mantione and Andrew Shantz, and their families, for their recognition and support for my work. A couple of years ago I started showing them photographs and video snippets of my visits to Heritage Fellows, and since then they have been enthusiastic allies.

Malcolm and Sue Knapp are wonderful supporters of the arts with a deep admiration for the National Heritage Fellowship program. Malcolm loves the Southwest, and since I have known him, he has told me stories about his visits with weaver Irvin Trujillo, whom he nominated for a Heritage Fellowship. His advice and counsel helped make my visit to Irvin's studio in Chimayo a wonderful experience. I realize that Malcolm and I share a passion for these artists. For a number of years he made a significant contribution to the quality of the annual celebrations honoring the NEA Fellows by procuring private support for these activities.

Thanks to my dear friend and collaborator Barry Bergey, who shares my passion for our nation's artistic heritage. We have spent many hours together on the road, in our homes, and on the phone. He has shared decades of knowledge and stories about these artists. Barry's wife, Jean, has supported me through her belief in and assistance with this project. Special thanks to their talented kids, Matthew and Claire, for helping envision this book. The Bergeys have introduced me to some fine folks. You would know what I mean if you ever attended one of Barry and Jean's house parties, which often include musicians, artists, and folklorists from around the region.

My sincerest thanks to all the National Heritage Fellows across our wonderfully diverse country for inviting me into their homes, workshops, and lives and for allowing me to join them and their families in celebrating this great honor. The individuals who receive this award reflect the best of America's past, present, and future.

I will be forever grateful.

Tom Pich
Cos Cob, Connecticut | April 2017

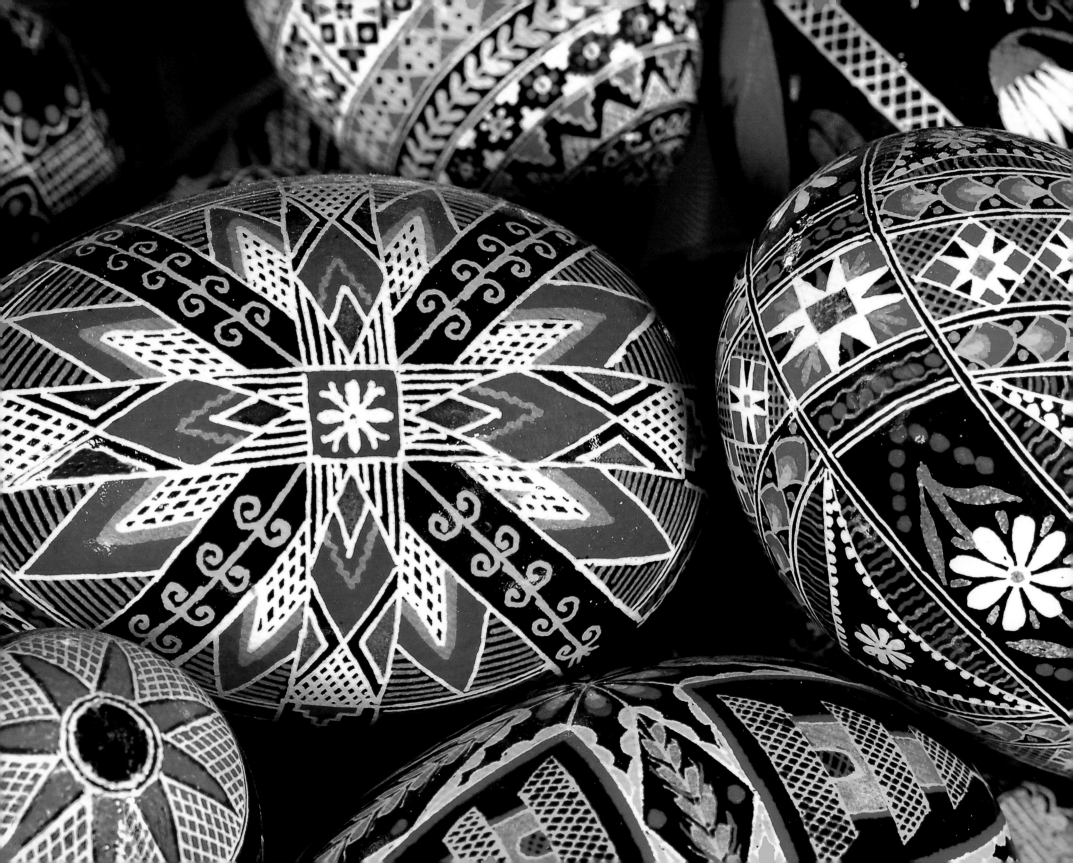

Pysanky (painted eggs) of 1996 Heritage Fellow
Betty Pisio Christenson.

ACKNOWLEDGMENTS

OVER MEMORIAL DAY weekend in 1985 I drove nearly a third of the way across the country, from Missouri to Washington, DC, to start a new job at the National Endowment for the Arts. My destination was an apartment that I had secured sight unseen and my purpose was to embark on a career that I could hardly imagine. I joined a small staff in the Folk Arts Program—Daniel Sheehy, Pat Sanders, Rose Morgan, and Pat Makell—led by a visionary director with big ideas. That director, Bess Lomax Hawes, was developing ways to support the work of myriad and largely unheralded folk and traditional artists dispersed across our nation's cultural landscape. I had the good fortune to arrive at a time when the program was still in the process of realizing that vision—building an infrastructure of folklorists at state arts agencies and cooperating institutions; initiating an apprentice-ship program to help perpetuate the unique knowledge, skills, and commitment to excellence of accomplished folk artists; and developing the National Heritage Fellowships to honor the contributions of master artists. Over the ensuing thirty years, I had the pleasure of serving alongside many committed staff members and cultural specialists at this model agency, and I thank them for their congeniality and support. Today, Cliff Murphy, Cheryl Schiele, Bill Mansfield, and Jennie Terman carry on that work in the Folk & Traditional Arts Program.

During my years at NEA we attempted to continually expand the reach of the public presentations related to the Heritage Program to broaden the impact of the awards. The National Council for the Traditional Arts was our partner in that process, and Joe Wilson, Julia Olin, and Andy Wallace played significant roles in that

effort. Madeleine Remez has been a key ally and continues to coordinate the Heritage events, making sure that the artists, some of whom are not terribly comfortable with the idea of a trip to Washington, DC, or the glare of the public spotlight, are well served.

The Heritage Fellowships also provided the first opportunity to meet and collaborate with Tom Pich, and that ultimately led to this publication. His skills as a photographer are matched only by his infectious amiability, his commitment to this self-motivated project, and his continued engagement with the artists and families he has visited and documented. Fortunately for me in attempting to write about his documentary journey, Tom, like most of the Heritage Fellows, has a gift for storytelling.

In the process of completing this text, I have benefited from the assistance of Daniel Sheehy, Cheryl Schiele, Charlie Seemann, Jon Lohman, Alan Govenar, Lauren Deutsch, Pratibha Patel, and Miyako Tachibana. Kurt Dewhurst did us the great favor of suggesting that we talk with Gary Dunham and Janice Frisch of Indiana University Press about our book ideas.

Most of all, thanks to my family. My wife Jean's suggestions on the difficult selection of photographs and her editing skills are evident throughout this work, and our daughter, Claire, offered valuable suggestions on design and content. We kidnapped our son, Matthew, from his studies at Rhode Island School of Design one weekend to help with the design and layout of a prototype for this publication. Thanks, Matt!

Finally, and most importantly, my appreciation goes to the more than 400 National Heritage Fellows who have been honored by the National Endowment for the Arts. Your contributions to our nation's living cultural heritage inspired this work, and your continuing impact is the reason our work is never done.

Barry Bergey
Bethesda, Maryland | April 2017

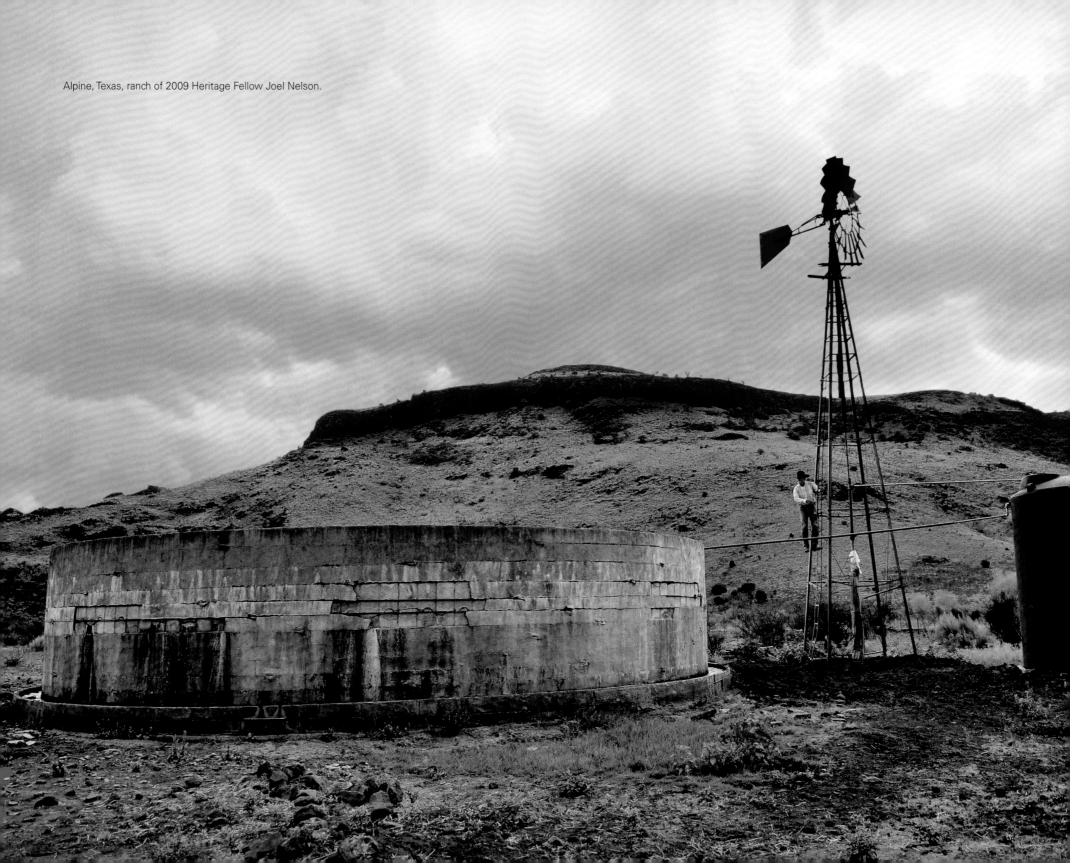

Alpine, Texas, ranch of 2009 Heritage Fellow Joel Nelson.

"Housetop" variation mural of US Postage Stamp Collection quilt by
2015 Heritage Fellow Mary Lee Bendolph on Gee's Bend Quilt Mural Trail.
http://www.ruralswalabama.org/attraction/the-gees-bend-quilt-mural-trail/

COMPLETE LIST OF NEA NATIONAL HERITAGE FELLOWSHIP AWARDEES, 1982–2016

1982

Dewey Balfa, Cajun Fiddler, Basile, LA

Joe Heaney, Irish Singer, Brooklyn, NY

Tommy Jarrell, Appalachian Fiddler, Mt. Airy, NC

Bessie Jones, Georgia Sea Island Singer, Brunswick, GA

George Lopez, Santos Woodcarver, Cordova, NM

Brownie McGhee, Blues Guitarist/Singer, Oakland, CA

Hugh McGraw, Shape Note Singer, Bremen, GA

Lydia Mendoza, Mexican American Singer, San Antonio, TX

Bill Monroe, Bluegrass Musician, Nashville, TN

Elijah Pierce, Carver/Painter, Columbus, OH

Adam Popovich, Tamburitza Musician, Dolton, IL

Georgeann Robinson, Osage Ribbon Worker, Bartlesville, OK

Duff Severe, Saddlemaker, Pendleton, OR

Philip Simmons, Ornamental Ironworker, Charleston, SC

Sanders "Sonny" Terry, Blues Harmonica/Singer, Holliswood, NY

1983

Sister Mildred Barker, Shaker Singer, Poland Spring, ME

Rafael Cepeda, Bomba Musician/Dancer, Santurce, PR

Ray Hicks, Appalachian Storyteller, Banner Elk, NC

Stanley Hicks, Appalachian Musician/Storyteller/Instrument Maker, Vilas, NC

John Lee Hooker, Blues Guitarist/Singer, San Francisco, CA

Mike Manteo, Sicilian Marionettist, Staten Island, NY

Narciso Martinez, Texas-Mexican Accordionist/Composer, San Benito, TX

Lanier Meaders, Potter, Cleveland, GA

Almeda Riddle, Ballad Singer, Greers Ferry, AR

Joe Shannon, Irish Piper, Chicago, IL

Simon St. Pierre, French American Fiddler, Smyrna Mills, ME

Alex Stewart, Cooper/Woodworker, Sneedville, TN

Ada Thomas, Chitimacha Basketmaker, Charenton, LA

Lucinda Toomer, African American Quilter, Columbus, GA

Lem Ward, Decoy Carver/Painter, Crisfield, MD

Dewey Williams, Shape Note Singer, Ozark, AL

1984

Clifton Chenier, Creole Accordionist, Lafayette, LA

Bertha Cook, Knotted Bedspread Maker, Boone, NC

Joseph Cormier, Cape Breton Violinist, Waltham, MA

Elizabeth Cotton, African American Singer/Songster, Syracuse, NY

Burlon Craig, Potter, Vale, NC

Albert Fahlbusch, Hammered Dulcimer Player/Builder, Scottsbluff, NE

Janie Hunter, African American Singer/Storyteller, Johns Island, SC

Mary Jane Manigault, African American Seagrass Basketmaker, Mt. Pleasant, SC

Genevieve Mougin, Lebanese American Lace Maker, Bettendorf, IA

Martin Mulvihill, Irish American Fiddler, Bronx, NY

Howard "Sandman" Sims, African American Tap Dancer, New York, NY

Ralph Stanley, Bluegrass Banjo Player/ Appalachian Singer, Coeburn, VA

Margaret Tafoya, Santa Clara Pueblo Potter, Espanola, NM

Dave Tarras, Klezmer Clarinetist, Brooklyn, NY

Paul Tiulana, Inupiat (King Island) Mask Maker/Dancer/ Singer, Anchorage, AK

Cleofas Vigil, Hispanic Storyteller/Singer, San Cristobal, NM

Emily Kau'i Zuttermeister, Hula Master (Kumu Hula), Kaneohe, HI

1985

Eppie Archuleta, Hispanic Weaver, San Luis Valley, CO

Periklis Halkias, Greek Clarinetist, Astoria, Queens, NY

Jimmy Jausoro, Basque Accordionist, Boise, ID

Mealii Kalama, Hawaiian Quilter, Honolulu, HI

Lily May Ledford, Appalachian Musician/Singer, Lexington, KY

Leif Melgaard, Norwegian Woodcarver, Minneapolis, MN

Bua Xou Mua, Hmong Musician, Portland, OR

Julio Negrón Rivera, Puerto Rican Instrument Maker, Morovis, PR

Alice New Holy Blue Legs, Lakota Sioux Quill Artist, Rapid City, SD

Glenn Ohrlin, Cowboy Singer/Storyteller/Illustrator, Mountain View, AR

Henry Townsend, Blues Musician/Songwriter, St. Louis, MO

Horace "Spoons" Williams, Percussionist/ Poet, Philadelphia, PA

1986

Alphonse "Bois Sec" Ardoin, Creole Accordionist, Eunice, LA

Earnest Bennett, Anglo-American Whittler, Indianapolis, IN

Helen Cordero, Pueblo Potter, Cochiti, NM

Sonia Domsch, Czech American Bobbin Lace Maker, Atwood, KS

Canray Fontenot, Creole Fiddler, Welsh, LA

John Jackson, African American Songster/Guitarist, Fairfax Station, VA

Peou Khatna, Cambodian Court Dancer/Choreographer, Silver Spring, MD

Valerio Longoria, Mexican American Accordionist, San Antonio, TX

Doc Tate Nevaquaya, Comanche Flutist, Apache, OK

Luis Ortega, Hispanic American Rawhide Worker, Paradise, CA

Ola Belle Reed, Appalachian Banjo Picker/Singer, Rising Sun, MD

Jennie Thlunaut, Tlingit Chilkat Blanket Weaver, Haines, AK

Nimrod Workman, Appalachian Ballad Singer, Mascot, TN, and Chattaroy, WV

1987

Juan Alindato, Carnival Mask Maker, Ponce, PR

Louis Bashell, Slovenian Accordionist, Greenfield, WI

Genoveva Castellanoz, Mexican American Corona Maker, Nyssa, OR

Thomas Edison "Brownie" Ford, Anglo-Comanche Cowboy Singer/Storyteller, Herbert, LA

Kansuma Fujima, Japanese American Dancer, Los Angeles, CA

Claude Joseph Johnson, African American Religious Singer/Orator, Atlanta, GA

Raymond Kane, Hawaiian Slack Key Guitarist/Singer, Wai'ane, HI

Wade Mainer, Appalachian Banjo Picker/Singer, Flint, MI

Sylvester McIntosh, Crucian Singer/Bandleader, St. Croix, VI

Allison "Tootie" Montana, Mardi Gras Chief/Costume Maker, New Orleans, LA

Alex Moore Sr., African American Blues Pianist, Dallas, TX

Emilio and Senaida Romero, Hispanic American Tin and Embroidery Workers, Santa Fe, NM

Newton Washburn, Split Ash Basketmaker, Bethlehem, NH

1988

Pedro Ayala, Mexican American Accordionist, Donna, TX

Kepka Belton, Czech American Egg Painter, Ellsworth, KS

Amber Densmore, New England Quilter/Needleworker, Chelsea, VT

Michael Flatley, Irish American Step Dancer, Palos Park, IL

Sister Rosalia Haberl, German American Bobbin Lace Maker, Hankinson, ND

John Dee Holeman, African American Musician/Dancer/Singer, Durham, NC

Albert "Sunnyland Slim" Laundrew, Blues Pianist/Singer, Chicago, IL

Yang Fang Nhu, Hmong Weaver/Embroiderer, Detroit, MI

Kenny Sidle, Anglo-American Fiddler, Newark, OH

Willie Mae Ford Smith, African American Gospel Singer, St. Louis, MO

Clyde "Kindy" Sproat, Hawaiian Cowboy Singer/Ukulele Player, Kohala Coast, HI

Arthel "Doc" Watson, Appalachian Guitarist/Singer, Deep Gap, NC

1989

John Cephas, Piedmont Blues Guitarist/Singer, Woodford, VA

Fairfield Four, African American A Capella Gospel Singers, Nashville, TN

José Gutiérrez, Mexican Jarocho Musician/Singer, Norwalk, CA

Richard Avedis Hagopian, Armenian Oud Player, Visalia, CA

Christy Hengel, German American Concertina Maker, New Ulm, MN

Vanessa Paukeigope [Jennings] Morgan, Kiowa Regalia Maker, Fort Cobb, OK

Ilias Kementzides, Pontic Greek Lyra Player/Builder, South Norwalk, CT

Ethel Kvalheim, Norwegian Rosemaler, Stoughton, WI

Mabel E. Murphy, Anglo-American Quilter, Fulton, MO

LaVaughn E. Robinson, African American Tap Dancer, Philadelphia, PA

Earl Scruggs, Bluegrass Banjo Player, Nashville, TN

Harry V. Shourds, Wildfowl Decoy Carver, Seaville, NJ

Chesley Goseyun Wilson, Apache Fiddle Maker, Tucson, AZ

1990

Howard Armstrong, African American String Band Musician, Boston, MA

Em Bun, Cambodian Silk Weaver, Harrisburg, PA

Natividad Cano, Mexican American Mariachi Musician, Fillmore, CA

Giuseppe and Raffaela DeFranco, Southern Italian Musicians/Dancers, Belleville, NJ

Maude Kegg, Ojibwe Storyteller/Craftsperson/Tradition Bearer, Onamia, MN

Kevin Locke, Lakota Flute Player/Singer/Dancer/Storyteller, Wakpala, SD

Marie MacDonald, Hawaiian Lei Maker, Kamuela, HI

Wallace "Wally" McRae, Cowboy Poet, Forsyth, MT

Art Moilanen, Finnish Accordionist, Mass City, MI

Emilio Rosado, Woodcarver, Utado, PR

Robert Spicer, Flatfoot/Buckdancer, Dickson, TN

Douglas Wallin, Appalachian Ballad Singer, Marshall, NC

1991

Etta Baker, African American Guitarist, Morganton, NC

George Blake, Native American Craftsman (Hupa-Yurok), Hoopa Valley, CA

Jack Coen, Irish American Flautist, Bronx, NY

Rose Frank, Nez Perce Cornhusk Weaver, Lapwai, ID

Eduardo "Lalo" Guerrero, Mexican American Singer/Guitarist/Composer, Cathedral City, CA

Khamvong Insixiengmai, Southeast Asian Lao Singer, Fresno, CA

Don King, Western Saddlemaker, Sheridan, WY

Riley "B.B." King, African American Blues Musician/Singer/Bandleader, Las Vegas, NV

Esther Littlefield, Alaskan Regalia Maker (Tlingit), Sitka, AK

Seisho "Harry" Nakasone, Okinawan American Musician, Honolulu, HI

Irván Pérez, Isleno Singer (Canary Islands), Poydras, LA

Morgan Sexton, Appalachian Banjo Player/Singer, Linefork, KY

Nikitas Tsimouris, Greek American Bagpipe Player, Tarpon Springs, FL

Gussie Wells, African American Quilter, Oakland, CA

Arbie Williams, African American Quilter, Oakland, CA

Melvin Wine, Appalachian Fiddler, Copen, WV

1992

Francisco Aguabella, Afro-Cuban Drummer, Los Angeles, CA

Jerry Brown, Potter (Southern Stoneware Tradition), Hamilton, AL

Walker Calhoun, Cherokee Musician/Dancer/Teacher, Cherokee, NC

Clyde Davenport, Appalachian Fiddler, Jamestown, TN

Belle Deacon, Athabascan Basketmaker, Greyling, AK

Nora Ezell, African American Quilter, Eutaw, AL

Gerald Hawpetoss, Menominee/Potawatomie Regalia Maker, Neopit, WI

Fatima Kuinova, Bukharan Jewish Singer, Rego Park, NY

John Yoshio Naka, Bonsai Sculptor, Whittier, CA

Marc Savoy, Cajun Accordion Player/Builder, Eunice, LA

Ng Sheung-Chi, Chinese Toissan Muk'yu Folksinger, New York, NY

Othar Turner, African American Fife Player, Senatobia, MS

Tanjore Viswanathan, South Indian Flute Maker, Middletown, CT

1993

Santiago Almeida, Texas-Mexican Conjunto Musician, Sunnyside, WA

Kenny Baker, Bluegrass Fiddler, Cottontown, TN

Inez Catalon, French Creole Singer, Kaplan, LA

Elena and Nicholas Charles, Yupik Woodcarver/Mask Maker/ Skin Sewer, Bethel, AK

Charles Hankins, Boatbuilder, Lavallette, NJ

Nalani Kanaka'ole and Pualani Kanaka'ole Kanahele, Hula Masters, Hilo, HI

Everett Kapayou, Native American Singer (Meskwaki), Tama, IA

McIntosh County Shouters, African American Spiritual/Shout Ensemble, St. Simons Island, GA

Elmer Miller, Bit and Spur Maker/Silversmith, Nampa, ID

Jack Owens, Blues Singer/Guitarist, Bentonia, MS

Mone and Vanxay Saenphimmachak, Lao Weaver/ Needleworker/Loom Maker, St. Louis, MO

Liang-Xing Tang, Chinese American Pipa (Lute) Player, Bayside, NY

1994

Liz Carroll, Irish American Fiddler, Mundelein, IL

Clarence Fountain and the Blind Boys of Alabama, African American Gospel Singers, Atlanta, GA

Mary Mitchell Gabriel, Native American (Passamaquoddy) Basketmaker, Princeton, ME

Johnny Gimble, Western Swing Fiddler, Dripping Springs, TX

Frances Varos Graves, Hispanic American "Colcha" Embroiderer, Rancho de Taos, NM

Violet Hilbert, Native American (Skagit) Storyteller/ Conservator, Seattle, WA

Sosei Shizuye Matsumoto, Japanese Tea Ceremony Master, Los Angeles, CA

D. L. Menard, Cajun Musician/Songwriter, Erath, LA

Simon Shaheen, Arab American Oud Player, Brooklyn, NY

Lily Vorperian, Armenian (Marash-Style) Embroiderer, Glendale, CA

Elder Roma Wilson, African American Harmonica Player, Oxford, MS

1995

Bao Mo-Li, Chinese American Jing-Erhu Player, Flushing, NY

Mary Holiday Black, Navajo Basketmaker, Mexican Hat, UT

Lyman Enloe, Old-Time Fiddler, Lee's Summit, MO

Donny Golden, Irish American Step Dancer, Brooklyn, NY

Wayne Henderson, Appalachian Luthier, Musician, Mouth of Wilson, VA

Bea Ellis Hensley, Appalachian Blacksmith, Spruce Pine, NC

Nathan Jackson, Tlingit Alaskan Woodcarver/Metalsmith/ Dancer, Ketchikan, AK

Danongan Kalanduyan, Filipino American Kulintang Musician, South San Francisco, CA

Robert Jr. Lockwood , African American Delta Blues Singer/ Guitarist, Cleveland, OH

Israel "Cachao" López, Afro-Cuban Bassist/Composer/ Bandleader, Miami, FL

Nellie Star Boy Menard, Lakota Sioux Quilt Maker, Rosebud, SD

Buck Ramsey, Anglo-American Cowboy Poet/Singer, Amarillo, TX

1996

Obo Addy, African (Ghanaian) Master Drummer/Leader, Portland, OR

Betty Pisio Christenson, Ukrainian American Pysanky Maker, Suring, WI

Paul Dahlin, Swedish American Fiddler, Minneapolis, MN

Juan Gutiérrez, Puerto Rican Drummer/Leader (Bomba and Plena), New York, NY

Solomon and Richard Ho'opii, Hawaiian Falsetto Singers/ Musicians, Makawao, HI

Will Keys, Anglo-American Banjo Player, Gray, TN

Joaquin Lujan, Chamorro Blacksmith, Barrigada, GU

Eva McAdams, Shoshone Craftsperson/Beadworker, Fort Washakie, WY

John Mealing and Cornelius Wright Jr. , African American Work Song Performers, Birmingham, AL

Vernon Owens, Anglo-American Potter, Seagrove, NC

Dolly Spencer, Inupiat Doll Maker, Homer, AK

1997

Edward Babb, "Shout" Band Gospel Trombonist/Band Leader, Jamaica, NY

Charles Brown, West Coast Blues Pianist/Composer, Berkeley, CA

Gladys Leblanc Clark, Acadian (Cajun) Spinner/Weaver, Duson, LA

Georgia Harris, Catawba Potter, Atlanta, GA

Wen-Yi Hua, Chinese Kunqu Opera Singer, Arcadia, CA

Ali Akbar Khan, North Indian Sarod Player/Raga Composer, San Anselmo, CA

Ramón José López, Santero/Metalsmith, Santa Fe, NM

Jim and Jesse McReynolds, Bluegrass Musicians, Gallatin, TN

Phong Nguyen, Vietnamese Musician/Scholar, Kent, OH

Hystercine Rankin, African American Quilter, Lorman, MS

Francis Whitaker, Blacksmith/Ornamental Ironworker, Carbondale, CO

1998

Apsara Ensemble, Cambodian Musicians/Dancers, Fort Washington, MD

Eddie Blazonczyk, Polish Polka Musician/Bandleader, Bridgeview, IL

Bruce Caesar, Sac/Fox/Pawnee Silversmith, Anadarko, OK

Dale Calhoun, Boatbuilder (Reelfoot Lake Stumpjumper), Tiptonville, TN

Antonio De La Rosa, Tejano Conjunto Accordionist, Riviera, TX

Epstein Brothers, Klezmer Musicians, Sarasota, FL

Sophia George, Yakima Colville Beadworker/Regalia Maker, Gresham, OR

Nadjeschda Overgaard, Danish Hardanger Embroiderer, Kimballton, IA

Harilaos Papapostolou, Byzantine (Greek Orthodox) Chanter/ Song Leader,, Potomac, MD

Roebuck "Pops" Staples, Gospel /Blues Musician, Dalton, IL

Claude "The Fiddler" Williams, Jazz Swing Fiddler, Kansas City, MO

1999

Frisner Augustin, Haitian Drummer, New York, NY

Lila Greengrass Blackdeer, Hocak Black Ash Basketmaker/ Needleworker, Black River Falls, WI

Shirley Caesar, Gospel Singer, Durham, NC

Alfredo Campos, Horsehair Hitcher, Federal Way, WA

Mary Louise Defender Wilson, Dakota Hidatsa Traditionalist/ Storyteller, Shields, ND

Jimmy "Slyde" Godbolt, African American Tap Dancer, Hanson, MA

Ulysses "Uly" Goode, Western Mono Basketmaker, North Fork, CA

Bob Holt, Ozark Fiddler, Ava, MO

Zakir Hussain, North Indian Master Tabla Drummer, San Anselmo, CA

Elliott "Ellie" Mannette, Trinidadian Steel Pan Builder/Tuner/ Performer, Osage, WV

Mick Moloney, Irish Musician, New York, NY

Eudokia Sorochaniuk, Ukrainian Weaver/Textile Artist/
Embroiderer, Pennsauken, NJ

Ralph Stanley, Master Boatbuilder (Friendship Sloop),
Southwest Harbor, ME

2000

Bounxou Chanthraphone, Lao Weaver/Embroiderer, Brooklyn
Park, MN

Dixie Hummingbirds, African American Gospel Quartet,
Philadelphia, PA

Felipe García Villamil, Afro-Cuban Drummer/Santero, Los
Angeles, CA

José González, Puerto Rican Hammock Weaver, San
Sebastián, PR

Nettie Jackson, Klickitat Basketmaker, White Swan, WA

Santiago Jiménez Jr. , Tex-Mex Accordionist/Singer, San
Antonio, TX

Genoa Keawe, Hawaiian Falsetto Singer/Ukulele Player,
Honolulu, HI

Frankie Manning, Lindy Hop Dancer/Choreographer/
Innovator, Corona, NY

Joe Willie "Pinetop" Perkins, Blues Piano Player, La Porte, IN

Konstantinos Pilarinos, Orthodox Byzantine Icon Woodcarver,
Astoria, Queens, NY

Chris Strachwitz (Bess Lomax Hawes Award), Record
Producer/Label Founder, El Cerrito, CA

B. Dorothy Thompson, Appalachian Weaver, Davis, WV

Don Walser, Cowboy and Western Singer/Guitarist/Composer,
Austin, TX

2001

Celestino Avilés, Santero, Orocovis, PR

Mozell Benson, African American Quilter, Opelika, AL

Wilson "Boozoo" Chavis, Zydeco Accordionist, Lake
Charles, LA

Hazel Dickens, Appalachian Singer, Washington, DC

Evalena Henry, Apache Basketweaver, Peridot, AZ

Peter Kyvelos, Oud Builder, Bedford, MA

João Oliveira Dos Santos (João Grande), Capoeira Angola
Master, New York, NY

Eddie Pennington, Thumbpicking-Style Guitarist,
Princeton, KY

Qi Shu Fang, Peking Opera Performer, Woodhaven, NY

Seiichi Tanaka, Taiko Drummer/Dojo Founder, San
Francisco, CA

Dorothy Trumpold, Rug Weaver, High Amana, IA

Fred Tsoodle, Kiowa Sacred Song Leader, Mountain View, OK

Joseph Wilson (Bess Lomax Hawes Award), Folklorist/
Advocate/Presenter, Fries, VA

2002

Ralph Blizard, Old-Time Fiddler, Blountville, TN

Loren Bommelyn, Tolowa Singer, Tradition Bearer,
Basketmaker, Crescent City, CA

Kevin Burke, Irish Fiddler, Portland, OR

Francis and Rose Cree, Ojibwe Basketmakers/Storytellers,
Dunseith, ND

Luderin Darbone/Edwin Duhon, Cajun Fiddler and
Accordionist, Sulphur/Westlake, LA

Nadim Dlaikan, Lebanese Nye (Reed Flute) Player/Maker,
Southgate, MI

David "Honeyboy" Edwards, Delta Blues Guitarist/Singer,
Chicago, IL

Flory Jagoda, Sephardic Musician/Composer, Alexandria, VA

Losang Samten, Tibetan Sand Mandala Painter, Philadelphia, PA

Bob McQuillen, Contra Dance Musician/Composer,
Peterborough, NH

Clara Neptune Keezer, Passamaquoddy Basketmaker, Perry, ME

Jean Ritchie (Bess Lomax Hawes Award), Appalachian Singer/Songwriter/Dulcimer Player, Viper, KY/Port Washington, NY

Domingo "Mingo" Saldivar, Conjunto Accordionist, San Antonio, TX

2003

Basque Poets (Bertsolari): Jesus Arriada, San Francisco, CA; Johnny Curutchet, South San Francisco, CA; Martin Goicoechea, Rock Springs, WY; Jesus Goni, Reno, NV

Rosa Elena Egipciaco, Puerto Rican Mundillo (Bobbin Lace) Maker, New York, NY

Agnes Oshanee Kenmille, Salish Beadworker/Hide Tanner, Ronan, MT

Norman Kennedy, Weaver/Ballad Singer, Marshfield, VT

Roberto and Lorenzo Martinez, Hispanic Guitarist and Violinist, Albuquerque, NM

Norma Miller, African American Jazz Dancer/Choreographer, Cape Coral, FL

Carmencristina Moreno (Bess Lomax Hawes Award), Mexican American Singer/Composer/Teacher, Fresno, CA

Ron Poast, Hardanger Fiddle Luthier/Player, Black Earth, WI

Felipe I. and Joseph K. Ruak, Carolinian Stick Dance Leaders, Saipan, MP

Manoochehr Sadeghi, Persian Santour Player, Sherman Oaks, CA

Nicholas Toth, Diving Helmet Builder, Tarpon Springs, FL

2004

Anjani Ambegaokar, Kathak Dancer, Diamond Bar, CA

Charles "Chuck" T. Campbell, Gospel Steel Guitarist, Rochester, NY

Joe Derrane, Irish American Button Accordionist, Randolph, MA

Jerry Douglas, Dobro Player, Nashville, TN

Gerald Subiyay Miller, Skokomish Tradition Bearer, Shelton, WA

Milan Opacich, Tamburitza Instrument Maker, Schererville, IN

Eliseo and Paula Rodriguez, Straw Applique Artists, Santa Fe, NM

Koko Taylor, Blues Musician, Country Club Hills, IL

Yuqin Wang and Zhengli Xu, Chinese Rod Puppeteers, Tigard, OR

Chum Ngek (Bess Lomax Hawes Award), Cambodian Musician/Teacher, Gaithersburg, MD

2005

Herminia Albarrán Romero, Paper-Cutting Artist, San Francisco, CA

Eldrid Skjold Arntzen, Norwegian American Rosemaler, Watertown, CT

Earl Barthé, Decorative Building Craftsman, New Orleans, LA

Chuck Brown, African American Musical Innovator, Brandywine, MD

Janette Carter (Bess Lomax Hawes Award), Appalachian Musician/Advocate, Hiltons, VA

Michael Doucet, Cajun Fiddler/Composer/Bandleader, Lafayette, LA

Jerry Grcevich, Tamburitza Musician/Prim Player, North Huntingdon, PA

Grace Henderson Nez, Navajo Weaver, Ganado, AZ

Wanda Jackson, Early Country, Rockabilly/Gospel Singer, Oklahoma City, OK

Beyle Schaechter-Gottesman, Yiddish Singer/Poet/Songwriter, Bronx, NY

Albertina Walker, Gospel Singer, Chicago, IL

James Ka'upena Wong, Hawaiian Chanter, Waianae, HI

2006

Charles M. Carrillo, Santero (Carver/Painter of Sacred Figures), Santa Fe, NM

Delores E. Churchill, Haida (Native Alaskan) Weaver, Ketchikan, AK

Henry Gray, Blues Piano Player/Singer, Baton Rouge, LA

Doyle Lawson, Gospel and Bluegrass Singer/Arranger/Bandleader, Bristol, TN

Esther Martinez, Native American Linguist/Storyteller, San Juan Pueblo, NM

Diomedes Matos, Cuatro (10-String Puerto Rican Guitar) Maker, Deltona, FL

George Na'ope, Kumu Hula (Hula Master), Hilo, HI

Wilho Saari, Finnish Kantele (Lap-Harp) Player, Naselle, WA

Mavis Staples, Gospel/Rhythm and Blues Singer, Chicago, IL

Nancy Sweezy (Bess Lomax Hawes Award), Advocate/Scholar/Presenter/Preservationist, Lexington, MA

Treme Brass Band, New Orleans Brass Band, New Orleans, LA

2007

Nicholas Benson, Stone Letter Carver/Calligrapher, Newport, RI

Sidiki Conde, Guinean Dancer/Musician, New York, NY

Violet De Cristoforo, Haiku Poet/Historian, Salinas, CA

Roland Freeman (Bess Lomax Hawes Award), Photo Documentarian/Author/Exhibit Curator, Washington, DC

Pat Courtney Gold, Wasco Sally Bag Weaver, Scappoose, OR

Eddie Kamae, Hawaiian Musician/Composer/Filmmaker, Honolulu, HI

Agustin Lira, Chicano Singer/Musician/Composer, Fresno, CA

Julia Parker, Kashia Pomo Basketmaker, Midpines, CA

Mary Jane Queen, Appalachian Musician, Cullowhee, NC

Joe Thompson, African American String Band Musician, Mebane, NC

Irvin L. Trujillo, Rio Grande Weaver, Chimayo, NM

Elaine Hoffman Watts, Klezmer Musician, Havertown, PA

2008

Horace P. Axtell, Nez Perce Elder/Spiritual Leader/Drum Maker, Lewiston, ID

Dale Harwood, Saddlemaker, Shelley, ID

Bettye Kimbrell, Quilter, Mt. Olive, AL

Jeronimo E. Lozano, Retablo Maker, Salt Lake City, UT

Walter Murray Chiesa (Bess Lomax Hawes Award), Traditional Crafts Advocate, Bayamón, PR

Oneida Hymn Singers of Wisconsin, Hymn Singers, Oneida, WI

Sue Yeon Park, Korean Dancer/Musician, New York, NY

Moges Seyoum, Ethiopian Church Musician, Alexandria, VA

Jelon Vieira, Capoeira Master, New York, NY

Michael G. White, Jazz Clarinetist/Band Leader/Scholar, New Orleans, LA

Mac Wiseman, Bluegrass and Country Singer/Musician, Nashville, TN

2009

The Birmingham Sunlights, A Cappella Gospel Group, Birmingham, AL

Edwin Colón Zayas, Cuatro Player, Orocovis, PR

Chitresh Das, Kathak Dancer/Choreographer, San Francisco, CA

Leroy Graber, German Russian Willow Basketmaker, Freeman, SD

"Queen" Ida Guillory, Zydeco Musician, Daly City, CA

Dudley Laufman, Dance Caller/Musician, Cantebury, NH

Amma D. McKen, Yoruba Orisha Singer, Brooklyn, NY

Joel Nelson, Cowboy Poet, Alpine, TX

Teri Rofkar, Tlingit Weaver/Basketmaker, Sitka, AK

Mike Seeger (Bess Lomax Hawes Award), Musician/Cultural Scholar/Advocate, Lexington, VA

Sophiline Cheam Shapiro, Cambodian Classical Dancer/ Choreographer, Long Beach, CA

2010

Yacub Addy, Ghanaian Drum Master, Latham, NY

Jim "Texas Shorty" Chancellor, Fiddler, Rockwall, TX

Gladys Kukana Grace, Lauhala (Palm Leaf) Weaver, Honolulu, HI

Mary Jackson, Sweetgrass Basket Weaver, Johns Island, SC

Del McCoury, Bluegrass Guitarist/Singer, Hendersonville, TN

Judith McCulloh (Bess Lomax Hawes Award), Folklorist/ Editor, Urbana, IL

Kamala Lakshmi Narayanan, Bharatanatyam Indian Dancer, Mastic, NY

Mike Rafferty, Irish Flute Player, Hasbrouck Heights, NJ

Ezequiel Torres, Afro-Cuban Drummer/Drum Builder, Miami, FL

2011

Laverne Brackens, Quilter, Fairfield, TX

Bo Dollis, Mardi Gras Indian Chief, New Orleans, LA

Jim Griffith (Bess Lomax Hawes Award), Folklorist, Tucson, AZ

Roy and PJ Hirabayashi, Taiko Drum Leaders, San Jose, CA

Ledward Kaapana, Slack Key Guitarist, Kaneohe, HI

Frank Newsome, Old Regular Baptist Singer, Haysi, VA

Carlinhos Pandeiro De Ouro, Frame Drum Player/ Percussionist, Los Angeles, CA

Warner Williams, Piedmont Blues Songster, Gaithersburg, MD

Yuri Yunakov, Bulgarian Saxophonist, Bloomfield, NJ

2012

Mike Auldridge, Dobro Player, Silver Spring, MD

Paul and Darlene Bergren, Dog Sled and Snowshoe Designers/ Builders, Minot, ND

Harold A. Burnham, Master Shipwright, Essex, MA

Albert B. Head (Bess Lomax Hawes Award), Traditional Arts Advocate, Montgomery, AL

Leonardo "Flaco" Jiménez, Tejano Accordion Player, San Antonio, TX

Lynne Yoshiko Nakasone, Okinawan Dancer, Honolulu, HI

Molly Jeannette Neptune Parker, Passamaquoddy Basketmaker, Princeton, ME

The Paschall Brothers, Tidewater Gospel Quartet, Chesapeake, VA

Andy Statman, Klezmer Clarinetist/Mandolinist/Composer, Brooklyn, NY

2013

Sheila Kay Adams, Ballad Singer/Musician/Storyteller, Marshall, NC

Ralph Burns, Storyteller (Pyramid Lake Paiute Tribe), Nixon, NV

Verónica Castillo, Ceramicist/Clay Sculptor, San Antonio, TX

Séamus Connolly, Irish Fiddler, North Yarmouth, ME

Nicolae Feraru, Cimbalom Player, Chicago, IL

Carol Fran, Swamp Blues Singer/Pianist, Lafayette, LA

Pauline Hillaire (Bess Lomax Hawes Award), Tradition Bearer (Lummi Tribe), Bellingham, WA

David Ivey, Sacred Harp Hymn Singer, Huntsville, AL

Ramón "Chunky" Sánchez, Chicano Musician/Culture Bearer, San Diego, CA

2014

Henry Arquette, Mohawk Basketmaker, Hogansburg, NY

Manuel "Cowboy" Donley, Tejano Musician/Singer, Austin, TX

Kevin Doyle, Irish Step Dancer, Barrington, RI

The Holmes Brothers (Sherman Holmes/Wendell Holmes/ Popsy Dixon), Blues/ Gospel/Rhythm and Blues Band, Rosedale, MD/Saluda, VA

Yvonne Walker Keshick, Odawa Quill Worker, Petoskey, MI

Carolyn Mazloomi (Bess Lomax Hawes Award), Quilting Community Advocate, West Chester, OH

Vera Nakonechny, Ukrainian Embroiderer/Weaver/ Beadworker, Philadelphia, PA

Singing and Praying Bands of Maryland and Delaware, African American Religious Singers, MD and DE

Rufus White, Omaha Traditional Singer/Drum Group Leader, Walthill, NE

2015

Rahim AlHaj, Oud Player/Composer, Albuquerque, NM

Michael Alpert, Yiddish Musician/Tradition Bearer, New York, NY

Mary Lee Bendolph, Lucy Mingo, and Loretta Pettway, Quilters of Gee's Bend, Boykin, AL

Dolly Jacobs, Circus Aerialist, Sarasota, FL

Yary Livan, Cambodian Ceramicist, Lowell, MA

Daniel Sheehy (Bess Lomax Hawes Award), Ethnomusicologist/Folklorist, Falls Church, VA

Drink Small, Blues Artist, Columbia, SC

Gertrude Yukie Tsutsumi, Japanese Classical Dancer, Honolulu, HI

Sidonka Wadina, Slovak Straw Artist/Egg Decorator, Lyons, WI

2016

Bryan Akipa, Dakota Flute Maker/Player, Sisseton, SD

Joseph Pierre "Big Chief Monk" Boudreaux, Mardi Gras Indian Craftsman/Musician, New Orleans, LA

Billy McComiskey, Irish Button Accordionist, Baltimore, MD

Clarissa Rizal, Tlingit Ceremonial Regalia Maker, Juneau, AK

Theresa Secord, Penobscot Nation Basketmaker, Waterville, ME

Bounxeung Synanonh, Laotian Khaen Player, Fresno, CA

Michael Vlahovich, Master Shipwright, Tacoma, WA/St. Michaels, MD

Leona Waddell, White Oak Basketmaker, Cecilia, KY

Artemio Posadas (Bess Lomax Hawes Award), Master Huastecan Son Musician/Advocate, San Jose, CA

Traditional Hupa Ceremonial House, Hoopa Valley, California.

SOURCES FOR ARTIST QUOTES

Hugh McGraw (19)

Hugh W. McGraw, "'There Are More Singings Now Than Ever Before': Hugh McGraw Addresses the Harpeth Valley Singers," Sacred Harp Publishing Company, December 31, 2013, http://originalsacredharp.com/2013/12/31/there-are-more-singings -now-than-ever-before-hugh-mcgraw-addresses-the-harpeth -valley-singers/.

Philip Simmons (21)

The National Endowment for the Arts National Heritage Fellowships 1982–2011, 30th Anniversary (Washington, DC: National Endowment for the Arts, 2011), 7.

Ray Hicks (22)

Marjorie Hunt and Boris Weintraub, "Masters of Traditional Arts," *National Geographic*, January 1991, 92.

Mary Jane Manigault (24)

Dale Rosengarten, *Row upon Row: Sea Grass Baskets of the South Carolina Lowcountry* (Columbia, SC: McKissick Museum, 1986), 39.

Ralph Stanley (27)

John Wright, *Traveling the High Way Home: Ralph Stanley and the World of Bluegrass Music* (Urbana: University of Chicago Press, 1993), 70.

Eppie Archuleta (29)

Mark Oswald, "Eppie Archuleta, master weaver, dies at age 92," *Albuquerque Journal*, April 14, 2014.

Julio Negrón Rivera (30)

"Julio Negrón Rivera, Premiado maestro artesano de instrumentos de Morovis," *The Puerto Rican Cuatro Project*, http://www.cuatro-pr.org/node/325.

Periklis Halkias (32)

"Periklis Halkias," *Masters of Traditional Arts*, http://www.mastersoftraditionalarts.org/artists/128?selected_facets=name_initial_last_exact:H.

Alphonse "Bois Sec" Ardoin (34)

Barry Jean Ancelet, *The Makers of Cajun Music.* (Austin: University of Texas Press, 1984), 87.

Helen Cordero (36)

Alan Govenar, *Masters of Traditional Arts.* 2 vols. (Santa Barbara, CA: ABC/CLIO, 2001), 141.

John Jackson (39)

Elijah Wald, "John Jackson Interview (written for Sing Out! in 1994)," http://www.elijahwald.com/longarch.html#jojack.

Sonia Domsch (41)

"Sonia Domsch Kansas Folk Art," *Kansaspedia*, https://www.kshs.org/kansapedia/sonia-domsch-kansas-folk-art/16549.

Juan Alindato (43)

Marjorie Hunt and Boris Weintraub, "Masters of Traditional Arts," *National Geographic*, January 1991, 86.

Genoveva Castellanoz (44)

Steve Siporin, *American Folk Masters: The National Heritage Fellows* (New York: Harry N. Abrams, 1992), 185, 187.

Kansuma Fujima (47)

Personal communication, 2017.

Newton Washburn (48)

Jane Beck, "Newton Washburn: Traditional Basket Maker," in *Traditional Craftsmanship in America*, ed. Charles Camp (Washington, DC: National Council for the Traditional Arts, 1983), 72.

Wade Mainer (51)

Dick Spottswood, *Banjo on the Mountain: Wade Mainer's First Hundred Years* (Jackson: University Press of Mississippi, 2010), 27.

Clyde "Kindy" Sproat (53)

National Endowment for the Arts National Heritage Files, quoted in Steve Siporin, *American Folk Masters: The National Heritage Fellows* (New York: Harry N. Abrams, 1992), 79.

Chesley Goseyun Wilson (54)

Sandra Rambler, "Apache Elder Chesley Wilson, Sr. Makes Movie with Brad Pitt in '12 Years a Slave,'" *Arizona Silver Belt*, August 28, 2012.

Harry V. Shourds (57)

The National Heritage Fellowships 1989 (Washington, DC: National Endowment for the Arts Folk Arts Program, 1989), 14.

Vanessa Paukeigope [Morgan] Jennings (59)

The National Heritage Fellowships 1989 (Washington, DC: National Endowment for the Arts Folk Arts Program, 1989), 11.

Natividad "Nati" Cano (61)

Daniel Sheehy, *Mariachi Music in America* (Oxford: Oxford University Press, 2005), 79.

Wallace "Wally" McRae (62)

Michael Becker. "There's More to Wally McRae than 'Reincarnation,'" *Mountains and Minds, The Montana State University Magazine*, November 24, 2009, http://www.montana.edu/mountainsandminds/article.php?article=7806&origin=news.

Etta Baker (65)

The Tenth National Heritage Fellowships 1991 (Washington, DC: National Endowment for the Arts Folk Arts Program, 1991), 4.

George Blake (67)

The Tenth National Heritage Fellowships 1991 (Washington, DC: National Endowment for the Arts Folk Arts Program, 1991), 4.

Irván Pérez (68)

Louis Alvarez and Andrew Kolker, *Mosquitoes and High Water*, ¾-inch videotape, ed. Louis Alvarez and Andrew Kolker, Center for New American Media, 1983, http://www.folkstreams.net /film, 75.

Jerry Brown (71)

Welcome to Brown Pottery & Sons!, https://www.jerrybrown pottery.com/.

Charles Hankins (72)

Rita Moonsammy and Louis Presti, *The Sea Bright Skiff: Working on the Jersey Shore*, 16 mm. film, dir. Rita Moonsammy and Louis Presti, New Jersey Network, 1991, http://www.folkstreams.net /film, 41.

D. L. Menard (74)

Barry Jean Ancelet, *The Makers of Cajun Music* (Austin: University of Texas Press, 1984), 49.

Simon Shaheen (76)

Simon Shaheen, "Beyond the Minor Second," *The Link*, December 2006, 5.

Sosei Shizuye Matsumoto (79)

KCET Local Heroes, May 3, 2013, https://www.kcet.org/local -heroes/alumni-update-2013-honoree-madame-sosei-matsumoto.

Blind Boys of Alabama (Ricky McKinnie) (81)

Melissa Ruggieri, "Ricky McKinnie Is Keeping the Faith with the Blind Boys of Alabama," *PopMatters*, July 9, 2012, http://www .popmatters.com/article/160795-ricky-mckinnie-is-keeping-the -faith-with-the-blind-boys-of-alabama/.

Danongan Kalanduyan (82)

The National Heritage Fellowships 1995 (Washington, DC: National Endowment for the Arts Folk & Traditional Arts Program, 1995), 13.

Nathan Jackson (85)

The National Heritage Fellowships 1995 (Washington, DC: National Endowment for the Arts Folk & Traditional Arts Program, 1995), 12.

Betty Pisio Christenson (86)

The National Heritage Fellowships 1996 (Washington, DC: National Endowment for the Arts, 1996), 6.

Obo Addy (89)

Alan Govenar, *Masters of Traditional Arts*, 2 vols. (Santa Barbara, CA: ABC/CLIO, 2001), 13.

Vernon Owens (90)

Mark Hewitt and Nancy Sweezy, *The Potter's Eye: Art and Tradition in North Carolina Pottery* (Chapel Hill: University of North Carolina Press, 2005), 246.

Ramón José López (93)

The National Heritage Fellowships 1997 (Washington, DC: National Endowment for the Arts, 1997), 10.

Julius Epstein, of the Epstein Brothers (95)

The National Heritage Fellowships 1997 (Washington, DC: National Endowment for the Arts, 1997), 10.

Alfredo Campos (96)

"Alfredo Campos," *Masters of Traditional Arts*, http://www
.mastersoftraditionalarts.org/artists/48?selected_facets=name
_initial_last_exact:C.

Elliott "Ellie" Mannette (98)

"Ellie Mannette. .. Continuing the Legacy," Mannette Musical In-
struments,http://www.mannetteinstruments.com/home2.html.

Frisner Augustin (100)

Joyce Wadler, "Public Lives; An Urban Folk Hero, Captive to the
Drums," *New York Times*, November 17, 1998.

Jimmy "Slyde" Godbolt (102)

Brian Seibert, "Jimmy Slyde (1927–2008), *Threepenny Review*, Fall
2008, https://www.threepennyreview.com/samples/seibert_f08
.html.

Mick Moloney (105)

Siobhan Long, "Gradam Ceoil: Rewarding Irish Music's Wonder-
ful Anarchy," *Irish Times*, February 6, 2014, http://www.irish
times.com/culture/gradam-ceoil-rewarding-irish-music-s
-wonderful-anarchy-1.1680726.

Ulysses "Uly" Goode (107)

The National Heritage Fellowships 1999 (Washington, DC: Nation-
al Endowment for the Arts, 1999), 11.

Felipe García Villamil (109)

Maria Teresa Vèlez, *Drumming for the Gods* (Philadelphia: Temple
University Press, 2000), 130.

Joe Willie "Pinetop" Perkins (111)

Robert Gordon, *Can't Be Satisfied: The Life and Times of Muddy
Waters* (Boston: Little, Brown, 2002), 239.

Konstantinos Pilarinos (112)

The National Heritage Fellowships 2000 (Washington, DC: Nation-
al Endowment for the Arts, 2000), 14.

Evalena Henry (114)

"Evalena Henry," Apache Nation Chamber of Commerce,http://
www.sancarlosapache.com/Evalena_Henry.htm.

João Oliveira Dos Santos (João Grande) (117)

Capoeira Angola Center of Mestre João Grande, http://www
.joaogrande.org/.

Peter Kyvelos (119)

The National Heritage Fellowships 2001 (Washington, DC: Nation-
al Endowment for the Arts, 2001), 11.

Qi Shu Fang (121)

Alan Govenar, *Extraordinary Ordinary People* (Cambridge, MA:
Candlewick Press, 2006), 13–14.

Seiichi Tanaka (123)

The National Heritage Fellowships 2001 (Washington, DC: Nation-
al Endowment for the Arts, 2001), 14.

Flory Jagoda (124)

Lauren Landau, "Flory Jagoda: Virginia Musician Preserving a
Tradition Rooted in Sephardic Judaism," WAMU 88.5 American
University, *Metro Connection*, June 5, 2015, http://wamu.org/story
/15/06/05/flory_jagoda_virginia_musician_preserving_a
_tradition_rooted_in_sephardic_judaism/.

Jean Ritchie (127)

Alanna Nash, "Jean Ritchie," in *Artists of American Folk Music*, ed.
Phil Hill (New York: William Morrow, 1986), 121.

Losang Samten (129)

"Losang Samten, Philadelphia Folklore Project,http://www
.folkloreproject.org/artists/losang-samten.

Nadim Dlaikan (130)

"Nadim Dlaikan," *Masters of Traditional Arts*, http://www
.mastersoftraditionalarts.org/artists/88?selected_facets=name
_initial_last_exact:D.

Manoochehr Sadeghi (133)

"Manoochehr Sadeghi," *Masters of Traditional Arts,* http://www
.mastersoftraditionalarts.org/artists/287?selected_facets=name
_initial_last_exact:S.

Nicholas Toth (134)

Nicholas Toth Fine Art: A. Lerios Marine since 1913, http://nicholas
tothfineart.com/the-artist-nicholas-toth.html.

Norman Kennedy (137)

"Norman Kennedy," *Masters of Traditional Arts*, http://www
.mastersoftraditionalarts.org/artists/173?selected_facets=name
_initial_last_exact:K.

Basque Poets (Bertsolari) Martin Goicoechea and Jesus Goni (139)

Elisa Hough, "The Basics of Bertsolaritza," *Festival Blog*, May 27,
2016, http://www.festival.si.edu/blog/2016/the-basics-of
-bertsolaritza/.

Jerry Douglas (140)

Stratton Lawrence, "Jerry Douglas Dishes on Silky Singer Alison
Krauss," *Charleston City Paper*, August 10, 2011.

Milan Opacich (143)

National Endowment for the Arts National Heritage Fellowships 2004
(Washington, DC: National Endowment for the Arts, 2004), 19.

Yuqin Wang and Zhengli Xu (145)

National Endowment for the Arts National Heritage Fellowships 2004
(Washington, DC: National Endowment for the Arts, 2004), 24.

Chuck Brown (146)

National Endowment for the Arts National Heritage Fellowships 2004
(Washington, DC: National Endowment for the Arts, 2004), 12.

Eldrid Skjold Arntzen (148)

Mary Eckstein, "Eldrid Arntzen: Interview with Mary Eckstein,"
NEA National Heritage Fellowships, National Endowment for the
Arts, https://www.arts.gov/honors/heritage/fellows/eldrid-skjold
-arntzen.

Herminia Albarrán Romero (151)

2005 National Endowment for the Arts National Heritage Fellowships
(Washington, DC: National Endowment for the Arts, 2005), 23.

Delores E. Churchill (152)

2006 National Endowment for the Arts National Heritage Fellowships
(Washington, DC: National Endowment for the Arts, 2006), 19.

Henry Gray (155)

James Segrest and Mark Hoffman: *Moanin' at Midnight: The Life
and Times of Howlin' Wolf* (New York: Thunder Mouth Press,
2004), 147.

Irvin L. Trujillo (157)

2007 National Endowment for the Arts National Heritage Fellowships
(Washington, DC: National Endowment for the Arts, 2007), 29.

Joe Thompson (159)

2007 National Endowment for the Arts National Heritage Fellowships
(Washington, DC: National Endowment for the Arts, 2007), 26.

Julia Parker (160)

"Julia Parker," *Masters of Traditional Arts*. http://www.masters
oftraditionalarts.org/artists/261?selected_facets=name_initial
_last_exact:P.

Nicholas Benson (162)

2007 National Endowment for the Arts National Heritage Fellowships (Washington, DC: National Endowment for the Arts, 2007), 10.

Bettye Kimbrell (164)

2008 National Endowment for the Arts National Heritage Fellowships (Washington, DC: National Endowment for the Arts, 2008), 14.

Horace P. Axtell (167)

2008 National Endowment for the Arts National Heritage Fellowships (Washington, DC: National Endowment for the Arts, 2008), 10.

Jeronimo E. Lozano (169)

2008 National Endowment for the Arts National Heritage Fellowships (Washington, DC: National Endowment for the Arts, 2008), 17.

Mac Wiseman (171)

Melissa R. Moss, "Bluegrass Giant Mac Wiseman Looks Back on a Legendary Career," *Rolling Stone*, September 26, 2016, http://www.rollingstone.com/music/news/bluegrass-giant-mac-wiseman-looks-back-on-a-legendary-career-20140926.

Michael G. White (172)

2008 National Endowment for the Arts National Heritage Fellowships (Washington, DC: National Endowment for the Arts, 2008), 26.

Moges Seyoum (175)

2008 National Endowment for the Arts National Heritage Fellowships (Washington, DC: National Endowment for the Arts, 2008), 22.

Sue Yeon Park (176)

2008 National Endowment for the Arts National Heritage Fellowships (Washington, DC: National Endowment for the Arts, 2008), 21.

Walter Murray Chiesa (178)

2008 National Endowment for the Arts National Heritage Fellowships (Washington, DC: National Endowment for the Arts, 2008), 30.

Chitresh Das (181)

2009 National Endowment for the Arts National Heritage Fellowships (Washington, DC: National Endowment for the Arts, 2009), 15.

Joel Nelson (183)

2009 National Endowment for the Arts National Heritage Fellowships (Washington, DC: National Endowment for the Arts, 2009), 25.

Teri Rofkar (184)

Teri Rofkar: Alaskan Native Artist & Basket Weaver, http://terirofkar.com/.

Jim "Texas Shorty" Chancellor (186)

2010 National Endowment for the Arts National Heritage Fellowships (Washington, DC: National Endowment for the Arts, 2010), 12.

Mary Jackson (189)

2010 National Endowment for the Arts National Heritage Fellowships (Washington, DC: National Endowment for the Arts, 2010), 16.

Frank Newsome (191)

2011 National Endowment for the Arts National Heritage Fellowships (Washington, DC: National Endowment for the Arts, 2011), 19.

Warner Williams (193)

2011 National Endowment for the Arts National Heritage Fellowships (Washington, DC: National Endowment for the Arts, 2011), 22.

Harold A. Burnham (194)

2012 National Endowment for the Arts National Heritage Fellowships (Washington, DC: National Endowment for the Arts, 2012), 14.

Leonardo "Flaco" Jiménez (197)

2012 National Endowment for the Arts National Heritage Fellowships (Washington, DC: National Endowment for the Arts, 2012), 17.

Molly Neptune Parker (199)

2012 National Endowment for the Arts National Heritage Fellowships (Washington, DC: National Endowment for the Arts, 2012), 21.

Nicolae Feraru (201)

Howard Reich, "A New Day for a Romanian Cimbalom Master in Chicago," *Chicago Tribune*, September 9, 2014, http://www.chicagotribune.com/entertainment/music/reich/ct-ent-0910-jazz-nicolae-feraru-20140910-column.html.

Ramón "Chunky" Sánchez (203)

2013 National Endowment for the Arts National Heritage Fellowships (Washington, DC: National Endowment for the Arts, 2013), 24.

Verónica Castillo (204)

2013 National Endowment for the Arts National Heritage Fellowships (Washington, DC: National Endowment for the Arts, 2013), 15.

Henry Arquette (207)

Josephine Reed, "Interview with Henry Arquette by Josephine Reed for the NEA," *NEA National Heritage Fellowships*, National Endowment for the Arts, September 17, 2014, https://www.arts.gov/honors/heritage/fellows/henry-arquette.

Dolly Jacobs (208)

"Dolly Jacobs: Circus Aerialist and 2015 National Heritage Fellow," October 1, 2015 (podcast), https://www.arts.gov/honors/heritage/fellows/dolly-jacobs.

Yary Livan (211)

David Iverson, "Yary Livan—Cambodian Ceramics Master," *Merrimack Valley Magazine*, September 29, 2016, https://www.mvmag.net/2016/09/29/19576/.

Quilters of Gee's Bend (Loretta Pettway) (212)

Amei Wallach, "Fabric of Their Lives," *Smithsonian Magazine*, October 2006, http://www.smithsonianmag.com/arts-culture/fabric-of-their-lives-132757004/.

Billy McComiskey (215)

Josephine Reed, "Billy McComiskey, 2016 National Heritage Fellow and Button Accordionist," July 1, 2016 (podcast), https://www.arts.gov/honors/heritage/fellows/billy-mccomiskey.

Clarissa Rizal (217)

National Endowment for the Arts 2016 National Heritage Fellowships (Washington, DC: National Endowment for the Arts, 2016), 15.

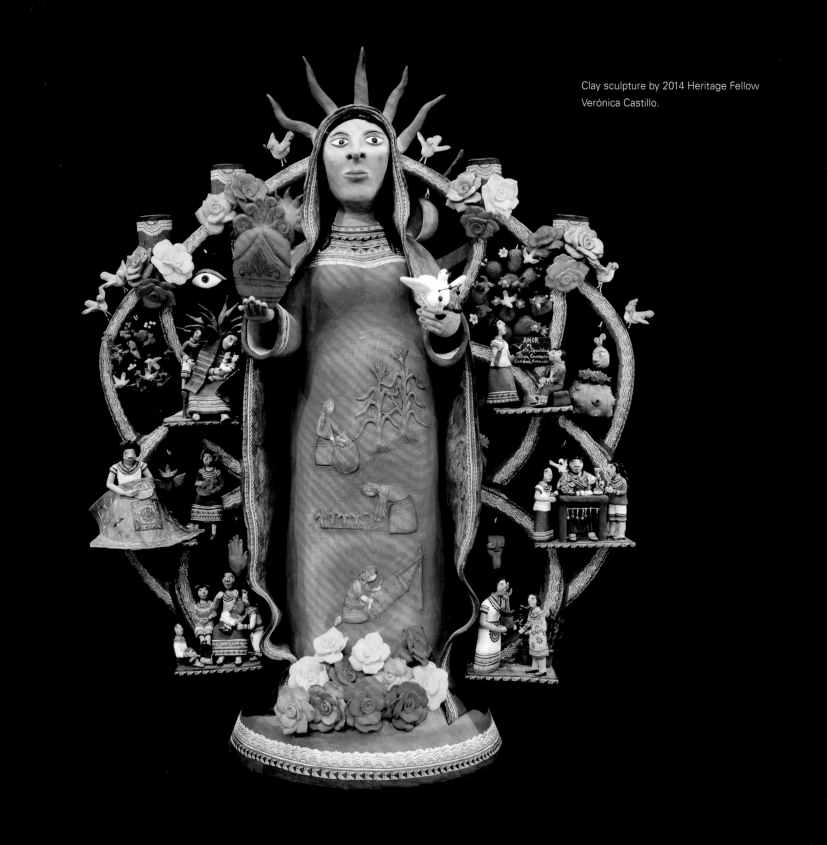

Clay sculpture by 2014 Heritage Fellow
Verónica Castillo.

TOM PICH, a native New Yorker, is a professional photographer who has specialized in documenting recipients of the National Heritage Fellowships, presented each year by the National Endowment for the Arts. The National Heritage Fellowships recognize an extraordinary group of people, legacies of America's cultural landscape, for their excellence in artistry, authenticity of style, and significance within their artistic tradition. Over the past twenty-five years, Tom has traveled across America photographing these extraordinary people in their homes, at their workshops, and during performances, and creating iconic images in America's landscape. His portraiture of National Heritage Fellows can be viewed on the NEA website and has been exhibited at Lincoln Center, the Kennedy Center for the Performing Arts, the National Museum of the American Indian, the Russell Office Building of the US Senate, and the Library of Congress.

Photo of Tom Pich by Eliza Piccininni.
Photo of Barry Bergey and 2006 Heritage Fellow Mavis Staples by Tom Pich.

BARRY BERGEY is past Director of Folk and Traditional Arts at the National Endowment for the Arts, recently retiring after a career of nearly thirty years at the agency. His experience as a fieldworker, researcher, festival producer, tour organizer, and exhibition curator has resulted in documentary recordings of Ozark music, radio programs, and a variety of publications, including a chapter on public policy for the *Garland Encyclopedia of World Music.* From 1995 to 2000 Bergey advised the Center for US-China Arts Exchange based at Columbia University on their Joint Plan on Yunnan Cultures Project. His involvement in international arts policy includes consultation with UNESCO, the Organization of American States, the World Bank, the US Information Agency, and the Department of State. Bergey wrote the foreword for *Lucky Joe's Namesake: The Extraordinary Life and Observations of Joe Wilson,* edited by Fred Bartenstein and published by the University of Tennessee Press in 2017. He currently serves on the boards of the American Folklore Society, National Council for the Traditional Arts, Craft Emergency Relief Fund Plus (CERF+), and Ward Museum of Wildfowl Art.

San Carlos, Arizona, Apache Indian Reservation,
home of 2001 Heritage Fellow Evalena Henry.

Overleaf: Ice out ceremony on the Passamaquoddy Reservation,
Maine, home of 2012 Heritage Fellow Molly Neptune Parker.

ACQUISITIONS EDITOR

Janice Frisch

ASSISTANT EDITOR

Kate Schramm

PROJECT MANAGER

Nancy Lightfoot

BOOK AND JACKET DESIGNER

Leyla Salamova

COMPOSITION COORDINATOR

Tony Brewer

TYPEFACES

Arno, Futura, Univers

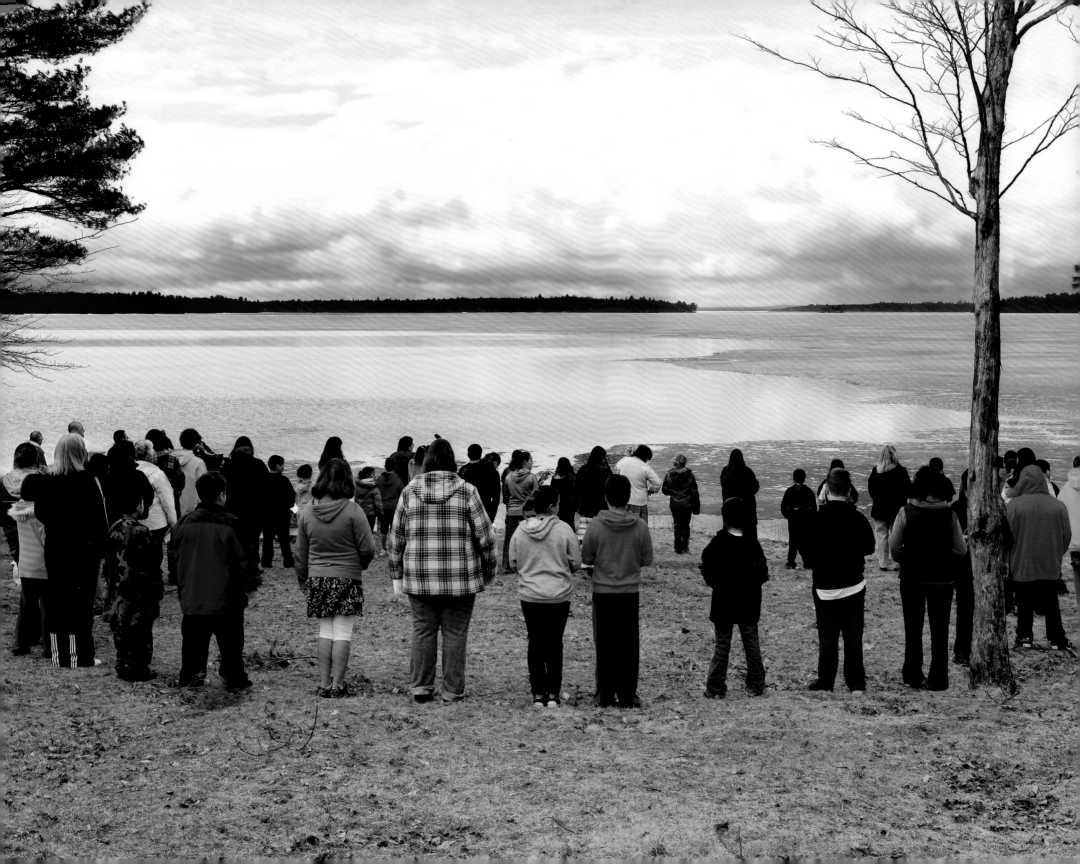